Artschwager, Richard

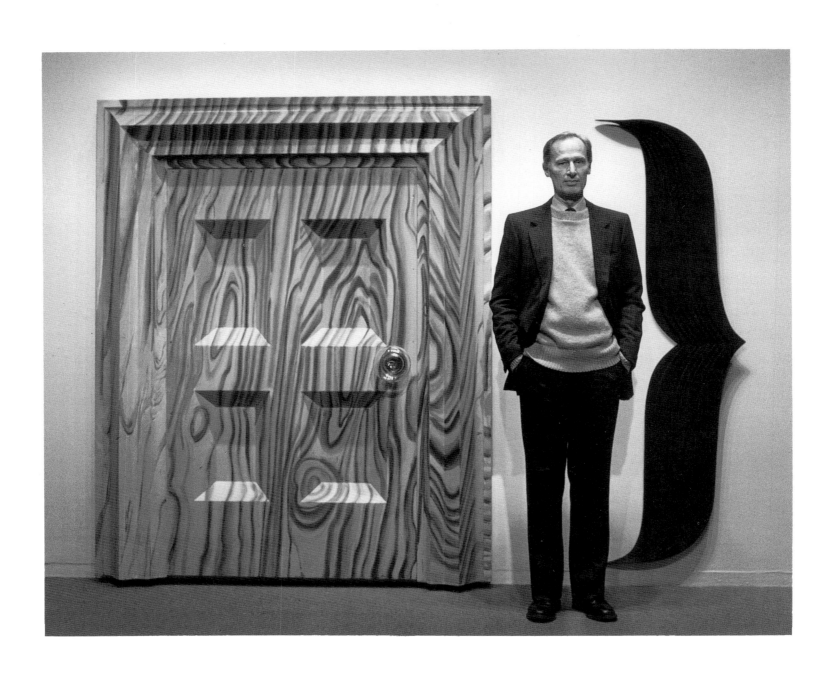

Richard Armstrong

Artschwager, Richard

Whitney Museum of American Art, New York

in association with

W. W. Norton & Company, New York, London

Exhibition Itinerary

Whitney Museum of American Art, New York
January–April 1988

San Francisco Museum of Modern Art
June–August 1988

The Museum of Contemporary Art, Los Angeles
September 1988–January 1989

Richard Artschwager is sponsored by the Lannan
Foundation, Douglas S. Cramer, and the National
Endowment for the Arts.

Research for and publication of this book have been
supported in part by income from an endowment
established by the Primerica Foundation, Henry and
Elaine Kaufman Foundation, Mrs. Donald A.
Petrie, and the Andrew W. Mellon Foundation.

Frontispiece:
Richard Artschwager with *Door* }, 1983–84

Library of Congress Cataloging-in-Publication Data

Armstrong, Richard.
 Artschwager, Richard.

 Bibliography: p.
 Includes Index.
 1. Artschwager, Richard, 1924– —Exhibitions.
I. Artschwager, Richard, 1924– . II. Whitney
Museum of American Art. III. Title.
N6537 .A72A4 1988 709'.2'4 87-23031

ISBN 0-87427-057-X (Whitney paper)
ISBN 3-393-30551-1 (Norton paper)
ISBN 0-393-02596-9 (Norton cloth)

Contents

List of Lenders 7

Director's Foreword 9

Acknowledgments 10

Art Without Boundaries 13
Richard Armstrong

Plates 47

Exhibitions and Selected Bibliography 161

Works in the Exhibition 172

List of Illustrations 174

List of Lenders

Richard Artschwager

Mr. and Mrs. S. Brooks Barron

Martin Bernstein

The Eli and Edythe L. Broad Collection

The Edward R. Broida Trust, Los Angeles

Ann and Donald Brown

Patricia Brundage and William Copley

Paula Cooper

The Detroit Institute of Arts

Norman Dolph

Edward R. Downe, Jr.

Mr. and Mrs. Ben Dunkelman

William S. Ehrlich

Suzanne and Howard Feldman

Mr. and Mrs. Oscar Feldman

Robert Freidus

Gagosian Gallery, Inc., New York

Janet Green

Agnes Gund

Ghislaine Hussenot

Nicola Jacobs Gallery, London

George A. and Frances R. Katz

Kent Fine Art, Inc., New York

Kasper König

Kunstmuseum Basel, Switzerland

La Jolla Museum of Contemporary Art, California

Emily Fisher Landau

The Albert A. List Family Collection

Balene C. McCormick

Anne and Martin Margulies

Robert B. Mayer Family Collection

Jeffrey and Marsha Miro

The Museum of Contemporary Art, Los Angeles

The Oliver-Hoffmann Family Collection

Kimiko and John Powers

Laurie Rubin Gallery, New York

Saatchi Collection, London

Shaklee Corporation, San Francisco

Smith College Museum of Art, Northampton, Massachusetts

John Torreano

Virginia Museum of Fine Arts, Richmond

Jill and Douglas Walla

Frederick R. Weisman Collection, Los Angeles

Bette Ziegler

Five anonymous lenders

Director's Foreword

It is an honor for the Whitney Museum of American Art to present the first major exhibition in New York City of the work of Richard Artschwager, one of the most influential artists of the postwar period. A singular amalgam of sculpture and painting, representation and abstraction, his art has challenged us for more than twenty years. His achievement is not easily categorized: it incorporates elements of a number of styles — Pop, Minimalism, Photo-Realism, and Conceptualism — yet remains apart from all of them.

Artschwager's work has been exhibited at the Whitney Museum regularly since the 1960s and the Permanent Collection includes important examples of his sculpture, painting, drawing, and printmaking. We were very pleased to have acquired *Organ of Cause and Effect III* from the 1987 Biennial Exhibition.

Richard Armstrong, who co-organized an Artschwager exhibition in 1979, has followed the artist's work for many years. His thoughtful essay and selection of pieces reveal and translate his insightful response to Artschwager's creative spirit.

We are extremely grateful to the Lannan Foundation for providing major funding for the exhibition, and to Douglas S. Cramer, Jessie and Charles Price, the National Endowment for the Arts, and the New York State Council on the Arts for additional support. We are also indebted to the private collectors and museums who have been generous in allowing their often fragile works to travel in this important exhibition.

Tom Armstrong
Director

Acknowledgments

My first acquaintance with the art of Richard Artschwager took place on the fourth floor of the Whitney Museum in Lawrence Alloway's 1974 exhibition "American Pop Art." I subsequently thought more about the work and came to know the man while organizing, with Linda Cathcart and Suzanne Delehanty, the 1979 exhibition "Richard Artschwager's Theme(s)" for the Albright-Knox Art Gallery, the Institute of Contemporary Art, University of Pennsylvania, and the La Jolla Museum of Contemporary Art. I am therefore pleased that the Whitney Museum is again showing Artschwager's work, this time comprehensively; and I am grateful to Tom Armstrong, Director, and Jennifer Russell, Associate Director, for their wisdom and enthusiasm during the planning and realization of this exhibition.

Through the timely cooperation of my colleagues at four other institutions, this retrospective survey will be seen by a broad national and international audience. We appreciate the efforts and encouragement of Jack Lane, Director, and Graham Beal, Curator, San Francisco Museum of Modern Art; Richard Koshalek, Director, and Mary Jane Jacob, Chief Curator, The Museum of Contemporary Art, Los Angeles; Nicholas Serota, Whitechapel Art Gallery, London; and Carmen Gimenez, Director of the National Center for Exhibitions, Spain.

All of Richard Artschwager's commercial representatives have assisted my research. Leo Castelli and the staff of the Leo Castelli Gallery, especially Susan Brundage, Melissa Feldman, Lisa Martizia, Mary Jo Marks, and Dorothy Spears, have responded to countless inquiries with accuracy and goodwill. Likewise, Brooke Alexander, Mary Boone, Wendy Brandow, Marianne Goodman, Vivian Horan, Margo Leavin, Laurie Rubin, Jill Sussman, and Barbara Toll assisted in supplying information. I am particularly indebted to Larry Gagosian and Andrew Fabricant of the Gagosian Gallery and Doug Walla of Kent Fine Art for their cooperation and help. Outside New York, other dealers provided invaluable assistance, Donald Young in Chicago and Daniel Weinberg in Los Angeles foremost among them. Susanne Hilberry guided me to the numerous Detroit collections that have examples of Artschwager's work, including that of Mr. and Mrs. Robert Hermelin, and I salute her sense of direction and her graciousness. Rita Guiney of Levi Strauss & Co. welcomed me in San Francisco and supplied important photographs. Betsy Carpenter, Julia Ernst, Connie Lewallen, and David Storey also located useful photographs.

Among the many fine critics who have studied Artschwager's work, Catherine Kord has freely offered insights during our friendship, as has Prudence Carlson. Richard Artschwager's sister, Rita Kay, generously contributed recollections of their childhood and family history. His wife, Molly O'Gorman, and his daughter, Clara Artschwager, kindly submitted to inconvenient phone calls and meetings at the family homestead. Tom MacGregor, Artschwager's assistant, has willingly cooperated in various studio situations.

Amy Barasch kept the office in order and faithfully transcribed many pages of my semilegible handwriting. I am very grateful to Denise Selati, who located photographs and collectors' whereabouts, often under trying circumstances. The bibliography and exhibition history took shape in Julie Grossman's capable hands, and Emily Russell has overseen the organization of the exhibition with her special talent for getting things done correctly.

Without the generosity of the lenders, who graciously parted with works from their collections, this exhibition could never have been realized. We are enormously grateful to them.

Richard Artschwager proved, once again, an enlightened partner in this enterprise. An artist whose work I have admired for a long time, he is also a man who has taught me much, gracefully.

RA

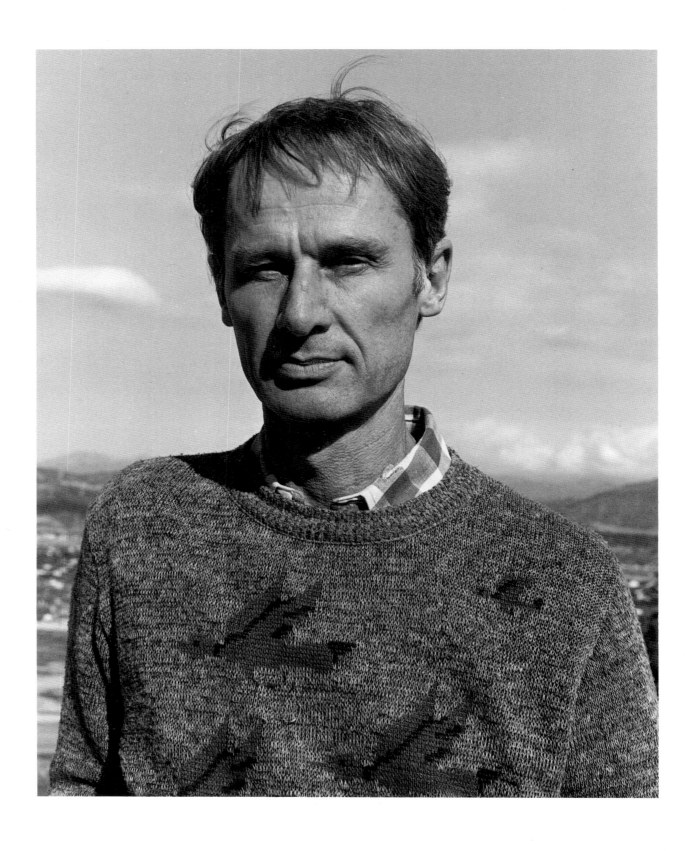

Richard Artschwager, 1985

Richard Artschwager's work has gone in and out of public focus since its appearance in the early 1960s. Maker of dimensional painting-surrogates and pictorial, furniturelike sculpture, Artschwager has consistently sought to use art to alter the context of viewing. His attack on the conventions of art—how it should look, what its subjects should be, and its physical place in life—has been both radical and ingratiating. In this pursuit he has employed two principal tools: seemingly functional, body-scale objects and framed grisaille paintings that refer, literally and metaphorically, to the space inside and outside of themselves. His chosen media, formica and celotex, are unlikely carriers of meaning. But in his hands they are ennobled as art, which he defines as "thought experiencing itself."[1] For although his work is uniformly well made and physically appealing, its potency is as cerebral as sensual. Tactile and admirably crafted, it is intended above all else as a visual catalyst for thinking.

Artschwager was nearly forty before he was able to articulate his own aesthetic. An aversion to the Abstract Expressionist climate of New York in the 1950s and the need to earn a steady living (which he chose to do as a craftsman) delayed his artistic maturation. When he finally began to work seriously as a sculptor, he knew what he expected of his efforts; as he explained it some fifteen years later:

It has been known since the Renaissance that art is produced by artists, and the notion has been available for more than a century that art is internal to the recipient; in a sense, 'made' by the recipient. The first notion has tended to block off the availability of the second, and I think my contribution has been to make it not only available but Necessary, i.e. to force the issue of context, or to put it in more old-fashioned terms, to make art that has no boundaries.[2]

How, when, and in what contexts these concepts have asserted themselves are the questions explored in this essay. An overview of the thematic and plastic interconnections between Artschwager's sculpture and painting will reveal why this enigmatic body of work has become one of the most widely admired in late twentieth-century art.

Richard Artschwager was born in 1923 in Washington, D.C., to immigrant parents. Both parents were German-speaking and Richard grew up fluent in the language. His father, Ernst Artschwager, a Prussian-born Protestant, had come to America in search of a warm, dry climate to cure his tuberculosis; in 1918 he earned a Ph.D. in botany from Cornell University. Richard's mother, Eugenia (Jennie) Brodsky, a Russian Jew born in the Ukraine, had trained as an artist at the Corcoran School of Art in Washington, D.C., and at the National Academy of Design in New York. She continued studying art after her marriage, sharing her enthusiasm with Richard and his younger sister, Margarita.

In 1935, after Dr. Artschwager suffered another bout of tuberculosis, the family moved to Las Cruces, New Mexico, a small and isolated town in the south central part of the state. Richard thought the move

the highest form of adventure, quickly adapting to his new, rural surroundings. Both children spent a good deal of time in the laboratory at the New Mexico College of Agriculture, where their father did research on sugar plants. At the same time, Richard showed an unusual aptitude for drawing; he recalls a camping trip with his mother to sketch the desert mesas that surround Las Cruces.

Artschwager attended the New Mexico Military Institute in his senior year of high school, and remained for another year of pre-college studies. Fully anticipating a career as a scientist, he entered Cornell University in 1941. He enjoyed the science-filled atmosphere in Ithaca, looking up old friends of his father and studying chemistry and mathematics. But at the end of his sophomore year he was drafted. In the fall of 1944, after receiving artillery training, he was shipped to England, then to France. He saw combat and was lightly wounded in the Battle of the Bulge, and then did administrative work at General Eisenhower's headquarters in Frankfurt, followed by a stint in the counterintelligence corps in Vienna, where he met his future wife, Elfriede Wejmelka.

The couple married in 1946 and in March 1947 left for the States. After three years in the Army, Artschwager recalls, he felt he had fallen behind the rest of the scientific community; he also had misgivings about his temperamental suitability for a career in science. Nevertheless, after a summer of considering other schools and possible careers, he returned to Cornell for the fall semester of 1947, earning a B.A. in physical science in February 1948. At this point, however, he began to think that his attraction to art was probably stronger than his aptitude for science. It was his wife who suggested that he give up science for art. He agreed, and the two decided to move to New York after his graduation.

Because art schools were overcrowded with returning veterans, Artschwager took a job as a baby photographer, while Elfriede found work designing textiles. Cribbing from diaper service lists to locate potential customers, Richard drove from one New York neighborhood to the next with his camera and light meter, photographing countless infants.

In 1949, Artschwager entered the studio school of the French émigré artist Amédée Ozenfant, where, with the assistance of the G.I. Bill, he studied for a year. Ozenfant, along with the architect Le Corbusier, had formulated a Cubist-derived, machine-influenced aesthetic in the essay "Après le Cubisme," published in 1919. Through the magazine L'Esprit Nouveau, which he directed from 1920 to 1925, Ozenfant rallied adherents to the aesthetic they called "Purism." Although Ozenfant's own painting was largely uninspired, it neatly embodied the Purist ideas of precision and rationality. It was prophetic of Artschwager's later asynchronism with the art world that he would have studied with Ozenfant rather than with the influential expressionist Hans Hofmann, whose school in Greenwich Village was attracting many returning veterans. But the gestural painting that flourished in the early years of the 1950s

never appealed to Artschwager, nor did the expressionist art scene centered around The Club and the small galleries on Tenth Street. He stayed away from the downtown crowd.

During the early 1950s, Artschwager temporarily abandoned art to work as, among other things, a lathe operator and a bank clerk. Looking back on his war years in Europe and on this period of abstinence from art, he once commented: "Studying the New York School (outside) and the School of Paris (inside) made some deep impressions, the telling one being an increasing conviction that nothing much could be added to these estimable bodies of art."[3] In 1953 he began to make furniture commercially. With the birth of his daughter the following year, he became even more committed to a tradesman's steady salary. By 1956 he was designing and building mass quantities of furniture—simple, modern, and well made. His work found admirers, and three wood pieces, a desk, a swivel chair, and shelves, were included in "Furniture by Craftsmen," a show organized by the Museum of Contemporary Crafts, New York, in early 1957. He has characterized this moment in his life as memorable since, at last, "a larger Usefulness was found in working rhythms assumed and mastered."[4]

Artschwager's workshop and its contents were destroyed in a disastrous fire in 1958. Deeply depressed and prevented by insurance complications from cleaning out the burned shop, he went to visit his sister in New Mexico and spent time drawing the landscape.

Back in New York, Artschwager was obliged to borrow heavily to reestablish his business. Oddly enough, it was at this time that he began reconsidering art. In New Mexico he had sought solace in drawing, and he had never totally given up his interest in contemporary art, visiting galleries and museums when his workshop schedule permitted. At this same moment, the undisputed reign of Abstract Expressionism was ending: in the first three months of 1958, the Leo Castelli Gallery exhibited Jasper Johns' startlingly iconic Target and Flag paintings and Robert Rauschenberg's landmark combines.

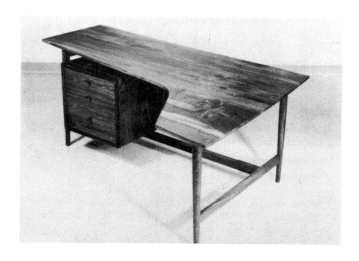

Desk designed and built by Artschwager in 1957

Untitled, 1962. Acrylic on canvas, 24 x 36 in. (61 x 91.4 cm). Collection of Mr. and Mrs. Robert Hermelin

Artschwager eased his way back into art-making by attending various open life-drawing studios that, for an hourly fee, provided models. He soon returned to the easel-scale, landscape-derived abstractions that had occupied him earlier in the decade. Loosely based on recollections of the Southwest, these pictures are principally interesting for the various kinds of brush marks Artschwager used to infer nature. Drawing, rather than color, has continued to be the dominant factor in his painting.

The paintings and drawings from this group were exhibited at Art Directions, a Madison Avenue gallery that showed submitted and judged work, in a two-artist show in October 1959. They attracted the attention of a fledgling *Art News* critic, Donald Judd: "In large oils of Arizona [*sic*] landscapes and smaller watercolors, Artschwager uses a quick spiked, stroke, elongated and communicative of abbreviation, a clipped dissolution. There is a sensitivity immanent in the stroke, especially when the technique is used in the sparse context of two effective watercolors of dunes."[5] In later work, his stroke would assume significance as he sought out painting materials that emphasized the "dissolution" of his subjects.

Solvent, if not prospering, from his furniture workshop, Artschwager nonetheless felt pleased to have reentered the art world. Dressed in coat and tie—"in camouflage," as he put it in his notebooks—he

visited galleries on Saturdays, gradually getting to know Richard Bellamy, the visionary director of the Green Gallery. Although he recognized the comparatively romantic, somewhat retardataire nature of his own work, he continued painting and drawing.

Around 1960, Artschwager was commissioned by the Catholic church to make altars for ships. He described them as "portable altars with all kinds of brass fittings. . . . I was making something that, by definition, is more important than tables and chairs—that is, an object which celebrates something."[6] The experience of making something functional that at the same time superseded mere utilitarianism excited him. When he saw Mark di Suvero's first sculpture at the Green Gallery in October 1960, it encouraged him to seek an art-making process more congruent with his identity as craftsman. Di Suvero's assemblages of ordinary things and urban detritus revealed to Artschwager that art truly could be made of anything.

Working from drawings he had made a few months earlier, Artschwager constructed a set of small wall objects—pseudo-paintings—that combined wood and formica. The latter, a synthetic laminate, proved an especially potent medium for him.

It was formica which touched it off. Formica, the great ugly material, the horror of the age, which I came to like suddenly because I was sick of looking at all this beautiful wood. . . . So I got hold of a scrap of formica—something called bleached walnut. It worked differently because it looked as if wood had passed through it, as if the thing only half existed. It was all in black and white. There was no color at all, and it was very hard and shiny, so that it was a picture of a piece of wood. If you take that and make something out of it, then you have an object. But it's a picture of something at the same time, it's an object.[7]

These early works with formica seemed rational in light of Artschwager's craft training. One of the early art-furniture works was an enclosed walnut shelf, its back plane constructed of "walnut" formica, what he referred to as "walnut memory or walnut picture."[8] It represented his first successful integration of fact (wood) and image (formica). A 3-foot-high formica and wood "altarpiece" followed, as did smaller, but more illusionistically ambitious wall objects incorporating mirror and glass. One of these latter has a shattered mirror that is reassembled and held in place by a sheet of plate glass bolted into a planar wood frame—a small reminder of Artschwager's debt to Surrealism, more particularly to Marcel Duchamp. Yet Duchamp's three-dimensional, roped-off tableaux could not satisfy Artschwager's profound desire for an art without boundaries. Duchamp's work, as he himself understood better than anyone, remained "artful" despite his intentions. By adapting utilitarian forms Artschwager could, however, furnish an environment and posit facts, as well as construct images in space.

Trained as a painter, Artschwager sought a new painting technique that could be as intellectually complete and physically satisfying as his developing sculpture. While the desert of the Southwest was too emotionally charged to function as a neutral subject, found imagery—at first, of figures—satisfied his need for neutrality. A serendipitous, momentary encounter with a discarded snapshot glimpsed in a pile of street trash in 1961 served as Artschwager's catalyst. Salvaging the photo—a snapshot, like countless others, of ordinary people playing at the beach—he set about making a new kind of picture for himself. Gridding the black-and-white photograph, he directly transposed and enlarged its imagery onto canvas. His nominal subjects were "not very glamorous looking. They would live their lives and they would be dead someday. I thought it would be good to paint them as they were, without satire, and made a fairly large canvas, gridding off the photo and following it pretty closely. It was a romantic idea, rooted in lonely voyeurism."[9] By using a found image he was absolved from composing a picture. The technique—painting one square of information at a time—absolved him from constructing a visual hierarchy. Each square inch could be as important as every other. Working in oil on canvas proved tedious, and Artschwager was not wholly satisfied either with the specific process or the result. Yet he knew that the general working method suited his intentions of integrating physical facts with depicted images.

Through Florence Barron, a Detroit decorator who came to Artschwager for custom bookshelves and left with a painting and drawing (the beginning of a long commitment to his work), he met the painter Malcolm Morley. He shared with Morley his nascent Photo-Realist technique and both artists began to

Formica and wood construction, 1962
14 x 6 x 12 in. (35.6 x 15.2 x 30.5 cm)
Collection of the artist

Formica and wood altar, 1962
38 x 27 x 5 in. (96.5 x 68.6 x 12.7 cm)
Collection of the artist

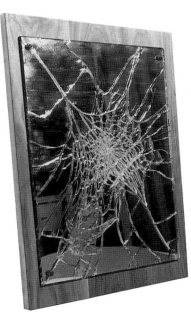

Mirror and wood construction, 1962
23 x 18 in. (58.4 x 45.7 cm)
Collection of the artist

make paintings that used found black-and-white photographs as sources. Nautical themes, especially attractive to the former sailor Morley, absorbed them for some time. While Morley eventually adopted color photographs and a more impressionistic technique, Artschwager stayed with grisaille.

Though his painting was evolving on a conceptual par with his objects, Artschwager found the latter best suited to his growing wish to overcome the limiting reality of function. *Handle* (1962; Pl. 1) bridges his two worlds—the utilitarian and the purely aesthetic. A rectangle of prefabricated oak railing, it curves at each hand-carved corner, forming a self-contained, wall-mounted grip. Its odd familiarity and installed location slightly above waist height invite kinesthetic participation, but to no functional end. Artschwager's proposition that sculpture can be "felt space" finds an early expression in *Handle*.[10]

Through Richard Bellamy, Artschwager had met Claes Oldenburg late in 1961, at the time of Oldenburg's installation *The Store* on the Lower East Side. Oldenburg's handmade surrogates for everyday stuff appealed to Artschwager. He recognized in Oldenburg's use of papier-mâché a kindred, if more flagrantly expressionist, attitude toward unconventional materials; neither papier-mâché nor formica had served any modern artist as a principal medium. The two artists became friendly, eventually exchanging ideas for future collaborative projects, all involving the construction of furniture. Artschwager built armature for some of Oldenburg's pieces in 1962, and in late October of that year gave Oldenburg ten or twelve drawings for their potential collaborations, projects that included variations on chairs and at least three versions of a chest of drawers. Oldenburg even talked about collaborating on a complete set of collapsed furniture, like his later *Drum Set*.

A few months earlier Artschwager had noticed a Franz Kline painting on celotex while on a visit to Chicago. The celotex enhanced the charged gesture typical of Kline's mature work. Artschwager realized that in his own work it would accentuate the graining and blurred edges inherent to so many black-and-white photographs. On further research in New York, he found that celotex—essentially a paper composite—had an exaggerated, fibrous tooth that recalled that of drawing paper (after 1970, celotex was embossed with different patterns). Drawing on the slightly hairy celotex surface was instantly satisfying to him, and he began using it as his painting support.

Artschwager's first combination of painted celotex with sculpture occurred in *Portrait I* (1962; Pl. 7). On an ordinary chest of drawers he painted a black-and-white exaggeration of the underlying wood grain. Propped on top, in the fashion of a tilted shaving mirror, is a rectangular, framed portrait somewhat suggestive of the artist himself. With its companion *Table and Chair* (1962–63; Pl. 4), *Portrait I* formed what was then Artschwager's boldest effort at transforming the functional into the aesthetic. Despite their true-to-life scales, the works are rendered dysfunctional by pictorial intervention. In painting them

with wild, swirling black-and-white bands imitative of wood grain, Artschwager makes them so visually powerful as to negate the idea of physical use. He was clearly overcoming the self-imposed standards of fine craftsmanship in the service of utility, which had once motivated him, in favor of artistic enigma.

Oldenburg saw *Portrait I* and *Portrait II* during a visit to Artschwager's workshop in May 1963. At that time they talked about Oldenburg's plans for work he expected to make in California for a Sidney Janis Gallery show late in the year. Although there is no written record of their conversation during this encounter, it is likely that Oldenburg repeated his previous criticisms of Artschwager's drawings as being too Surrealistic. The *objet trouvé* status of the chest of drawers in *Portrait I* and *Table and Chair,* compounded by their outlandish decoration, probably reinforced Oldenburg's reservations—and perhaps Artschwager's too, for he never again used found objects in his work. Nevertheless, this and other comments by Oldenburg prompted Artschwager's notebook entry that Oldenburg "made me take myself seriously."[11]

Portrait II (1963; Pl. 14) manifests the rapid formal evolution of Artschwager's work from the specific to the general. In contrast to the first version, Artschwager here fabricated a unitary, formica-covered abstraction with a crackled yellow plane for its mirror and thin yellow horizontal bands to delineate its drawers. Instead of the enigmatic figure in the celotex mirror, he employed a crinkly-patterned formica that returns the viewer's look with a blank plane symbolizing reflected light and infinite space.

The remaining months of 1963 were productive ones for Artschwager. He completed the portentous *Chair* (1963; Pl. 15), a compressed abstraction of a Victorian parlor chair in formica-covered plywood. Again, instead of painting a preexistent chair, he concocts a chair surrogate. Low and boxy, it is a geometricized version of its cozy counterpart. Crackled red formica locates the plush velvet seat and back of the chair, its "wooden" frame surrounding the back and supporting the seat. The space under the frame is described by black formica set flush with the cubical void beneath the bottom of the seat. *Chair* and *Portrait II* represent the first fully developed examples of Artschwager's furniture genre.

Chamfered frames were familiar to Artschwager from his years of woodworking, and the frame's role both as external boundary for the image and as physical transition from non-art to art appealed to his plastic inquisitiveness. He made a number of small, framed objects during the mid-1960s, most of them wholly of formica. Varying their overall scale and the internal ratio of frame to what is framed produced widely varying results, from obvious picture-surrogates to puzzling geometrically concave objects, where image is subsumed within sculptural reality. An early and large example of this work is the two-part wall piece *Expressionism and Impressionism* (1963; p. 161). Two identically sized rectangles, the right covered in buff formica, the left in light green, hang side by side. On its upper half, the left side sports projecting,

gently tapering rectangular protrusions: Artschwager's symbols for "expressionism." Echoing that, the same area on the right is depressed as if to receive its neighbor: this geometric concavity metaphorically stands for "impressionism." This iconoclastic work is a harbinger of Artschwager's search for meaning. Its humorous literality will gradually evolve into a well-mannered assault on the strictures of art history. In a consistently enigmatic fashion, Artschwager will seek to fuse sculpture's patent reality with the essential fiction of painting. Part of what distinguishes those efforts is Artschwager's allusions to the work of artists whom he admires—Seurat, the Post-Impressionists (especially Van Gogh), Duchamp, and Magritte. Though he opens up the arena of art, he does so with respect for the Modernist past.

As the ghostly apparition in the "mirror" of *Portrait I* and the yellow "mirror" of *Portrait II* imply, Artschwager deliberately incorporates or alludes to the presence of the figure in his early sculpture. A comparable concern for animation—real or illusory—is to be found in the paintings that evolved out of his experimentation with black-and-white Photo-Realism. Perhaps as a reflex from his portrait photography days, Artschwager's paintings on celotex were mostly figurative, frontal portrayals. *Three Musicians* (1963; Pl. 12) and the larger *Three Women* (1963; Pl. 13) are typical of this work. (The larger, but less successful *Seated Group* [p. 29], in particular, suggests a commemorative portrait.) Consistently attracted to varied, somewhat perplexing imagery, he uses the trios to different ends. The painting of musicians probably represents a tongue-in-cheek reference to Picasso's classic canvas. Most likely lifted from a record album cover, it features three men in dark, indistinguishable suits, their instruments crossed, their identities unclear. The picture is significant for the cream-colored formica frame in which Artschwager places it, a frame that forms a three-dimensional transition from image to wall. A similar, though two-dimensional, transition occurs in *Three Women* (another Picasso title). The same model parades down a runway in three different outfits, the flanking figures seen face-on, the middle one from behind. A thin, reflective metal frame borders the picture, and its three interior parts are separated by two white-painted vertical bands. Artschwager allows the fan-shaped trail of the central dress to pop out over the neutralizing interior separations—a small explosion of trompe l'oeil that both confounds the implied chronological sequence and reasserts the primacy of illusionism.

An untitled diptych from this period (Pl. 11) signals Artschwager's early attempt to incorporate dimensional space into his paintings. He employs two identically shaped, truncated pyramidal shapes to establish a deep space. Their projecting sides are painted black. Each rises several inches off the wall before ending in a celotex picture plane. To the left, Artschwager gave an even, acrylic and charcoal wash to the pressed, incident-filled celotex. To the right, the ludicrous bust of some media personality of the era looks out inscrutably. These objects' shape and scale, which recall the black-and-white televisions of those days, make the empty pictures look like static-filled screens. Artschwager seems to be pushing toward the

point at which a deeply dimensional, wall-bound painting becomes a painted sculpture. It is an exercise that would occupy him throughout the decade as he worked variations on the diptych and triptych formats, eventually shedding painted imagery in favor of the inherently pictorial pattern of formica.

The year 1964 began inauspiciously. Oldenburg had come back from his long stay in Los Angeles with a suite of bedroom furniture replete with marbleized lampshades and abstractly patterned pictures that at first glance resembled Artschwager's furniture. He had installed the work at the Janis Gallery in New York for the show "Four Environments by Four New Realists" (January 3–February 1). Pat and Claes Oldenburg visited the Artschwagers the night before the opening and saw some of Artschwager's new formica furniture (principally *Portrait II* and *Chair*) and were nonplussed by its resemblance to the bedroom. Artschwager, in turn, was upset by the description of Oldenburg's *Bedroom Ensemble* that he got from friends who had seen the Janis show. In a misguided effort to ameliorate the problem, Ivan Karp told people Artschwager helped Oldenburg construct the bedroom, a claim that was repeated in the press.[12]

Seen today, particularly in light of Oldenburg's subsequent work, the *Bedroom Ensemble* seems distinctly non-Artschwagerian. For one thing, its oversize scale, reinforced both by the extreme elongation of the bed and the cacophonous mixture of giant, clashing patterns, sets it apart from Artschwager's

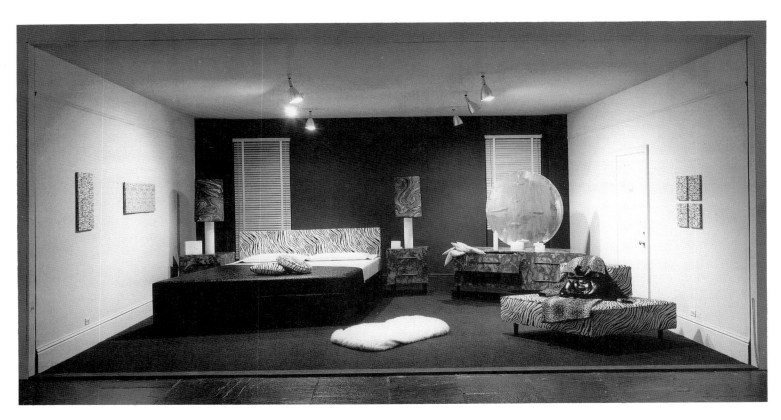

Claes Oldenburg. *Bedroom Ensemble,* 1963. Mixed-media construction, dimensions variable
National Gallery of Canada, Ottawa

work, which typically approximates the anatomical norm. Secondly, Oldenburg's wholesale incorporation of tactility—from the vinyl bedspread to the fake fur rug—are foreign to Artschwager, who consistently imposes a sense of physical removal by using a material that does not elicit tactile response. Perhaps most tellingly, the clothes stuffed into one of the vanity drawers and the leopard coat and purse strewn on the chair strongly imply the existence of a specific narrative, a characterization of the environment that never appears in Artschwager's three-dimensional work.

The essential differences between the works of Artschwager and Oldenburg—most obviously in Artschwager's relatively high degree of abstraction—exemplify the relationship between Artschwager and all of Pop Art. Although chronologically part of the Pop movement and in fact spurred by Johns' and Rauschenberg's implicit refutation of Abstract Expressionism, Artschwager's work is nonetheless comparatively deadpan, his early paintings' blurry, static-filled screens quite unlike the TV-saturated blitz of Pop. Likewise, the sculptures are mostly monochromatic abstractions that mimic furniture. Artschwager's work of the mid-1960s shares nothing but its origins with the boldly legible compositions of Roy Lichtenstein, Andy Warhol, or James Rosenquist. Pop, an aesthetic enterprise based on a set of preexistent, advertising-derived signs, is best realized in paintings; and best of all in paintings that manipulate and replicate those signs. Pop sculpture, as exemplified by Oldenburg's work, Tom Wesselmann's life-size reliefs, and George Segal's tableaux, is fundamentally dependent on the human figure for its fullest realization. Many of the signs and advertising devices exist (literally, in Wesselmann's case) in Pop sculptures, but only as accoutrements for the figurative subject matter.

By contrast, Artschwager's work (in the mid-1960s still mostly sculptural), is a plastic transformation of the familiar addressed principally to non-narrative, spatial perception. At this point the work seeks to engage the viewer to do something, to know space by moving through it to see a reflection, to sit, to grab hold of—in short, to act out and thus invent meaning. With its emphasis on real or implied body motion, Artschwager's work should, theoretically, be empathetic to the body-scaled, early Minimalist sculpture of such artists as Donald Judd and Robert Morris. (The work of each was being seen in 1963 for the first time at the Green Gallery.) On closer inspection, however, the Minimalists' strong bias against illusion, their polemic against applied rather than intrinsic surface color, and their abhorrence of symbolic meaning quickly distinguish their art from Artschwager's. Although initially interested in Artschwager's sculpture, by 1965 Judd was criticizing it for its close resemblance to furniture sources.

For Artschwager, the tantalizing resemblance of his sculpture to furniture was central. He recognized that furniture forms offered him subjects suffused with human personality—the fussiness of the Victorian, the rationality of International Style, etc.—that could simultaneously operate as abstractions. In *Table and Chair* (1963–64; Pl. 16), for instance, a wood-colored formica defines the table legs and chair

frame, while white does double duty as solid and void—as tabletop, chair back, and the spaces under the table and, when seen from the sides, as the space under the chair. From behind, however, this space is left open: space portrays itself as void. A comparable treatment prevails in *Mirror/Mirror—Table/Table* (1964; Pl. 23), where mahogany-colored formica forms two small tables and matching frames. The mirror and space under the table of one set is yellow formica, the other pink. The mirrors' obdurate, non-reflective surfaces are obliged to exist as finite planar spaces, effectively questioning both pictorial space and our expectations of mirrored vision. The mirror's ability to return infinite sections of reality, thus including the light and motion of the real world, makes it a particularly appealing vehicle for Art-schwager. In its initial incarnation as painted celotex and formica, it describes this reflective role. Later, with the literal incorporation of mirrors, Artschwager gains both a new light source in his work, and quotations from the real world, replete with its ceaseless activity.

A profound desire to transcribe painting values to sculpture and vice versa distinguishes the related *Table with Pink Tablecloth* (1964; Pl. 18). A squat, cubical form, the piece relies on three colors of formica to replicate a cloth-covered table: pink for the symmetrically draped cloth, white for the legs, and black for the space under the table. Artschwager saw this work as more pictorial than sculptural. In fact, he claimed: "It's not sculptural. It's more like a painting pushed into three dimensions. It's a picture of wood. The tablecloth is a picture of a tablecloth. It's a multipicture."[13] By using formica as a pictorial representation of voids, as he does here and in the earlier *Chair*, Artschwager successfully forces a two-dimensional reading of three-dimensional space. *Table and Chair* (Pl. 16) mixes the two: a real void is seen from the back of the chair, while its sides and front, as well as all four sides of the table, use formica to represent space.

Artschwager's paintings, until now small and lacking convincing exterior references, gained new authority in 1964 with the adoption of architectural imagery, much of it taken from the real estate section of the *New York Post. Lefrak City* (1962; Pl. 8), *Tract Home* (1964; Pl. 20); and *High-Rise Apartment* (1964; Pl. 28) all still employ the grid transference system. As modular containers for life's implements and implementers, these spooky representations of modern habitats complement the furniture sculpture—they are the pictures of its locale. By either elaborately framing these in formica frames of his own making (*Tract Home*), or isolating them by a painted white border that in effect marks out the building in question from the city (*High-Rise Apartment*), Artschwager once again shows his concern for art's context: its real context is mediated by elaborate frames, its formal or internal context edited for an isolating effect.

In 1963 Artschwager had written to the Leo Castelli Gallery asking for representation of his work. As a result, he met Ivan Karp, Castelli's director, and the two had become friends. Both Karp and Castelli enthused over Artschwager's work and included a few of his pieces in two group shows in the spring and

fall of 1964. His first one-artist show opened at Castelli's in January 1965, and featured *Table with Pink Tablecloth* and *Long Table with Two Pictures* (1964; Pl. 22) among other pieces. The *Long Table*, a narrow harvest table with a "draped" tablecloth and companion "pictures" — gray celotex in painted wood frames — embodied Artschwager's entire conceptual repertoire to date: furniture as sculpture, pictures as furniture, the material touchstones of formica and celotex, manifested constructions of perspectival space, and re-contextualized, preexistent forms and imagery.

In the months that followed, Artschwager experimented both with more elaborate construction-decoration methods, as in *Chair/Chair* and *Piano* (both 1965; Pls. 31, 36), and with various relief constructions, in order to explore how we see in space. *Tower* (1964; Pl. 25), a large-scale example of this work, offers a life-size site for a ceremony of looking. Steps on two sides of an upright slab lead up to a recessed horizontal slot. Fully utilized, with one person on each side, the piece would host a pair of voyeurs, the gaze of each directed at the other, only inches away. The idea of looking at and looking into is also explored in a number of smaller wall reliefs from this period, culminating in the didactically titled *Step 'n' See II* (1966; Pl. 41). The floor-bound rhomboid depicts a step with its incised rectangular notch, complete with a recessive white formica bottom plane, "lit" from the side by different colored formica. Hanging on the wall above is a separate component: a shallow rectangular relief with its own incised rectangular notch, echoing the step but constructed to show an overhead light source. These combinations of darker and lighter formicas marked the beginning of Artschwager's concern for incorporating or implying light and its origins — another transcription of painterly qualities to sculpture.

Because habitual acts and functions inhere in furniture surrogates, they perfectly express Artschwager's definition of sculpture as "felt space." As he commented in the early 1970s about his work: "Space is an abstraction that grows naturally out of our looking at, looking into, looking through, walking, opening, closing, sitting, thinking about sitting, passing by, etc."[14] *Swivel* (1963; Pl. 9), *Sliding Door* (1964; Pl. 17), *Rocker* (1964; Pl. 32), and *Counter II* (1964; Pl. 33) each physically engage, literally or metaphorically, an activity that empirically illustrates Artschwager's notions of how space is perceived. User-friendly and relatively uncomplicated actions like those implied in *Swivel* and *Rocker* become more patently absurd in *Sliding Door*, which is too narrow to ever completely close off the blank insides. On a grimmer note, *Walker* (1964; Pl. 10) (first known as *Desk-tender*, then *Beyond Realism*), with its bloated, knee-high stature, would frustrate the very movement it is supposed to assist. By frustrating, and eventually denying, implied use, Artschwager finalized his transition from craftsman to artist. He allowed himself to be freer and more imaginative in his work, inspired, in part, by a new and growing friendship with Walter De Maria — the most advanced and boldest of the emerging Conceptualists. The latter's proposed projects, incorporating vast areas of real sites (the Great Wall of China, for instance) instructed Artschwager.

As if to celebrate the critical evolution from craftsman to artist, in *Triptych II* (1964; Pl. 30) Artschwager returned to the portable altars that had liberated his artistic imagination four years earlier. Nearly 4 feet high x 8 feet wide, this tripartite wood-grain formica object consciously evokes medieval and Renaissance painted altars, replacing their Catholic iconography with a pattern of fake naturalistic growth whorls. Religious objects had been referred to in some of Artschwager's early work, such as a smaller altarpiece of 1961 (p. 18) and the oak *Cross* (1962; Pl. 6). In early interviews, he repeatedly uses the word "celebration" to describe the nature of his evolving work.[15] The inherently celebratory nature of religion would continue to inspire his work at different times during the next twenty-five years.

The neutrality of touch, coloration, and imagery in most of Artschwager's work is conscious but not intended as cynical. Despite the enigmatic social meaning of such imagery as bleak high-rise apartment buildings, Artschwager meant to avoid expressions of anxiety and alienation. He hoped instead to elevate for contemplation all variety of depicted things, once again to situate art outside boundaries, especially those of appropriateness, taste, convention.

Artschwager had been an avid—and talented—pianist since childhood, continuing his studies at Cornell. After graduation, he had even briefly considered further training toward a career as a piano soloist. His use of musical metaphors is typified in a notebook entry dated March 23, 1964, presumably made after visiting the Jasper Johns retrospective at the Jewish Museum: "The early work has much grandeur, emits sounds. All great work I can think of emits sound like a large shell held to the ear, or a ringing in the ears. A few of my things emit sounds."[16] A few pages later, as if concretely responding to that insight, are sketches of a keyboard and a piano. The keyboard would appear later in his work as an architecturally scaled installation. Meanwhile, Artschwager began two piano sculptures: *Piano* (1965; Pl. 36) is a condensed spinet abstracted to emphasize its cubical, furniturelike aspect, its foot pedals rendered in bright yellow and resembling giant beaver teeth. This is probably Artschwager's most emphatically comic and celebratory sculpture to date. *Piano II* (1965–79; Pl. 35) approximates the Bosendorfer grands that he prefers to play. Again, an abstracted formica keyboard forms the instrument's head (which was completed first) but, in an unusually aggressive assertion of elongated space, the body of the piano—all 10 feet of it—is made of rubberized hair, which he added to the keyboard in the late 1970s.

Artschwager's desire to have his work alter its physical context may have inspired an odd, untitled table piece from 1962 that questions the traditional placement of art. It is situated in the right angle where wall meets ceiling. Splaying the legs and breaking the tabletop into four akimbo quadrants, Artschwager transformed the original form almost beyond recognition. The demonstrative repositioning of the table reveals at least one of the form's nonutilitarian readings, while its construction represents a small *tour de force* of woodworking and lamination. It may be this ultimately unsatisfying combination of Surrealist

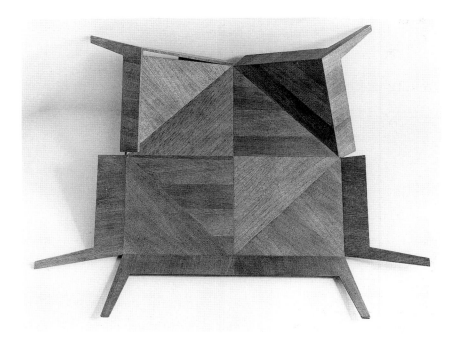

Untitled (Table), 1962. Wood, 36 x 36 x 12 in. (91.4 x 91.4 x 30.5 cm). Collection of Mr. and Mrs. Robert Hermelin

overtones with overt handicraft that makes this piece an anomaly in Artschwager's oeuvre. But it does exemplify his search for situations and forms capable of activating traditional spaces, and foretells the fantastic, polychromed *Flayed Tables* (1984–85; Pl. 99).

Artschwager's efforts to activate space were gradually becoming more sophisticated, as he consciously exploited the traditional roles and spatial rights of furniture. He once said of his art that it was intended as a "garlic sliver into a joint of mutton."[17] He may have had in mind *Corner I* (1964; Pl. 24), a formica-covered wedge designed to be inserted in the upper reaches of a receptive corner. Its tapered face is reminiscent of a security detection device. When it is placed in its overhead site, Artschwager's message is "art goes here, too."

Besides the desire to activate odd reaches of any given space in order to psychically extend its physical boundaries, Artschwager also understood early in his career that a hybridization of painting and sculpture confuses and enriches the traditional two- and three-dimensional attributes of each medium. For this reason, from the early 1960s on, he transformed the frames of his paintings into sculptural elements. Fabricated by him in formica or milled aluminum, they gave the pictures real, measurable depth. In later work, mirrors, originally implied or described, more recently physically incorporated, would likewise lend depth to wall-hung work.

Certain early pieces such as *Diptych II* (1967; Pl. 52) use framing as a sculptural element joined to a painting, so that the work can be seen either as a sculptural painting or as a painted sculpture. Here a 9½-inch-deep, wedge-shaped formica wall relief frames and protects two pieces of celotex inset at an angle into the formica. On them Artschwager has painted a woman's face, using the seam of the angle to divide the portrait. The formation of a whole image by means of mirrorlike halves—implied here,

literally realized in later work—is a recurrent device in Artschwager's oeuvre which reaches its apogee in his sole self-portrait, *Janus II* (1981; Pl. 92).

Other hybridized configurations, such as *Diptych IV* (1964; Pl. 21), are often incongruous conjunctions of fanciful imagery with geometrically composed armatures covered in ambiguously swirling formica. *Diptych IV,* an inversion of the formica-celotex arrangement of *Diptych II,* shows a nude woman in the act of scraping leftovers off a plate for a waiting dog. Artschwager, who chose the scene partly for the "sincerity" he thought it conveyed, interrupts the narrative depicted in the celotex with a relatively broad formica slab. Painted representational image and printed, abstract image create a symbiosis of charged emotion, one that enlivens the pattern of the laminate as the formica assumes implied representational illusions in between the domestic scene on either side of it. With this work Artschwager successfully begins to exploit the para-narrative powers of the marbleized formica he was using. It can be understood as a pictorial abstraction for space or as an image surrogate for figurative subjects. More than twenty years later in the large *Loop* (1986; Pl. 114), Artschwager returned to the three-faceted shape of *Diptych IV,* this time by painting the flanking sides and surrounding face black, reinforcing the visual richness and many possible readings of the formica.

Celotex proved to have a similar potential for multiple readings. As Artschwager worked with his chosen Photo-Realist, grisaille painting method, he realized the pictorial equivalence of celotex to the pre-patterned formica. When painted, the embossed, repeated patterns of celotex, either wavy explosions of concentric circular marks or interwoven crosshatchings, were as visually loaded as formica. Both materials, with their inherent visual activity, simultaneously offer more than enough for the insatiable eye to read and prevent any attempt at holistic, instantaneous comprehension. Artschwager's work operates as a conceptual provocation rather than as an aesthetic manifestation. The sculptures exist as room-size monuments to furniture and the ghostlike celotex pieces as memorials to painting.

Although Artschwager's approach does not seem to lend itself to the treatment of the full figure, he produced a number of photo-derived figurative paintings in the 1960s. One little-known series (with few exceptions, all destroyed in a gallery fire) depicts various sex acts. Artschwager occasionally even undertook portraits of patrons. The better figure paintings, such as *Seated Group* (1962), celebrate unknown subjects and rely on ambiguously depicted bodies for their limited success. Unlike furniture, with its universal, stylized characteristics, the human figure requires too much particularization of personality, posture, and ambient space to adapt well to Artschwager's media of paint with charcoal on celotex. His method precludes the accuracy—literal and metaphorical—required of a good portrait. The strength of his paintings is in their odd, invented space and their conceptual eccentricity rather than in the rendering of individual likenesses or familiar congregations of people.

The principal exception would at first seem to be the sailor paintings of the mid-1960s. But, in fact, military personnel, precisely because they are interchangeable units for warfare, are compatible with Artschwager's aim—to investigate the role of vision in comprehending space. A series of small panel paintings done during 1964–66 in which he used photographs of groups of sailors for imagery culminated in the four-panel *Sailors* (1966; Pl. 38). Sailors' uniforms and caps lend an evenness of detail that permits the segmentation and framing to have a pictorial value equal to that of the imagery. In *Sailors*, the relatively small (25 x 22½-inch) surfaces of the four celotex pieces are challenged for visual primacy by the wide frames that abut one another to form a windowlike structure. In 1965, Artschwager had begun to use commercially manufactured, grooved metal frames on his paintings. Their shiny, reflective surfaces at once announced the material independence of the enclosed paintings from their surrounds, and, paradoxically, served to mirror and hence integrate the static images into their fluctuating environments. Viewers see themselves reacting in motion to the picture as well as to the constantly shifting quality of the ambient light. These metal frames, used by Artschwager for the next twenty years, literalize the obdurate formica mirrors and beveled formica frames of his earlier work.

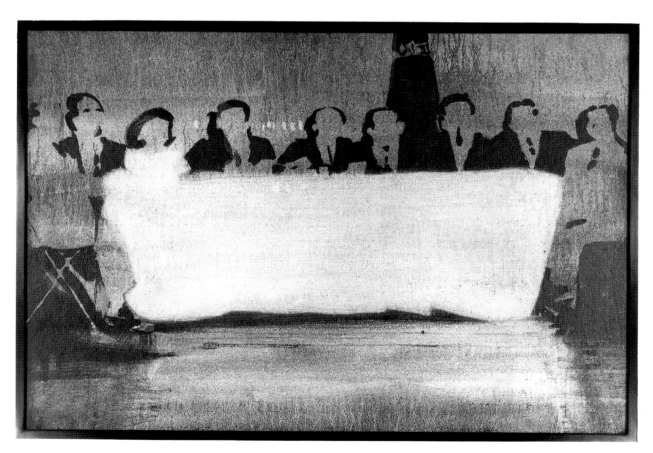

Seated Group, 1962. Acrylic on celotex, 42 x 60 in. (106.7 x 152.4 cm). PaineWebber Group Inc., New York

Once adjusted to this constant metallic intrusion (that seems illusionistically to sit on top of a conjoined picture plane), it becomes clear that parts of heads and uniforms are interrupted and repeated from one panel of the composite image to the next. The separated, repetitive images approximate the disjointed glances that the mind synthesizes to create moving vision. The movement caught in the frames is thus complemented in the implied motion inside the paintings. This pictorial device, with its implicit recognition of the role of time in vision, will occupy Artschwager for the next several years.

With Artschwager's incorporation of time and motion into painting came an increasing fascination with perspective as the convention for creating illusory space. In such paintings as *Office Scene* and *House* (both 1966; Pls. 39, 40), the orthogonals required by perspective become compositional elements, as evidenced by the scored concrete walk leading to the house or by the linear arrangement of the desks and the lines of the ceiling in the office. At this point Artschwager's method had become fairly standard: after selecting from the two varieties of embossed patterns available in celotex at that time, he would draw a version of the final image, highlighting it in white. On top of this he poured a thin coat of black acrylic paint, which in its movement across the picture plane would adhere to, and/or fill in, the topography of the celotex. Once it was dry, Artschwager would return to the surface with black and white paint to heighten or suppress the underlying drawing. *Office Scene* is unusual for the intensity of the dark areas, considerably more opaque and defined than in most of Artschwager's paintings. Yet evident even here is the curiously imprecise line that results from his method. In these celotex works nothing is ever quite still enough to gain perfect definition. Instead, we are faced with highly active, slightly out-of-focus edges reminiscent of those in the work of the Post-Impressionists he admires. In his art, too, the visual fluidity of the world is paramount. His scientific bent obliges him always to impose order on, to seek concrete meaning for, ever-changing reality. Celotex offered the delusion of a constantly changing field, while one line deftly rendered on it could create illusionistic depth. By the end of the decade, Artschwager's elementary experiments with illusion emboldened him to attempt grander paintings.

The panoramic and horrific *Hospital Ward* (1968; Pl. 51) incorporates incidents of highly contrasted definition with other, more ambiguous passages. Perspectival focus and empathetic focus are intermingled here as in no other Artschwager work. The parts of the large, three-panel painting are edged in thin metal strips that vertically interrupt the logical narrative flow. Artschwager opens up the wide-angle view of a bed-filled ward on the right side to provide a visual escape. In this third panel, a nurse ministers to an invalid, the picture's sole island of comfort. Elsewhere, either in the relentless rows of the machinery of illness or in incidents such as the struggle of one victim on the left to sit up in bed, the picture is difficult to look at, almost impossible to resolve. Just as he had previously rendered the functional *Table and Chair* dysfunctional simply by decorating it to the point of repulsion, so here the subject is so

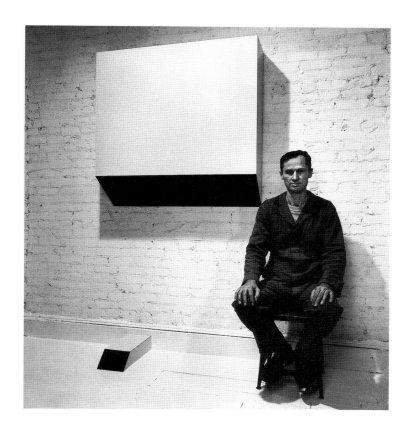

Richard Artschwager, 1966

integrated with the agitated surface of the celotex as to repel the eye. *Hospital Ward* is literally hard to look at, and thus as a painting could be considered equally "dysfunctional."

If *Hospital Ward* represents one, nearly intolerable, extreme of pictorial reality, the sculptural work that occupied Artschwager during this period constitutes another: that of representational mass abstracted to nearly illegible states. This suite of work, characterized by his use of rich, brown marbleized formica, began with a piece of 1966 (Pl. 45) that could be read either as a chair or a chest of drawers with mirror. As always, Artschwager successfully inserts an essentially foreign, utterly abstract thing into a common space, but makes it familiar through its furniturelike appearance. In considering this piece, one observer noted, "by being a little too high, too shiny, and with no place for your legs it conveys perfectly what is meant by abstraction."[18]

This kind of marbleized work made up Artschwager's second one-artist show at the Castelli Gallery, which opened in late 1967. Besides *Key Member* (1967; p. 33)—a small wrap-around, multifaceted piece that prompts a visually guided, ambulatory reading of its supporting door frame—and the chair-chest, Artschwager showed a curious table-chair abstraction called *Two-Part Invention* (1967; Pl. 44). Highly geometrized, the chair hangs on and faces the wall. Its framed rectangular opening recalls Artschwager's longtime fascination with indentation (his "impressionism") and projection ("expressionism"). Squatting beneath the wall piece is a short platform that could be an especially low coffee table or a boosting step for this schematized revision of *Step 'n' See* (Pl. 41).

The show included other elaborations on previous Artschwager forms, all employing marbleized formica and including the folding wall-bound format of earlier diptychs and triptychs. The latter is echoed in *Diptych III* (1967; Pl. 46), with its two wooden panels flanking a wider, all-white central panel. In *Faceted Syndrome* (1967; Pl. 49), a kindred combination of all-over pattern and neutrally colored formica is joined in a five-panel structure. Inlaid, light-colored formica makes a horizontal band across the brown patterns, suggesting a horizon or an extended literary passage; the band induces an involuntary reading from left to right that serves as a strong reminder of how often art is obliged to conform to literary organization. Artschwager will return to this art-literature intersection in the 1980s with astonishing results (Pl. 100). In *Diptych III* and *Faceted Syndrome,* he pushed the convention of gilded and painted altarpieces almost beyond recognition. In the latter, maintaining the planar integrity of the formica sheets and elevating the work to eye level obliges its reading as painted surface. Though the burl formica in question appears to be a continuously active, aleatoric field, it is, in fact, a regularly repeated pattern. These pieces seem to be assaults on the sacrosanct idea of "all-over" painting as it had been codified after Jackson Pollock. Some—such as *Faceted Syndrome*, with its cheeky title (suggested, as were *Two-Part Invention* and other apt names, by Ivan Karp)—are like sardonic critiques of the dogmatic serialization of much Minimalist sculpture.

In the dimensional reliefs of this group, such as *Untitled* (1966; Pl. 43) or *Two Indentations* (1967; Pl. 48), Artschwager uses the indented structure to impart physical reality to perspectival recession. Real and implied illusion is explored in various ways throughout this series. These outsize, wall-bound cubes can also be seen as bloated, ponderous frames for the recessive focal points each of their various depres-

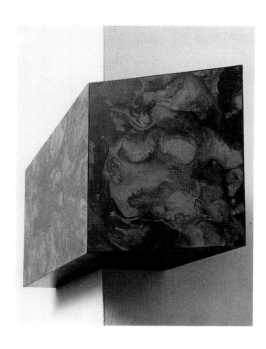

Key Member, 1967
Formica on wood, 11⅞ x 29½ x 8¼ in. (30.2 x 74.9 x 21 cm)
The Museum of Modern Art, New York; Gift of Philip Johnson

sions represents. Other variations of these structures, some with louvered projections that cast shadows, show the artist's concern for the space-defining properties of light. Still others—mostly small and featuring a single indentation—exist in other marbleized colors, such as bleached walnut and blue.

The searing color of the blue pieces, *Logus* (1967; Pl. 47) foremost among them, further separates Artschwager's work of this period from its ostensible origins in furniture. *Logus* (the title a Karp invention that joins locus with logic) is an enlargement of the twinned, cubical depressions of *Double Speaker* from the previous year (Pl. 37). At the 3 x 4-foot scale of *Logus*, the previously comprehensible, seemingly utilitarian form becomes patently fictive, hence more incontestably artistic. Stranded on the floor, it is the most abstract of Artschwager's constructions. The related wall reliefs, such as *Two Indentations*, represent a sustained inquiry into the differences between the illusions of painting and those of sculpture. They are especially interesting because of Artschwager's attempt to supersede those differences, creating dimensional, fictional objects that become as pictorial as they are sculptural.

Besides the all-gray celotex panels that served as mirror surrogates or as blank counterparts to companion pieces, Artschwager also produced a number of independent, abstract paintings during this period that made illusion their subjects. This work relates to the spatial concerns of the marbleized wall reliefs. For these paintings he would "invent" imagery, often capitalizing on the embossed surface of the celotex as a source. With the conceptual range of his ambition in mind, it is not surprising that Artschwager, simultaneously with his figurative and architectural works, would also produce simpler, somewhat more abstract paintings that consciously explore the nature of illusion. In such small works as a pair of

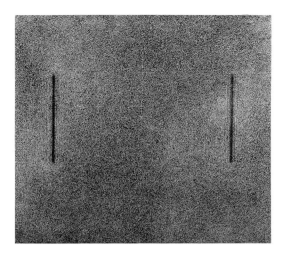

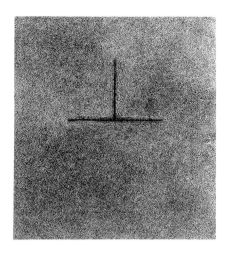

Untitled, 1967
Acrylic on celotex, 20 x 22 in. (50.8 x 55.9 cm)
Private collection

Untitled, 1967
Acrylic on celotex, 22 x 19 in. (55.9 x 48.3 cm)
Private collection

untitled paintings (1967), he gives the celotex field an even, black-and-white coloration, forcing the painted fibers to pictorially fill the entire surface. On both, he has drawn two short lines. In one painting, a separated and parallel pair cuts into the surface, while in the other a perpendicular intersects a horizontal, forming two corners or two seats sharing a single back. Other small paintings feature illusionistically rendered concave depressions. These rounded forms suggested arches or half-ovals, among other geometric shapes; a suite of these came to be known as *Eight Rat Holes* (1967–68 and 1973–75). The reduced, simple linear "subjects" Artschwager calls forth—liberates—from the celotex are more often associated with carved sculpture, and many of these small paintings resemble carved stone. This is another instance of Artschwager's transcription (here made illusionistically "real") of sculptural characteristics to paintings.

In a few other pieces of this time such as *Open Door* (1967; Pl. 50), Artschwager literalized the perspectival inferences that had been appearing in his work for three years. As in *Faceted Syndrome,* he puts wood-grain formica together with monochromatic formica. But this time it is with the notable addition of a shrunken, recessive depression—a spot, really—that marks the perspectival center and presumably most interesting part of the blank "painting." This dark spot, rounded at its corners but otherwise undistinguished, is about to expand and proliferate as Artschwager's new sculptural vehicle—his "blp."

An inveterate draftsman and note taker, Artschwager had made a series of landscape-figure drawings using his characteristic combination of choppy, accentlike strokes and swirling, space-filling marks during the winter of 1967–68. He decided to work from these drawings for a show he was to do while a visiting artist at the University of California, Davis, in the spring of 1968. He had noticed that the drawings' marks embodied a rich ambiguity. "When there were few marks the work would represent the marks themselves as well as the figures or landscapes. When they became very few they would only occasionally hint at figure, etc."[19] But it was purely as marks themselves—as spatial punctuation—that Artschwager

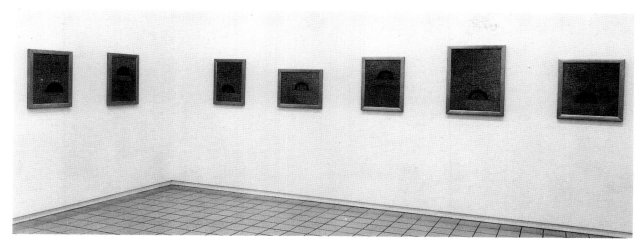

Eight Rat Holes, 1967–68 and 1973–75
Acrylic on celotex with metal frames, eight panels of varying dimensions, the largest 28½ x 23 in. (72.4 x 58.4 cm)
Saatchi Collection, London

began to employ them in four elemental shapes of black painted wood, each about 12 inches long, which he affixed to the wall. Originally conceived as gigantically enlarged drawing marks—accents—they assumed independent life and validity. After further refinements, one of these shapes, about the size of a bread loaf, became predominant. Profoundly attracted to this elongated oval shape, he then inked tiny versions of it on a number of randomly selected magazine illustrations and photographs. He dubbed the shape "blp," partly because "if you take out the vowel (the 'i') the spoken word is automatically crisper."[20] The black blps, usually a foot in length and 5 or 6 inches wide, were a literal incarnation of Artschwager's desire, recorded in a notebook in 1964, for a "very hard, dense, heavy after image."[21] Portable (either as wood objects or paint) and easily realized, they cogently embodied his developing taste for linguistic references. Typically used as vertical signs, they could be seen as abstracted punctuation or even as odd musical notations. Terse, arresting, and enigmatic, they seem quintessentially Artschwager.

Constructed and spray painted *in situ*, blps constituted the exclusive contents of Artschwager's first one-artist show in Europe at Galerie Konrad Fischer, Düsseldorf, in 1968. Fischer's pristine, barrel-vaulted space provided the perfect architectural arena for Artschwager's ubiquitous ovals. Streamlined, mechani-cal-looking, and uncompromisingly abstract, the blps (black on a white field, white when on black) are the ultimate Purist object—conceptual Ozenfantilism. They perfectly corporealize Artschwager's wish to engage his work in a larger arena, physically and philosophically. For Artschwager, "the blp business is a model (Hypostasis???) for memory, providing an instrument to show 'the same'—themselves—and an instrument to show the 'different'—the variable context...."[22]

The blp size and placement began to crescendo in the Whitney Museum's Sculpture Annual late in 1968. Artschwager re-contextualized the contents of this typical survey show of contemporary American sculp-ture—spread over three floors of the Whitney's new building on Madison Avenue—by installing his piece *100 Locations*. At exactly this number of places throughout the museum he either spray painted or

affixed painted wood blps. This act of sustained graffiti drew attention both to Breuer's stark architecture and to other artists' pieces in the show in a way that publicly questioned the institutional context of art. In this and other blp installations at various galleries and museums, or on the streets of New York, or anywhere else he found himself, Artschwager used his invented shape as an instrument for easily manifesting his aesthetic: as he deputized others to put the things around, the blps democratized creativity. Their quasi-utilitarian look could be understood by anyone as a sign, and, by the willing, as art.

Artschwager's repeated use of the blps in these years reveals his ongoing preoccupation with the space of art. He could contextualize the work of others in group shows like the 1970 "Information" exhibition at the Museum of Modern Art, or the gallery itself, as happened in a one-artist show called "Ten Years of the Black Spot" at the Walter Kelly Gallery, Chicago, in 1976. In both cases—the first (like the 1968 Whitney show) involving the work of others, and the second, a retrospective for his invented blp— Artschwager continued to push against the boundaries of art.

Perhaps in reaction to these new wider arenas and in response to acquiring and restoring an old farmhouse in upstate New York, architectural motifs assumed new significance in Artschwager's work. First attracted to them in the early 1960s, he now sought them in more stylized structures, such as the Greek Revival mansion of *Rosehill Pediment* (1970; Pl. 57). Unlike the quadripartite break-up of different images in *Sailors* (Pl. 38), we are confronted here with two fragments of a single image. Unaligned, so that the roof line is visually discontinuous, it is impossible, finally, to synthesize the panels into an otherwise straightforward depiction of a nineteenth-century neoclassical house. In frustrating the eye's powerful wish to synthesize visual parts into an intelligible whole, Artschwager recalls the thwarted physical movements of earlier sculptures, such as *Sliding Door* (Pl. 17).

Through the first half of the 1970s, Artschwager employed two of the hallmarks of modern art— fragmentation and enlargement. Although some pastoral themes, like *The Tree* (1971; Pl. 66) and *Farm III* (1972; Pl. 67), appear in the work of this period, his principal focus is on a wide-ranging series of domestic interiors. Some of these paintings are related in scale to *Hospital Ward* (Pl. 51); they all seemingly address the order of life indoors, but with depopulated, relatively neutral scenes.

Polish Rider IV (1971; Pl. 62) is one of the earliest, largest, and most visually ambitious of these residential views. The traditional spatial rights of furniture, which mutely mimics human behavior, occupy Artschwager here, as he paints what could be considered large group portraits of furniture. He now depicts what he had once constructed. The dialogue between his sculpture and his paintings suddenly becomes audible. A two-panel painting, *Polish Rider IV* represents the view down an entry hallway to a backlighted front door. The title refers to the Frick Collection's Rembrandt portrait of a man on horseback, which is arranged so that the equestrian blocks the painting's light source. Here a closed door does

the same. Artschwager's rendition relies, of course, on furniture for its population: a scroll-leg bookcase sits opposite an Empire couch in the foreground, echoed by a table-mirror across from another couch in the background. A trio of ornately framed painting-mirrors recedes on the left wall, while a molded ceiling unites the two panels at top. A diamond- and shell-figured carpet, its pattern interrupted by the aluminum frames, courses its way from front to back, recalling Artschwager's exercises with linear perspective. The shimmering door, with its flanking fenestrated panels, assumes a central role in the composition. It is the framed mechanism that admits outside to inside, and defines here from there, them from us. As if to qualify that definitive separation, Artschwager jolts and dislocates the perspective in *Polish Rider IV* so that the door's flanking left panel is repeated twice.

This illogic will become more prevalent in Artschwager's subsequent paintings as he attempts to permit as many readings — both abstract and representational — as his pictures can bear. Although articulating thought and provoking meaning remain central to his enterprise, he allows differing, simultaneous comprehensions of his work. As early as 1967 he had lauded this kind of ambiguity in an article he authored called, in his standard deadpan style, "The Hydraulic Door Check." He wrote:

The most striking property of doors (although not unique to doors) is RESONANCE between two states, which can be conveniently labeled as "open" and "closed." Resonance is never a simple, unqualified fluctuation between two states; even so in this case. A door — at any given moment — is in a state of being closed with the possibility of its being opened, or in a state of being open with the possibility of its being closed. This is not a speculative model for a door but a description of the state of affairs which immediately existed when the first door was brought into being.[23]

If the furniture of *Polish Rider IV* is by now a standard part of Artschwager's repertoire, its composite luxuriousness and nostalgia-suffused environment are new. The furniture in these works shifts away from the generalized boxiness of his earlier sculpture to take on the associations of style, from Federal to Sheraton to International. Grand homes of the bourgeois, many of them adapted from *New York Times* Sunday magazine illustrations, now inspire Artschwager. With their evocation of domesticity and elaborate comfort, these works imply a nostalgia foreign to their predecessors. If part of Artschwager's previous message was addressed to the repetitive, mechanical features of modern architecture, as evidenced by the stacked, modular units of *High-Rise Apartment* (Pl. 28), he seems here to employ imagery that evokes collective recollections of halcyon days. Paradoxically, as the images gain in widely understood and socially acceptable associations, they reveal their fundamental dislocation from reality. Why precisely would anyone purchase, hang, and revere a blurry black-and-white reproduction of a richly furnished room in the true *de luxe* of a real house or apartment?

From the swagged Baroque of *Mirror* (1971; Pl. 61)—with its fish-eye reflection of a furniture-filled room—to the functional modernism of the shuttered room of *The Bush* (1971; Pl. 64), Artschwager tackled a variety of scenes that challenged his drawing skills and lent themselves with surprising grace to the peculiarities of his working methods. These highly elaborate rooms attained their greatest impact in *Triptych V* (1972; Pl. 68). The absurdity of celotex—a cheap, manufactured paper product mostly used for ceilings in mobile homes—being used as a support for representations of upper-class perfection—is never more apparent. It is a small triumph of the artist's persuasive power that we admire the domestic correctness and physical stability of a scene rendered with black and white paint on a coarse surface covered with embossed circles and drawn dots and dashes. The paradox of the picture is that this conglomeration of chaotic marks gels into a regimented order. A view into an especially resplendent dining room, the picture is divided into three equal parts, each encased in its own thin aluminum frame. A molding around the ceiling seems to unite the capriciously segmented parts of the scene. A far door-way and the carpet border leading to it are repeated in the left and central panels, just as a mantel and mirror are duplicated on the far walls of the central and right panels. The spectator gradually realizes the pictorial deceits that animate this cozy yet stately room. A glossy table, chairs, a mirror, a doorway, a rug, and windows—all the elements of the essential Artschwager world—are to be found here. It is a civilized chamber par excellence, but on close inspection a visually unstable one. The figured carpet on the left dissolves into a fleeting herd of dots and dashes. Likewise, the wing chair in the left foreground swirls uncontrollably into the space under itself and the round table beside it. The drapes and swags above it, colored in bluish charcoal, drift briefly into the ceiling of the center panel. There, the far end of the table falls off and the opposing wall around the fireplace becomes a busy swarm of dark dots. On the right an opulent, reflective chandelier hovers over a tabletop decorated with an opaque vase of flowers. An inexplicable dark gash cuts into the table at its far end—another chair or perhaps the tangible reflection of the chair backs in the foreground. While we initially respond to the painting's hearty cele-bration of the things and the setting of the good life, we finally register its true subject—its panorama of hyperactive particles, mute testimony to the instability of all material.

A year later, in *Interior (West)* and *Interior (North)* (both 1973; Pls. 76, 77), Artschwager congeals his dusty, atomized universe into two forceful and final versions of the interior theme that introduce new conditions of light and, by implication, space into his very narrow palette. Made from two different views of the same modern clerestory space, these pictures reassemble a more up-to-date chair, table, rug, etc. The horizontally stacked panels of each painting reinforce the planarity of the modern architecture and furnishings, whose spareness allows Artschwager to isolate various textural treatments in the celo-tex: a light and slightly textured wall is fenestrated by two clerestory openings, illuminated so that a darker, denser atmosphere prevails below. There, a patterned carpet rolls the eye back into the space

toward a fireplace and basket. Plants, an overscale painting, and strap-arm chairs bespeak the faddish correctness of the setting, but Artschwager's principal concern seems not to engage in social commentary but rather to paint a convincing version of a modern living space using a two-colored spectrum. With their Bauhaus-derived accoutrements and architecture, these *Interiors* are as close to the present as any of Artschwager's depictions. After them, his subjects reassume their vaguely historical look.

If the *Interiors* form a magnificent, somewhat paradoxical ode to stability, other paintings of this period overtly address instability. These integrate fact—the visual dissolution of anything rendered on celotex—with image. In 1972 Artschwager made six paintings of the demolition by explosives of the Traymore Hotel in Atlantic City. Taken from sequential news photographs of the hotel's collapse, *Destruction III, V,* and *VI* (Pls. 69, 70, 71) each split the image of the building into two panels, further heightening its literal fragmentation. The rondelay (a trade name) pattern of the celotex conveys perfectly the clouds of masonry dust that ultimately rise as high as the slowly disappearing structure. Artschwager's favored aluminum frames once again draw the viewer uncomfortably close to the picture plane, as he portrays a dynamic antidote to the static fixedness of the concurrent *Interiors*.

When Artschwager returned to more traditional architectural motifs, as in *Rockefeller Center IV* and *Johnson Wax Building* (both 1974; Pls. 81, 82), he took a middle course between the frozen-in-time feeling of the *Interiors* and the in-process disintegration of the *Destruction* series. The motion of vision, its fluid, ceaselessly changing focus, can be considered his real subject. The structure of the Johnson Wax Building, again articulated in the celotex texture, fuses the circular motion of the underlying medium with the various curves of Frank Lloyd Wright's design—from the rounded desks and chairs to the pillar-supported lily pads that seem to swirl through the room. In *Rockefeller Center IV* the pattern is subtly enhanced in the light-colored sky, while thin parallel strips, something like the stone fasciae of the actual building, cohere to suggest great mass. Neighboring structures sit in parallel and oblique relationships with the central slab. At the bottom left a very dense and active rectangular specter floats forward, calling attention to the painting's relatively broad tonal variations—so noticeable and planar as to mimic "push-pull" theories of abstract composition. The defining properties of light, and light's ability to lead the eye through the space of a painting, are the preponderant concerns of this picture.

In a final reprise of dissolving focus and material instability, Artschwager in 1973 enlarged a photograph of an undistinguished outdoor spot to an eight-panel painting, calling it *Garden* (Pl. 79). His largest painting (almost 17 feet across), this work transfers the active dissolution of the *Destructions* to nature. The visual overlap from one panel to the next inhibits a sweeping, uninterrupted reading. The "scene" is presented, instead, as a series of short, contiguous glimpses. On the left, a picnic table and benches are barely discernible, surrounded by an intensely active group of trees. These trees and a recessive

foreground continue across the middle panels. A telephone or electric pole introduces a cross, with its idealized, geometric form, into an otherwise randomly organized setting. The wires run off the top of a panel, inferring a dramatic foreshortening of a space. To the right, the bramble disintegrates into a swarm of swirling lines, a leafy chaos.

As early as 1965 Artschwager had painted a small portrait of his idealized three-dimensional forms in *Chair, Chair, Sofa, Table, Table, Rug* (Pl. 34). The rug is a simple rhomboid that neatly re-frames and situates the furniture in an easily comprehended space. This single painting remained an isolated and stable lexicon of idealized meaning amid the shifting subjects that Artschwager subsequently addressed. Ostensibly related to his experiments with perspective, the chair, sofa, table, and rug were about to be joined by mirror and basket, as Artschwager carefully pondered the permutations of these six nouns. This painting's subjects are modest and modern but effect a group portrait even more haunting than the *Sailors* of the previous year. After his intense painting activity during the first half of the 1970s, Artschwager turned to a protracted suite of imaginary drawings that featured similar basic elements from his previous work—door, window, table, basket, mirror, and rug. For the next few years these six things constituted Artschwager's entire vocabulary, as he combined them in an amazing display of playful invention. Two sculptures from this time indicate the new elasticity of vision the drawings afforded him. *Six Mirror Images* (1975–79; Pl. 85) consists of a six-part, folding, wall-bound collation of the door, window, table, basket, mirror, and rug, executed in molded, metallized plexiglass. The object reads like a book of drawings in relief, made reflective and framed in a cheery blond formica. In *Pyramid* (1979; Pl. 86), the six have been abstracted and tilted to stack on the tapering pyramidal structure. Artschwager has painted each carved-wood section of the four-sided structure either to help define or to obscure its symbolic parts: resting on a splayed-leg table are a horizontal door, a chamfered window, a rug grid, a vertical window, and a pointed, cross-woven basket.

The Alice-in-Wonderland scale inversions and wildly imaginative combinations and placement of the six objects in the drawings and, by extension, in *Pyramid,* revived Artschwager's unfinished "blp" business. Inventing spaces to contain the six objects led naturally to a reconsideration of the question of context. At the Clocktower in 1978 he had reintroduced, for one final time, that para-punctuation into his imagery. He had also manufactured an edition of black, inverted commas about this time that, when installed, had the effect of labeling their environs "so-called." The conjunction of these linguistic signs with his furniture-portraits strongly suggests an unpopulated narration. *Chair Table* (1980; Pl. 87), for instance, is another version of Artschwager's by now familiar duo—this time made bulky and official-looking by its institutional oak-grain formica. A heavy-duty metal handle on the drawer recalls the first appearance of this implement in *Handle* (1962; Pl. 1). His bemused attitude toward the enterprise of art,

an attitude that previously confined itself to some witty titles and an array of somewhat preposterous images, now takes the form of a 3-foot-high exclamation point suspended over the table. For once, an implied spoken reaction is given real form.

Much of Artschwager's output over the next five years, most of it three dimensional, calls for comparable reactions of puzzled astonishment. His previous restraints seem to give way to wittier, publicly scaled objects. By exploiting the absurdist humor inherent to many of his chosen forms, Artschwager redoubles their enigmatic significance. The implied narration in earlier work, such as the various triptychs, remains unspoken but gains punctuation. Artschwager incorporates it in two particularly exuberant recent works, *Door }* (1983–84; Pl. 97) and *Up and Across* (1984–85; Pl. 100). In the former, a ponderously thick door rests on the floor against a wall. Too fat and surrounded by thick molding, its functionality is immediately compromised. Equally irrational are the florid ocher and yellow zebra stripes which garishly mimic the underlying wood grain. This piece represents Artschwager's most flamboyant use of paint, and his notes for its coloration are revealing: "back lit / Chinese mountains / Northern lights." On the next page he makes his sources and ideas more explicit: "Chinese paintings — O.K. / heavy on the Burchfield and some German I can't think of / Manner of paintings probably O.K. if done on a big scale and go for Magritte color which corresponds to that which rendered, i.e. back to Magritte Oak."[24] The door's massive immobility is reasserted by its swollen but daintily blown glass knob. Floating to the right is a wooden bracket, painted black and confidently inclusive. Artschwager had developed the elegant bracket form in related notes, suggesting it as a "whaletail" or as "art nouveau." The same page in his notebook has drawings for a larger group of furniture set off on both sides by brackets, a piece yet to be realized.

Magritte oak animates *Up and Across* as well. Artschwager's reference to Magritte is important, since he recognized in the Belgian painter's work a spirited exposition of the mundane made extra-mundane through close attention to the great symbolic powers of ordinary things. The piece infers physical participation, and, by its constructed, multi-dimensional nature, seems more environmental than the pictorial *Door }*. Artschwager built and painted two short steps on the left side of a long wooden shelf. Midway across the zebra-striped shelf sit three black balls, perhaps signifying the ellipses in an edited quotation. Next to them hangs another of the emphatically physical exclamation points. Whether understood as a stage for a balletic display of overscale punctuation, an abstractly diagrammed sentence, or simply an inexplicable and humorous work of art, *Up and Across* is one of Artschwager's liveliest and best pieces. With his characteristically oblique candor, Artschwager comments on this piece: "Ever since our mind learned to fly out of our bodies, we have been moving rapidly from the accessible to the inaccessible, and back, rapidly, most likely because the accessible and the inaccessible have been trading places very fast. Maybe the mind is actually staying right where it is. In this sculpted piece I have been busy celebrating passage from the accessible to the inaccessible."[25]

Untitled, 1981. Mixed-media construction, 102 x 180 x 30 in. (259.1 x 457.2 x 76.2 cm). Levi Strauss & Co., San Francisco

Rendering the seemingly accessible inaccessible continues to occupy Artschwager. In *Book III (Laocoön)* of 1981 (Pl. 95), a chunky prie-dieu offers comfort in a kneeling position, but the slant of the formica prayer-book holder and the hefty metal handles on either side of the inset "book" oblige a bowing motion that goes beyond customary practice. Although ostensibly somewhat familiar, the distorted form of *Book III* removes it from common experience. Its implied activation seems logical at first glance, but on closer inspection becomes absurd. The purest and least distorted activity in this series of sculptures that serve as narrative locales is *Book II (Nike)*, also of 1981 (Pl. 94). In this piece, a V-shaped lectern holds the open white page of a formica book easily reached by ascending a short step. By title and in the implied action, Artschwager both likens the work to the ancient statue that graces the Louvre's main staircase and encourages our kinesthetic response.

Artschwager has long been concerned with moving the viewer to exploit empirical understandings of space and intermingling reflections of movement. The mirror, as the furniture object embodying reflection, had been a subject and medium of his since 1961–62. In the 1980s, it assumes a central position in his work, as he focuses more and more on real and implied doubling. A large commission for the Levi Strauss corporation headquarters in San Francisco reactivated Artschwager's interest in mirrors. Divided into three painted sections, each flanked and divided by shallow, vertical mirrors, the piece offers a view in each direction from the top of the Levi Strauss building to downtown San Francisco—the back of Telegraph Hill, neighboring buildings, and the bay. It constitutes Artschwager's most literal reference to the landscape, and led to other, related landscapes. *Fence II* (1980; Pl. 89), for example, is more typical in its mysterious subject, a large clapboard house, presumably in New England. The scene is divided between two panels, separated by frames, whose imagery is continuous. The scene recedes from a white picket fence, to a gray picket fence, to the house. Trees, sky, and the ground are picked out from the endless swirl of the celotex. The outer sides of each recessed frame are mirrored, thus extending the vertically composed landscape into a short segment of infinity.

In a related work, *Three Trees (Shark)* (1981; Pl. 90), Artschwager combines several media—mirror, painted celotex, zebra-striped wood, and formica—in a serrated, half-round wall relief. The trees of the title seem direct quotations from Van Gogh's *Starry Night*, but they are used here very differently. Reflected by a mirror on the right side, the painted trees are surrounded by an implied landscape created by the zebra-striped sky above, which echoes the oak-grain shelf of formica below. The photocopied wood grain and its painted double are made to assume landscape roles as sky and water. Previously employed as surrogates for the organic growth represented by wood grain, they function differently here, as more direct representative devices. Concrete, if not always strictly rational, his work continually offers new hypotheses.

Mirrors also play an integral and unusually psychologically charged role in *Janus II* (1981; Pl. 92). The enigmatic title comments both on the limited powers of illusion and on the participating-observing identities of the artist. A single stepped piece of celotex painted with a half-image of a man with his legs crossed rests against wall. A similarly stepped sheet of mirror joins the celotex at the angle of the corner, and both units are framed on their outer edges by black-and-white painted grain strips (the top edge of the stepped-in celotex has a yellow formica frame). The elongated figure sits, with his hand over his knees and his lips compressed, looking—to those familiar with his physiognomic likeness—for all the world like a middle-aged Marcel Duchamp. The neckless man, his head detached from the shoulders, is in fact Richard Artschwager. It is his sole self-portrait, a demi-representation made whole by a mirror.

Implied doubling animates the strange architecture of Artschwager's grand *City of Man* (1981; Pl. 91). Coursed down its center by a 5-inch piece of clear plexiglass, the panorama shows two classical, colum-nar edifices receding into a dissolving distance, each repeated in a water or mirror reflection along its horizon. Four instances of mirroring result, with a fifth created by the identically positioned, abstract blue formica inset hovering over the architecture on each side. The two component parts are distin-guished from one another by the ground—on the left, white formica, on the right, cream-colored. Unusual both for its scale and for its fusion of found representational imagery and invented abstraction, the picture is a grand summary of Artschwager's architectural themes.

Spurred on in part by his satisfaction with painted wood—the "Magritte oak"—of *Door* }, Artschwager produced two more non-door monuments during 1984–85. *Low Overhead* (Pl. 103) features a formica portal, its rounded transom bulging forward. Incised with thin grooves painted in black-and-white wood-grain whorls, the door and transom establish a clumsy torque from the wall plane, further empha-sized by a massive asymmetrical overmolding decorated in a bold zebra-stripe pattern. By far the most visually active and exaggerated of Artschwager's recent work, the whole contraption—8 feet high and 2 feet deep—staggers off the wall, inducing a disoriented, punchy reaction from the viewer. The piece is Artschwager's most declaratively hallucinatory.

Bizarre, but somewhat more prim, are the joined-at-the-hip fraternal twins of *Door/Door II* (Pl. 101). Each door fits tightly to the wall and appears as if it might allow exit for someone or thing. The more traditional oak formica door on the left is reached by a painted set of stairs that begin slightly off the floor. Worse yet, the door has no handle and opens onto, as its four windows reveal, an anarchy of grisaille swirls. A horizontal piece on the right connects this door to a more fanciful, short and peaked one. Again a step-ledge—this time beginning two feet off the floor—leads up to the entry, but there is no handle on this side either. The door appears to be the grandest rat hole in existence.

Artschwager's ideas for work have burgeoned in the last few years. As always, drawing has been integral to his creative process. The sparely rendered *Hoosier Cabinet* (1984–85; Pl. 98) is an almost direct transcription of a pencil drawing to three dimensions. Artschwager gave notice of such transcription in *Drawing of Table* (1984–85; Pl. 102) which concretizes his peculiar dot-dash drawing technique. Slender, vertical black sticks form a sketchy structure of a Parsons table profile, with gray rubberized hair stuffed between the stick-marks to solidify the table-drawing.

Artschwager had begun using rubberized hair around 1968, attracted to it for its "perfect imprecision." Wiry, rubber-coated horsehair offered both a physical analogue to his drawing and a malleable antidote to the hard edges of formica. Besides a suite of hair boxes from the late 1960s—paradoxically geometric formations of hairy chaos—Artschwager used the material sparingly. It formed a "drawing" counterpart to the dimensional solidity of *Piano II*'s keyboard (Pl. 35), and makes the *Drawing of Table* a literal translation of his idea from two to three dimensions.

The *Door, Mirror, Basket, Rug, Table, Window* drawings also inspired two paintings from 1985, *D.M.B.R.T.W. I* and *II* (Pls. 108, 109). They are enclosed in the dark, painted frames that have superseded Artschwager's earlier metal frames as the imagery of his paintings has evolved from one found to one purely invented. These pictures situate the six subjects in two locales. *D.M.B.R.T.W. I* is an almost plausible grisaille interior where rug and basket crowd the foreground while their siblings range around the background. Artschwager painted the door in a slightly bilious chartreuse that emanates a peculiar light. In *D.M.B.R.T.W. II* the elements are absurdly attenuated by extreme foreshortening and lie prone, each receding into the horizon. The upper half of the picture is a particularly radiant green sky with a marzipan surface.

Artschwager's new sense of freedom in method continues to find expression in a more colorful palette. He has painted a series of tabletop portraits, known variously as *Dinners* or *Diners*. In some of them luminously colored aureoles, reminiscent of the fruit in his first colored painting, *Bowl of Peaches on Glass Table* (1973; Pl. 78), glow from the plates. In the more austere *Dinner (Two)* of 1986 (Pl. 115), a

horizontal celotex panel hosts two plates with utensils. One plate contains bright food—is it an especially vibrant fried egg or, more poetically, a domesticated symbol for the sun, source of all light? In other, larger compositions such as *Two Diners* (1987; Pl. 118), celotex shares the picture plane with formica. On the celotex are painted representations of diners, while the formica serves as table. As Artschwager paints curved, shorthand strokes for plates and flatware, the illusory grain of the wood formica gains another layer of trompe l'oeil information. By means of a few deft marks, the picture of wood is transformed into another kind of picture plane, one that simultaneously exists as an abstraction in itself and as host to an abstracted representation. Narrative amalgamations of celotex and formica— Artschwager's embodiments of painting and sculpture—these dining scenes are his contribution to a tradition of contented bourgeois tableaux that goes back at least to Bonnard, by no coincidence one of Artschwager's favorite Post-Impressionists.

In the *Diners* series, Artschwager once again demonstrates his iconoclastic position in the current art scene, which is dominated by ominous, disjunctive conglomerations of imagery or by politically self-conscious quotations from the mass media. *Organ of Cause and Effect III* (1986; Pl. 116) proclaims the celebratory mood that has animated his work. The largest and most joyful of his recent constructions, it reprises the musical theme of the two pianos of the 1960s and the blp-as-keyboard installation at the Clocktower in 1978. Five tapering, convex pipes, covered with reed-patterned formica, shoot up from the projecting formica keyboard. Foot pedals stand out a few feet below the keyboard, completing the three-part instrument. Visually, its five pipes suggest a giant hand about to engage the keyboard. The playful title can be read on two levels: literally, it simply refers to the natural function of a musical instrument; metaphorically, this same function embodies Artschwager's practice of eliciting thought and action from his audience. In this sense, music, with its implicit combination of logic and rapture, provides a perfect analogue to Artschwager's artistic production.

For twenty-five years, Richard Artschwager has sought to alter the context of viewing by making pictorial sculpture and dimensional, space-occupying paintings. Equally conceptual and physical, his work is not intended as a simple demonstration of thought or as a purely aesthetic experience. He engages mind and body by situating us in front of a thing, often familiar-looking and always convincingly well made. What he said of the early *Handle* (Pl. 1) could apply to all that followed: "A grasp of the work is provided by the left and right sides of the work. This establishes the proper viewing distance for the work and locates the soles of the feet, also leaving a clear track between the work and one's shoulder and beyond."[26] For Artschwager, that "beyond" is a context without physical or theoretical boundaries, which he constantly invites us to enter. It is the vast intersection of thought and action, of looking and doing, of seeming and being; a place where enigma supersedes truth. And vice versa.

Notes

1. Richard Artschwager, Unpublished lecture notes, California Institute of the Arts, Valencia, 1975.

2. Quoted in Colin Naylor and Genesis P-Orridge, eds., *Contemporary Artists* (New York: St. Martin's Press, 1977), p. 46.

3. Richard Artschwager, "Autochronology," in *Richard Artschwager's Theme(s)*, exhibition catalogue (Buffalo: Albright-Knox Art Gallery, 1979), p. 93. Later, in Artschwager's own shorthand, "outside" would refer to expressionism in general, while "inside" would refer to Impressionism.

4. Ibid.

5. Donald Judd, "Dick Artschwager and Richard Rutkowski," *Art News*, 58 (October 1959), p. 63.

6. Quoted in Jan McDevitt, "The Object: Still Life. Interviews with the New Object Makers, Richard Artschwager and Claes Oldenburg, on Craftsmanship, Art, and Function," *Craft Horizons*, 25 (September–October 1965), p. 30.

7. Ibid., p. 54.

8. Ibid.

9. Quoted in Coosje van Bruggen, "Richard Artschwager," *Artforum*, 22 (September 1983), p. 47.

10. Note in the Artists' Files, The Museum of Modern Art, New York.

11. Since the early 1960s, Artschwager has kept notebooks in which he mingles drawings with numerous technical notes, put down in a quasi-scientific fashion that may recall his early training, and everyday reminders such as lists of materials, phone numbers, and deadlines. Aside from an address and date, the books are not sequentially numbered. Artschwager's remark about Oldenburg appears in a notebook labeled 12/23/63.

12. For example, see Donald Judd, "Four," *Arts Magazine*, 38 (September 1964), p. 69. He later retracted the statement in "Richard Artschwager," *Arts Magazine*, 39 (March 1965), p. 60. Lucy Lippard referred to Artschwager as "a carpenter on Oldenburg's *Bedroom* . . ." in *Pop Art* (New York: Frederick A. Praeger, 1966), p. 137.

13. Quoted in McDevitt, "The Object: Still Life," p. 54.

14. Richard Artschwager, interview with Wouter Kotte, in *Sonsbeek Buiten de Perken*, exhibition catalogue (Arnhem/Utrecht, The Netherlands: Park Sonsbeek, 1971), n.p.

15. See, for example, McDevitt, "The Object: Still Life," p. 30.

16. Artschwager, notebook labeled 12/23/63.

17. Naylor and P-Orridge, *Contemporary Artists*, p. 46.

18. Catherine Kord, *Richard Artschwager*, exhibition catalogue (Hamburg, West Germany: Kunstverein Hamburg, 1978), p. 8.

19. Quoted in van Bruggen, "Richard Artschwager," p. 50.

20. Ibid., p. 51.

21. Artschwager, notebook labeled 12/23/63.

22. Van Bruggen, "Richard Artschwager," p. 51.

23. Richard Artschwager, "The Hydraulic Door Check," *Arts Magazine*, 42 (November 1967), p. 41.

24. Artschwager, notebook labeled 6/7/83, pp. 68–69.

25. Quoted in Richard Marshall, ed., *Fifty New York Artists* (San Francisco: Chronicle Books, 1986), p. 19.

26. Richard Artschwager and Catherine Kord, *Richard Artschwager*, exhibition catalogue (Chicago: Museum of Contemporary Art, 1973), n.p.

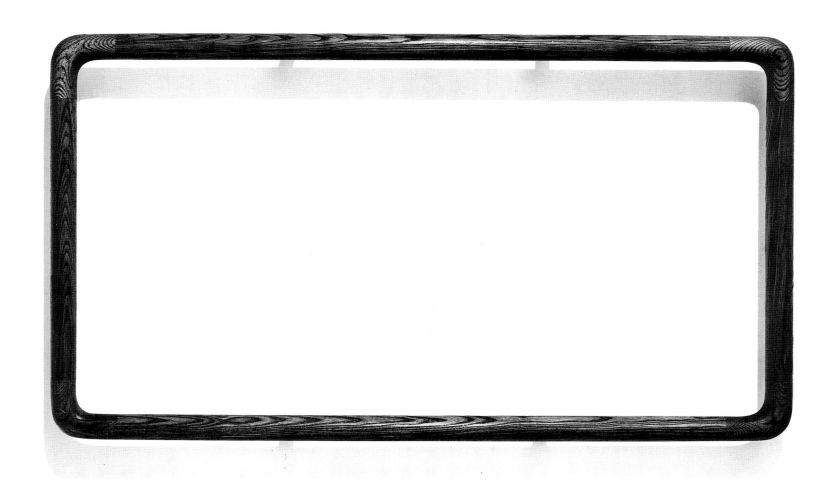

1
Handle, 1962
Wood,
30 x 48 x 4 in. (76.2 x 121.9 x 10.2 cm)
Collection of Kasper König

2
Gorilla, 1961–62
Acrylic on masonite and wood with metal casters,
47 x 32 x 32¼ in. (119.4 x 81.3 x 81.9 cm)
Kent Fine Art, Inc., New York

3
Counter I, 1962
Acrylic on wood and formica with rubber wheels,
48 x 15½ x 25 in. (121.9 x 39.4 x 63.5 cm)
Collection of the artist

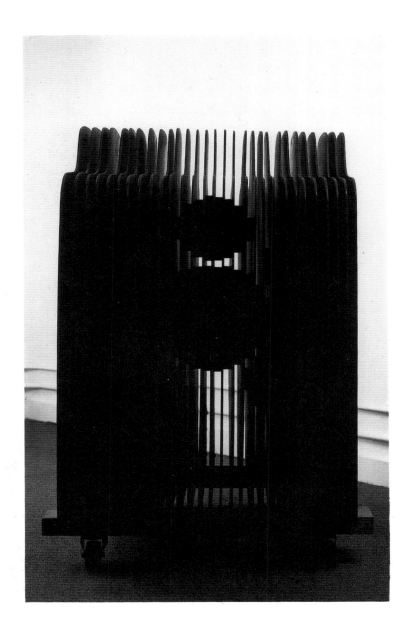

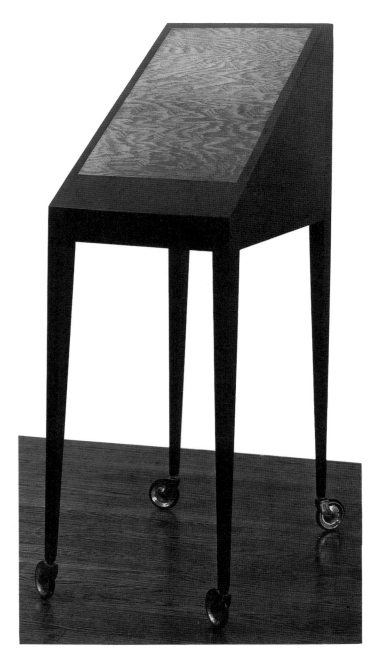

4
Table and Chair, 1962–63
Acrylic on wood, two parts:
table, 29½ x 23¾ x 16½ in. (74.9 x 60.3 x 41.9 cm);
chair, 37 x 17¾ x 20¼ in. (94 x 45.1 x 51.4 cm)
Collection of Paula Cooper

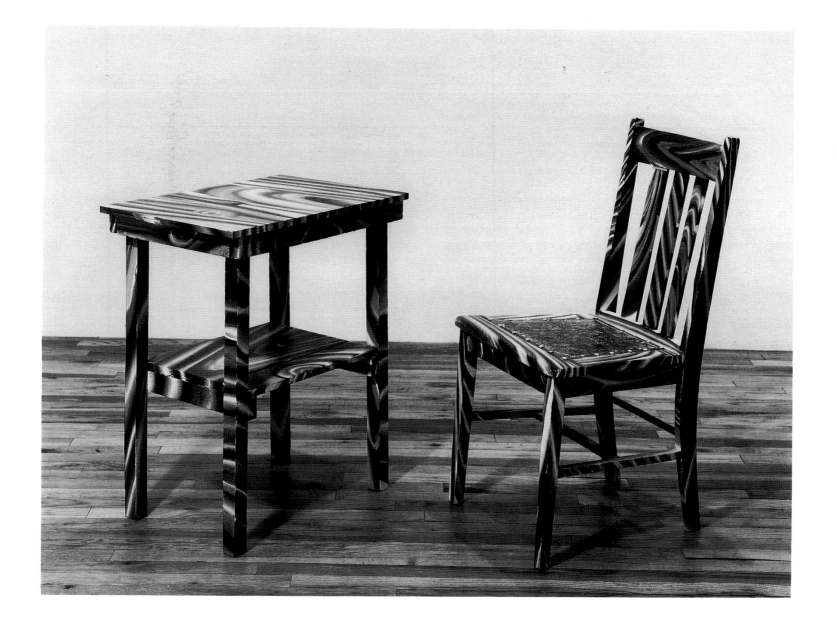

5
Triptych, 1962 (two views)
Acrylic on wood and formica,
38 x 27 x 4½ in. (96.5 x 68.6 x 11.4 cm) closed;
38 x 54 x 2¼ in. (96.5 x 137.2 x 5.7 cm) open
Collection of John L. Stewart

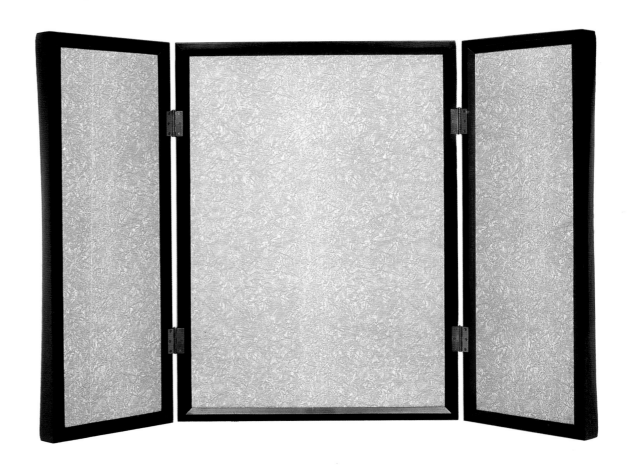

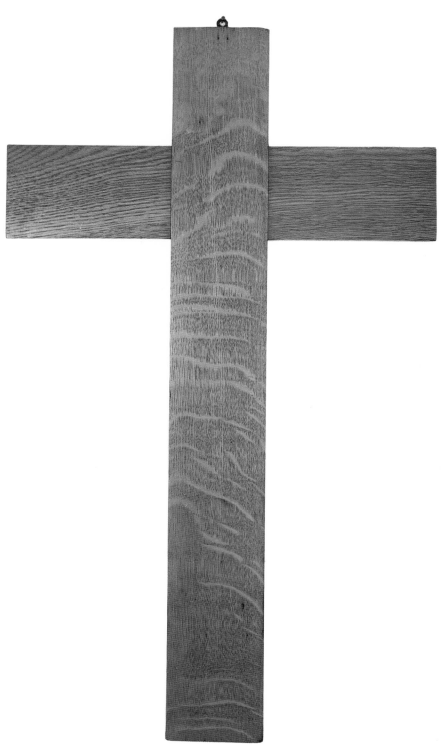

6
Cross, 1962
Wood,
24 x 14 x ⁷⁄₈ in. (61 x 35.6 x 2.2 cm)
Collection of Ellen Phelan

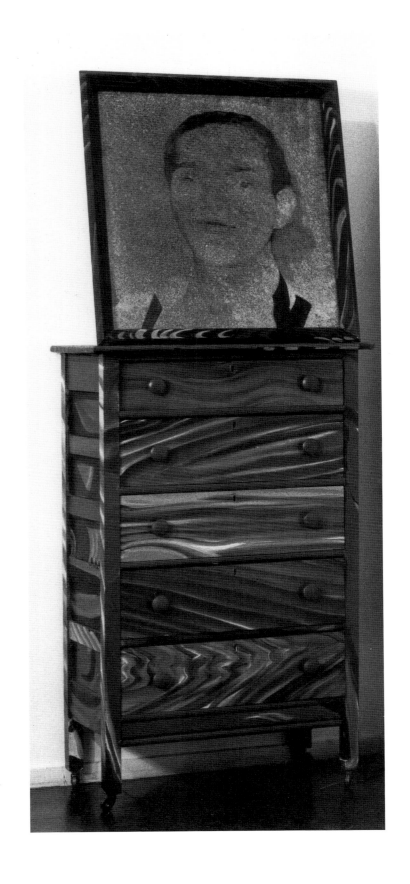

7
Portrait I, 1962
Acrylic on wood and celotex,
74 x 26 x 12 in. (188 x 66 x 30.5 cm)
Collection of Kasper König

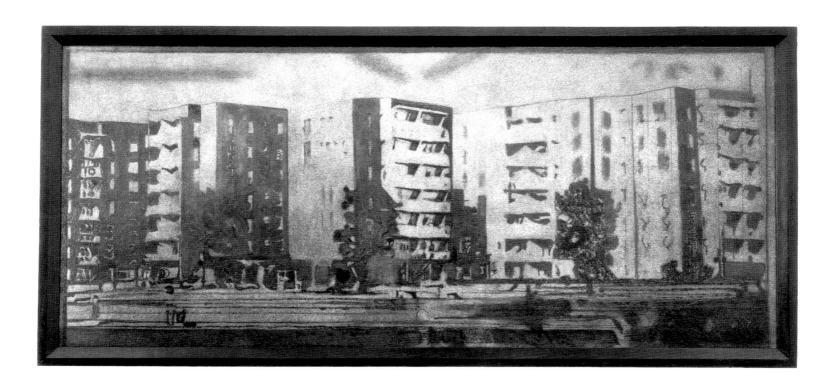

8
Lefrak City, 1962
Acrylic on celotex with formica frame,
44 1/2 x 97 1/2 in. (113 x 247.7 cm)
Collection of the artist

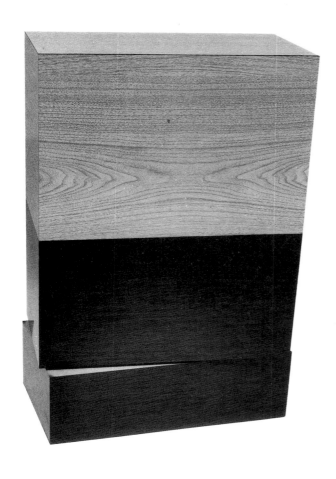

9
Swivel, 1963
Formica on wood,
40⅜ x 26⅛ x 14⅜ in. (102.6 x 66.4 x 36.5 cm)
The Metropolitan Museum of Art, New York;
Gift of Vivien and Justin Ebersman

10
Walker, 1964
Formica on wood,
26⅛ x 38¼ x 35¹/₁₆ in. (66.4 x 97.2 x 89.1 cm)
Collection of the artist

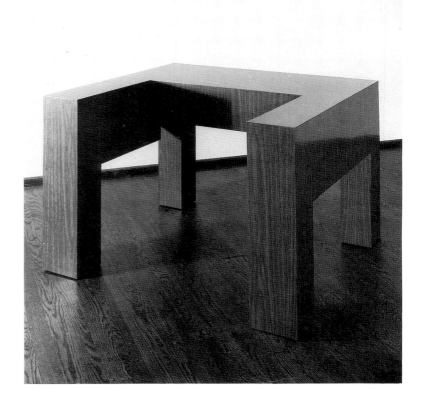

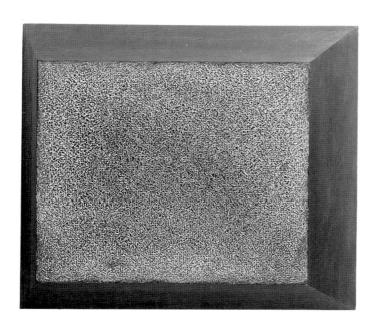 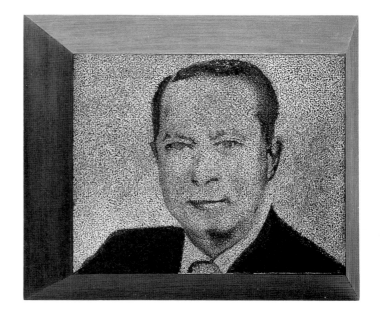

11
Untitled (Diptych), 1963
Acrylic on celotex, two parts:
13 x 17 x 7¼ in. (33 x 43.2 x 18.4 cm) each
Collection of Norman Dolph

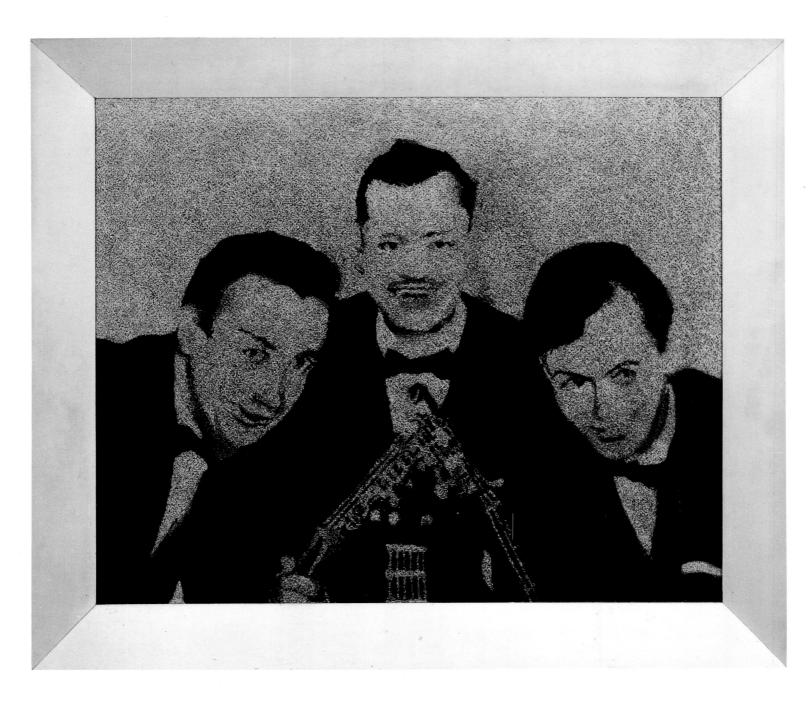

12
Three Musicians, 1963
Acrylic on celotex with formica frame,
29 x 34 in. (73.7 x 86.4 cm)
Collection of Norman Dolph

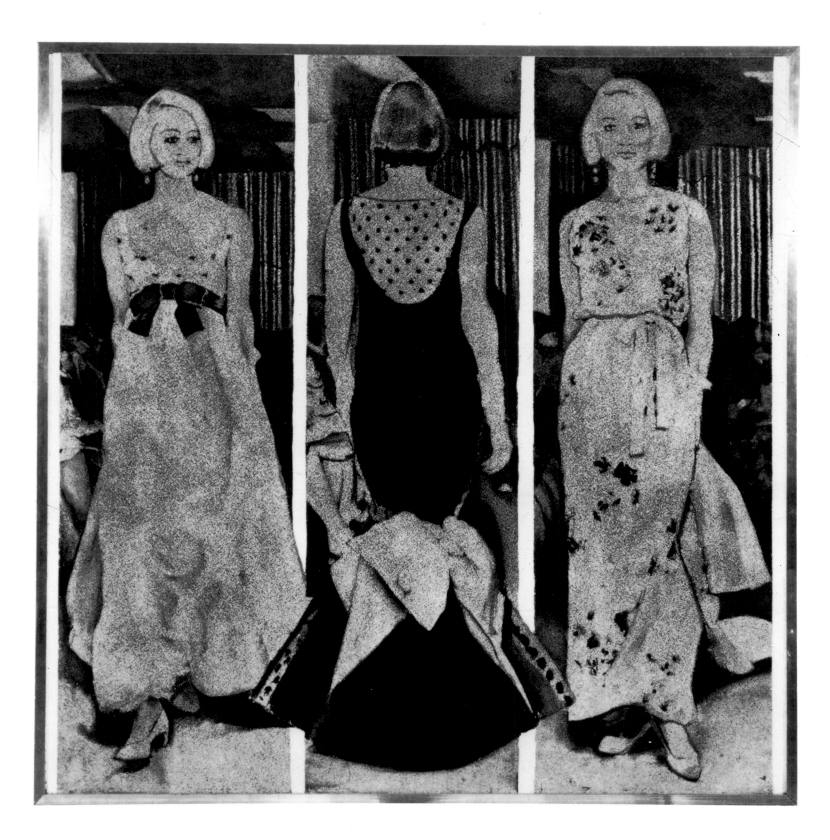

13
Three Women, 1963
Acrylic on celotex with metal frame,
47 x 48½ in. (119.4 x 123.2 cm)
The Edward R. Broida Trust, Los Angeles

14
Portrait II, 1963
Formica on wood,
68 x 26 x 13 in. (172.7 x 66 x 33 cm)
Private collection

15
Chair, 1963
Formica on wood,
37 x 20 x 22 in. (94 x 50.8 x 55.9 cm)
Collection of Mr. and Mrs. S. Brooks Barron

16
Table and Chair, 1963–64
Formica on wood, two parts:
table, 29¾ x 52 x 37¾ in. (75.6 x 132.1 x 95.9 cm);
chair, 45¼ x 21 x 17¼ in. (114.9 x 53 x 43.8 cm)
The Tate Gallery, London

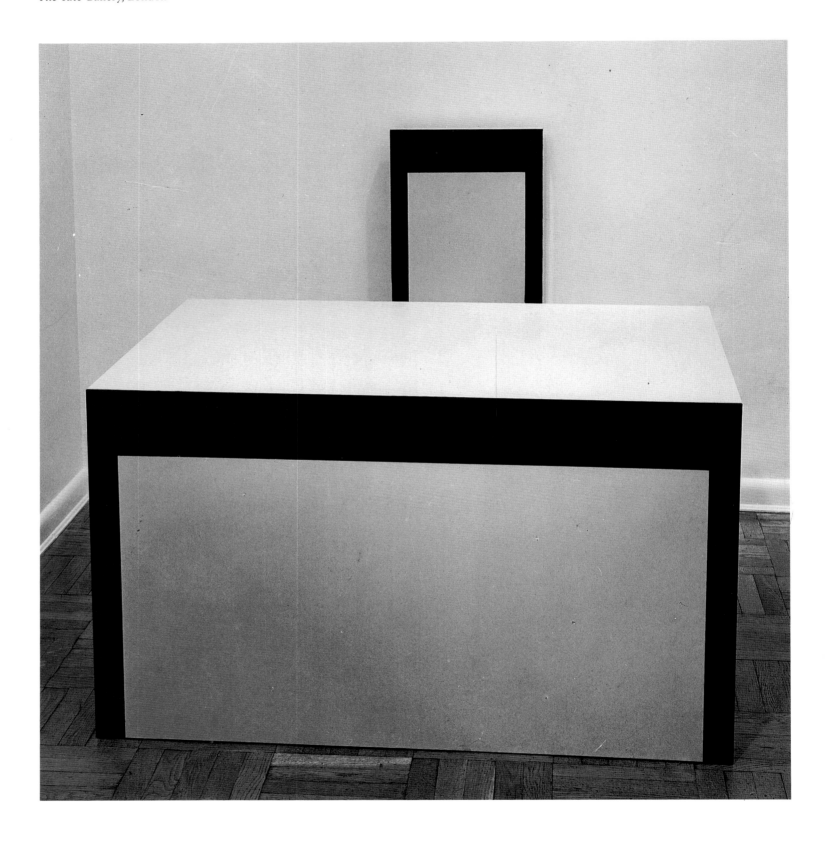

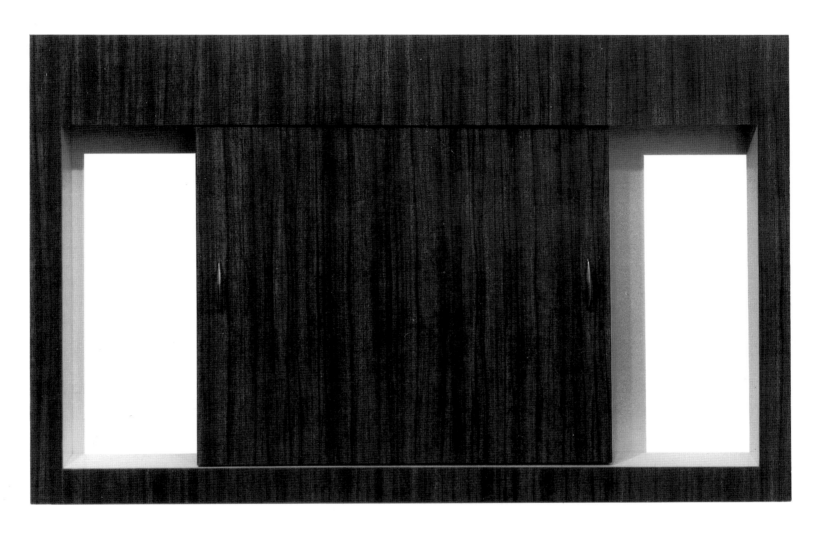

17
Sliding Door, 1964
Formica on wood with metal handles,
41⁵/₈ x 66¹/₈ x 6¹/₈ in. (105.7 x 168 x 15.6 cm)
Private collection

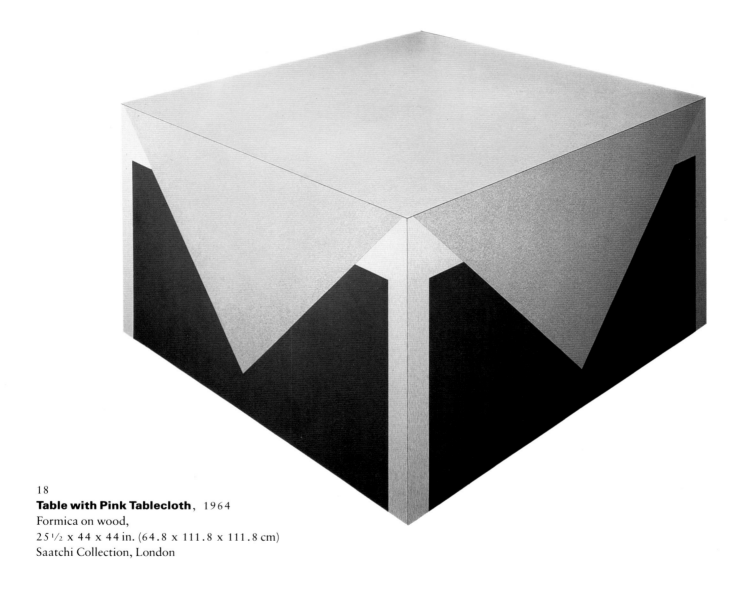

18
Table with Pink Tablecloth, 1964
Formica on wood,
25 ½ x 44 x 44 in. (64.8 x 111.8 x 111.8 cm)
Saatchi Collection, London

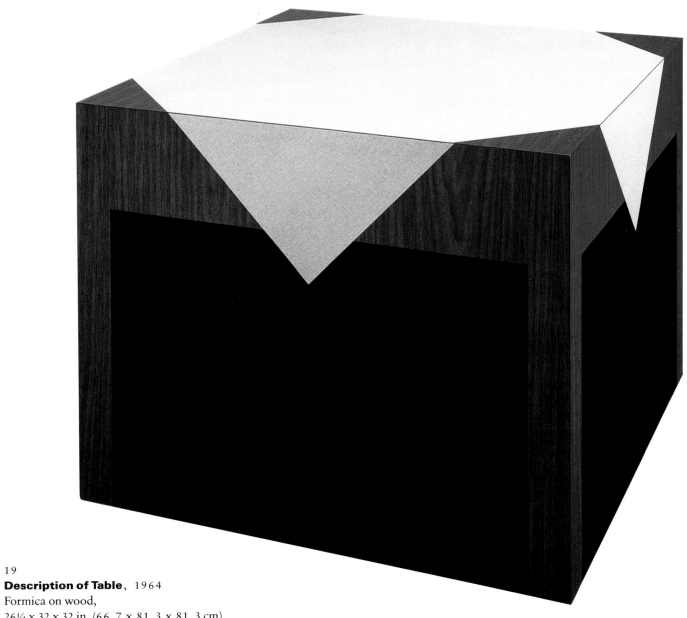

19
Description of Table, 1964
Formica on wood,
26¼ x 32 x 32 in. (66.7 x 81.3 x 81.3 cm)
Whitney Museum of American Art, New York;
Gift of the Howard and Jean Lipman Foundation, Inc. 66.48

20
Tract Home, 1964
Acrylic on celotex with formica frame,
48¼ x 68½ in. (122.6 x 174 cm)
Collection of Kimiko and John Powers

21
Diptych IV, 1964
Acrylic on celotex and formica on wood,
38 x 45 x 16 in. (96.5 x 114.3 x 40.6 cm)
The Eli and Edythe L. Broad Collection

22
Long Table with Two Pictures, 1964
Formica on wood and acrylic on celotex with wood frames, three parts:
table, 33¾ x 96 x 22¼ in. (85.7 x 243.8 x 56.5 cm);
two pictures, 42 x 32¼ in. (106.7 x 81.9 cm) each
Saatchi Collection, London

23
Mirror/Mirror—Table/Table, 1964
Formica on wood, four parts:
two mirrors, 37 x 25 x 5 in. (94 x 63.5 x 12.7 cm) each;
two tables, 24 x 25 x 30 in. (61 x 63.5 x 76.2 cm) each
The Museum of Contemporary Art, Los Angeles;
The Barry Lowen Collection

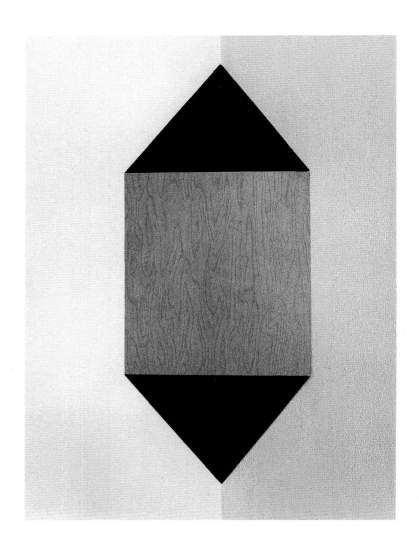

24
Corner I, 1964
Formica on wood,
30 x 11¼ x 8 in. (76.2 x 28.6 x 20.3 cm)
Private collection

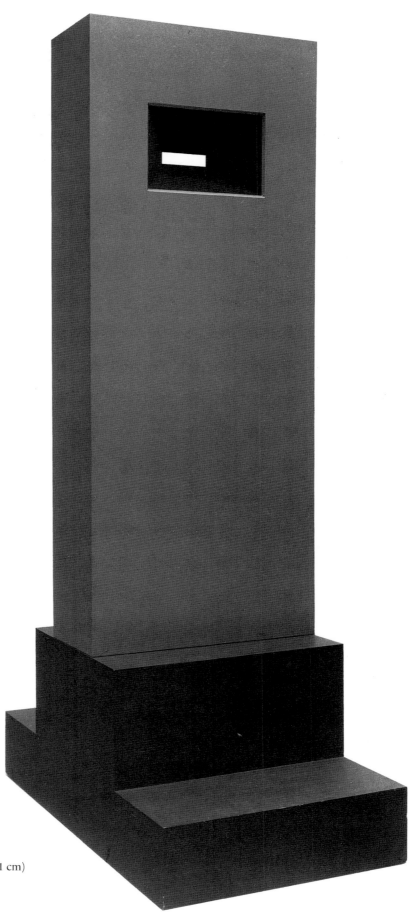

25
Tower, 1964
Formica and acrylic on wood,
78 x 24⅛ x 39 in. (198.1 x 61.3 x 99.1 cm)
The Museum of Modern Art, New York;
Gift of Philip Johnson

26
Chest of Drawers, 1964 (rebuilt 1979)
Formica on wood,
36 x 42 x 14 in. (91.4 x 106.7 x 35.6 cm)
Margo Leavin Gallery, Los Angeles

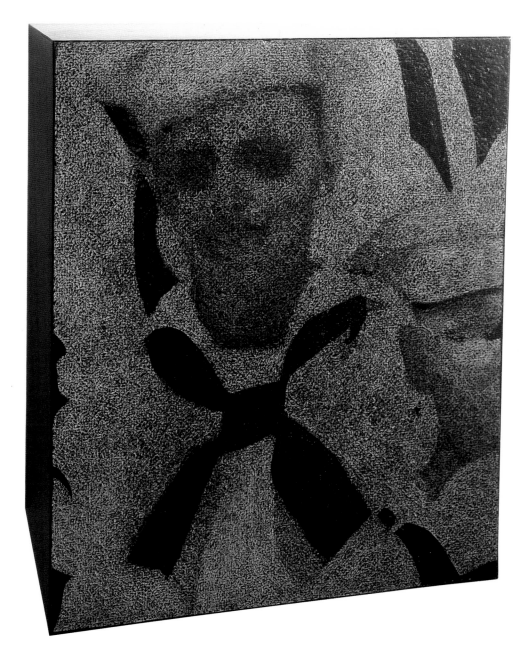

27
Sailors, 1964
Acrylic on celotex with formica frame,
20 x 26 x 8½ in. (50.8 x 66 x 21.6 cm)
Collection of Jill and Douglas Walla

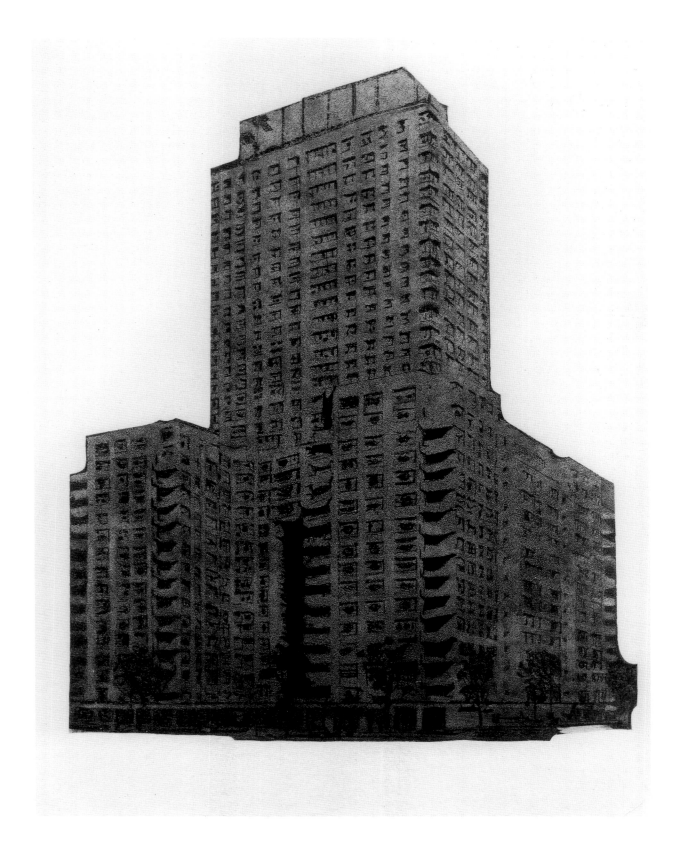

28
High-Rise Apartment, 1964
Acrylic on celotex with formica sides,
63 x 48 x 4½ in. (160 x 121.9 x 11.4 cm)
Smith College Museum of Art, Northampton, Massachusetts; Gift of Philip Johnson

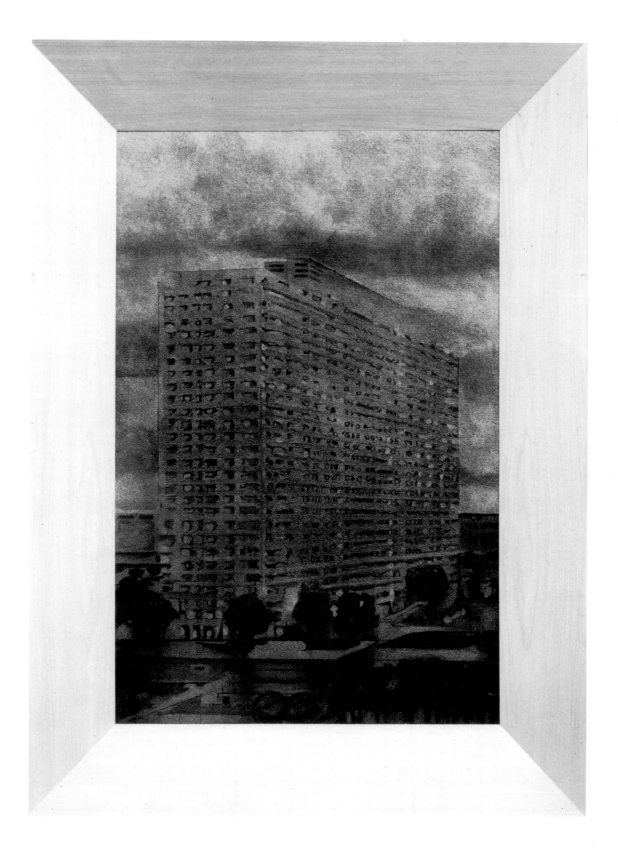

29

Apartment House, 1964
Acrylic on celotex with formica frame,
70 x 49½ x 6 in. (177.8 x 125.7 x 15.2 cm)
Museum Ludwig, Cologne, West Germany

30
Triptych II, 1964
Formica on wood,
40 x 92 x 6 in. (101.6 x 233.7 x 15.2 cm)
Kent Fine Art, Inc., New York

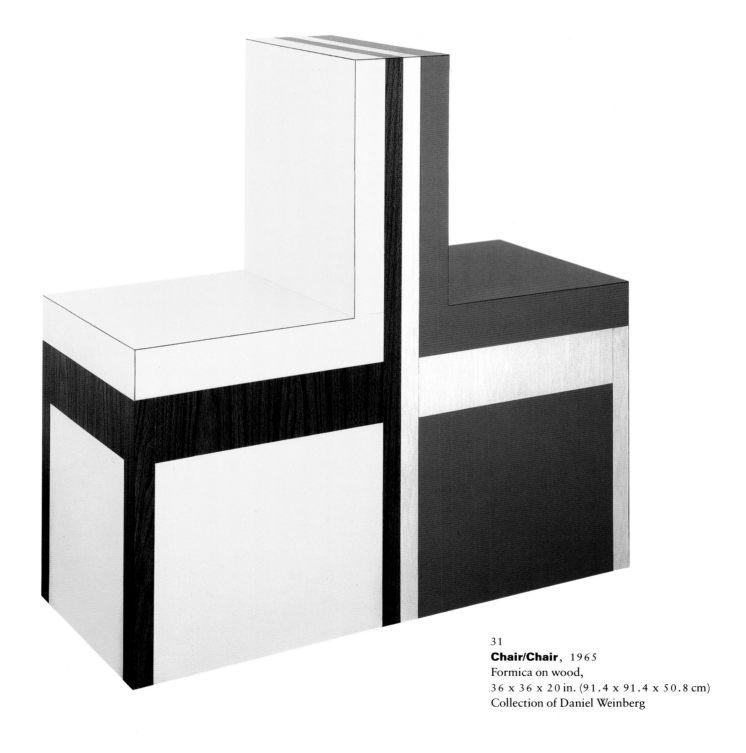

31
Chair/Chair, 1965
Formica on wood,
36 x 36 x 20 in. (91.4 x 91.4 x 50.8 cm)
Collection of Daniel Weinberg

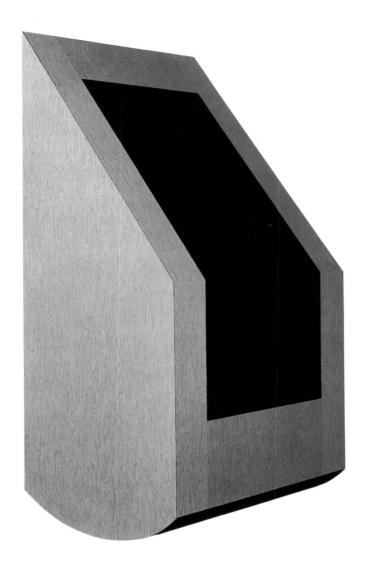

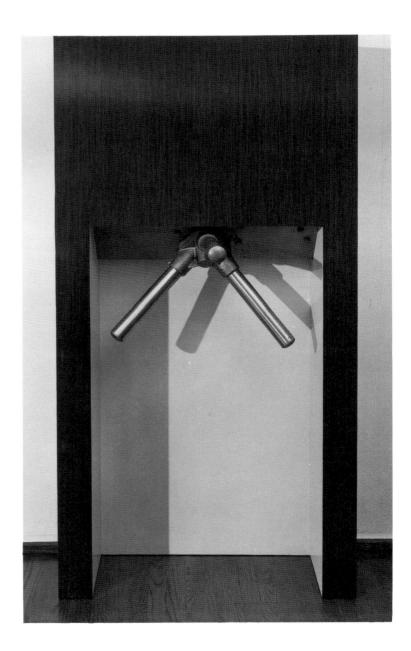

32
Rocker, 1964
Formica on wood with steel counterweight,
62 x 26 x 28 in. (157.5 x 66 x 71.1 cm)
Collection of Bob and Marilyn Stanley

33
Counter II, 1964
Formica on wood with metal turnstile mechanism,
71¼ x 36 x 21 in. (181 x 91.4 x 53.3 cm)
Musée Départemental des Vosges, Épinal, France

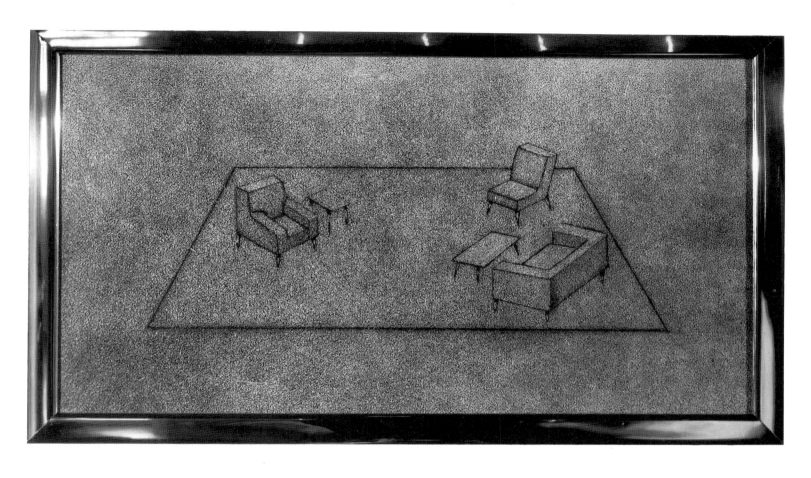

34
Chair, Chair, Sofa, Table, Table, Rug, 1965
Acrylic on celotex with metal frame,
23⅛ x 41⅛ in. (58.7 x 104.5 cm)
Collection of Jill and Douglas Walla

35
Piano II, 1965–79
Formica on wood with rubberized hair,
33¾ x 34 x 130 in. (85.7 x 86.4 x 330.2 cm)
Collection of Robert Freidus

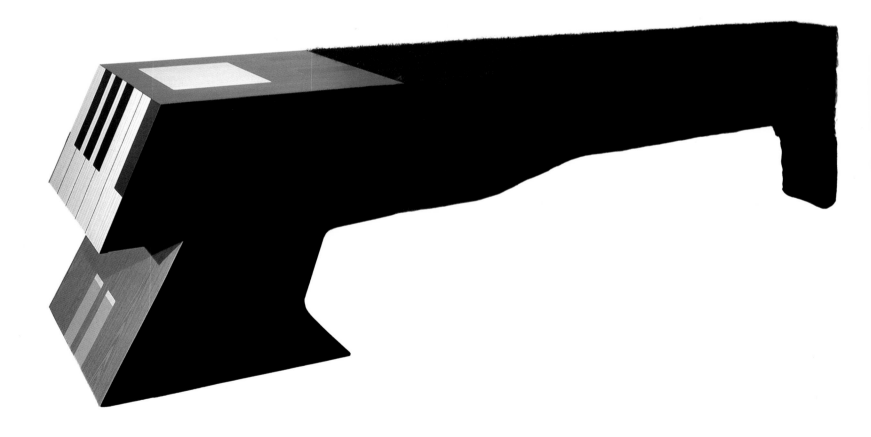

36
Piano, 1965
Formica on wood,
32 x 48 x 19 in. (81.3 x 121.9 x 48.3 cm)
Collection of Edward R. Downe, Jr.

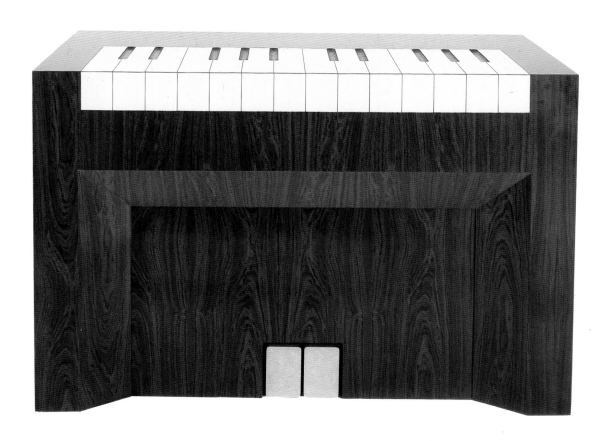

37
Double Speaker, 1966
Formica on wood,
15¹/₂ x 26 x 12¹/₄ in. (39.4 x 66 x 31.1 cm)
Nicola Jacobs Gallery, London

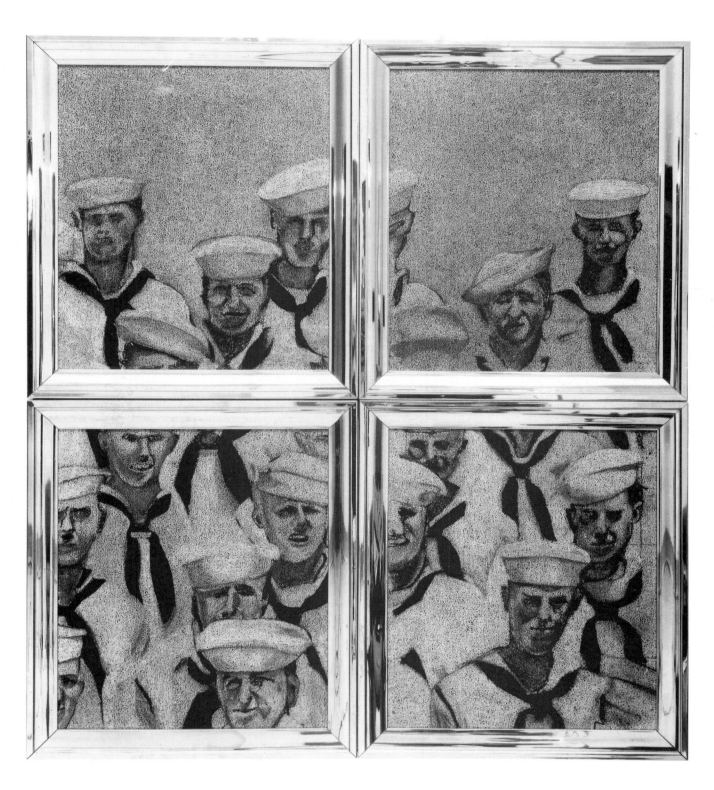

38

Sailors, 1966
Acrylic on celotex with metal frames, four panels:
25 x 22½ in. (63.5 x 57.2 cm) each
Collection of Jill and Douglas Walla

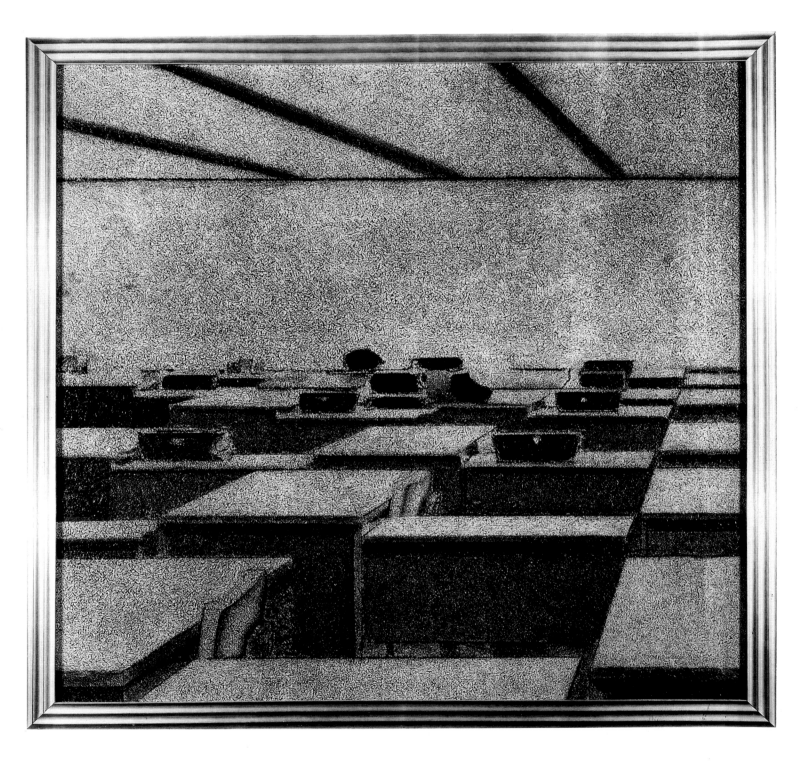

39
Office Scene, 1966
Acrylic on celotex with metal frame,
42 x 43 in. (106.7 x 109.2 cm)
Collection of Mr. and Mrs. S. Brooks Barron

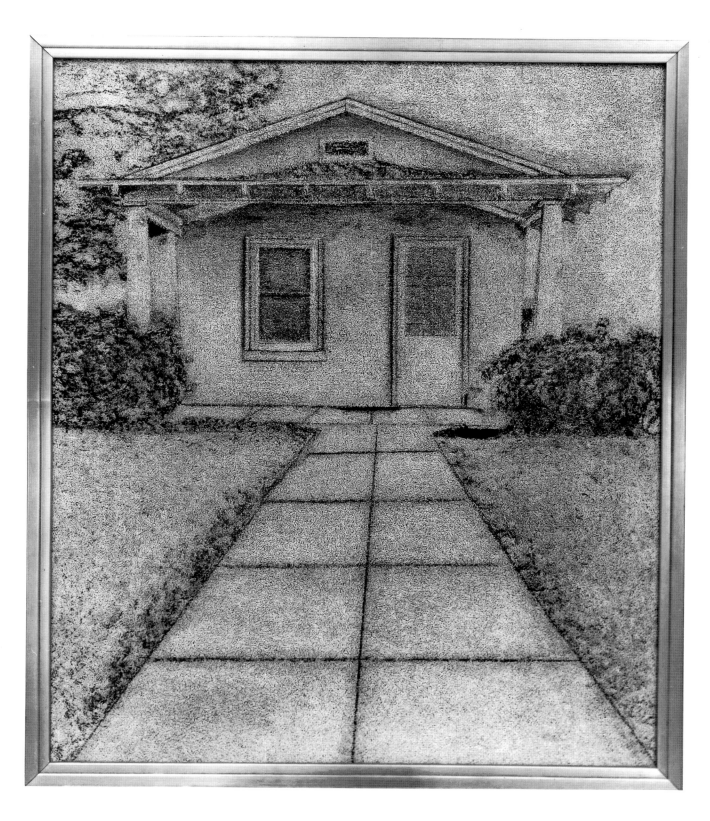

40
House, 1966
Acrylic on celotex with metal frame,
57 x 43 in. (144.8 x 109.2 cm)
Collection of John Torreano

41
Step 'n' See II, 1966
Formica on wood, two parts:
wall piece, 36 x 36 x 10¾ in. (91.4 x 91.4 x 27.3 cm);
floor piece, 53½ x 33 x 34½ in. (135.9 x 83.8 x 87.6 cm)
Collection of Roy and Dorothy Lichtenstein

42
Cradle, 1967
Formica on wood,
40¼ x 48⅛ x 24 in. (102.2 x 122.2 x 61 cm)
The Detroit Institute of Arts;
Gift of Mr. and Mrs. S. Brooks Barron

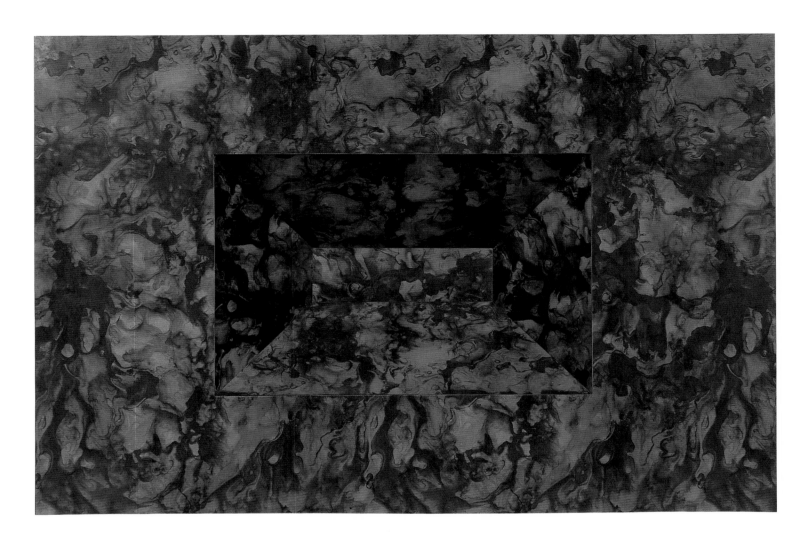

43
Untitled, 1966
Formica on wood,
48 x 72 x 12 in. (121.9 x 182.9 x 30.5 cm)
La Jolla Museum of Contemporary Art, California

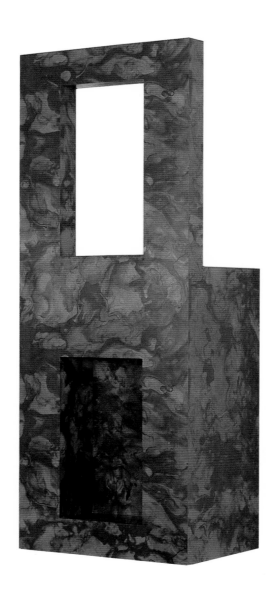

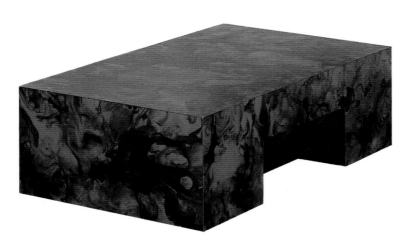

44
Two-Part Invention, 1967
Formica on wood, two parts:
wall piece, 57 x 21½ x 16 in. (144.8 x 54.6 x 40.6 cm);
floor piece, 10¼ x 33 x 21½ in. (26 x 83.8 x 54.6 cm)
The Albert A. List Family Collection

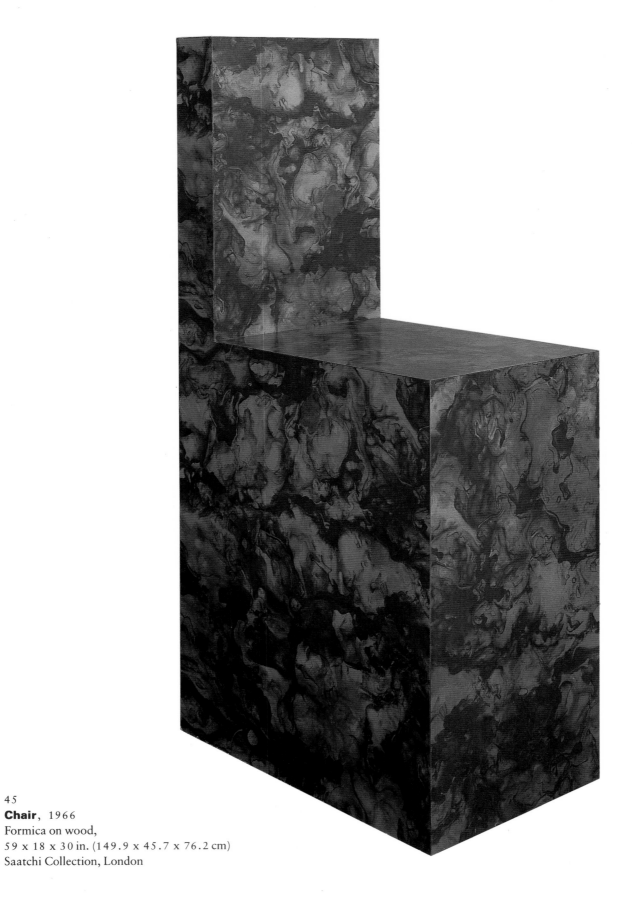

45
Chair, 1966
Formica on wood,
59 x 18 x 30 in. (149.9 x 45.7 x 76.2 cm)
Saatchi Collection, London

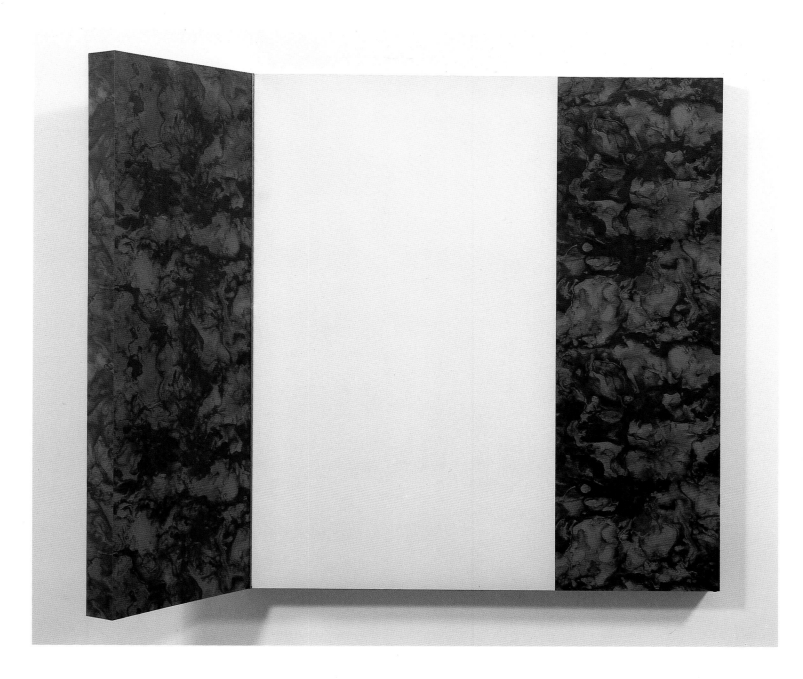

46
Diptych III, 1967
Formica on wood,
68 x 84 x 4½ in. (172.7 x 213.4 x 11.4 cm)
Private collection

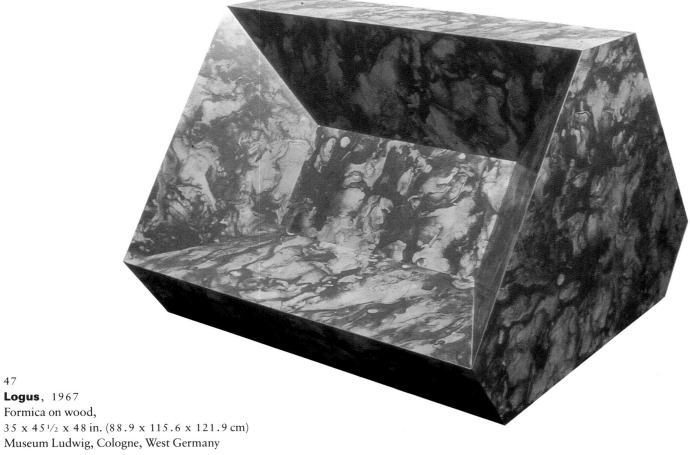

47
Logus, 1967
Formica on wood,
35 x 45 ½ x 48 in. (88.9 x 115.6 x 121.9 cm)
Museum Ludwig, Cologne, West Germany

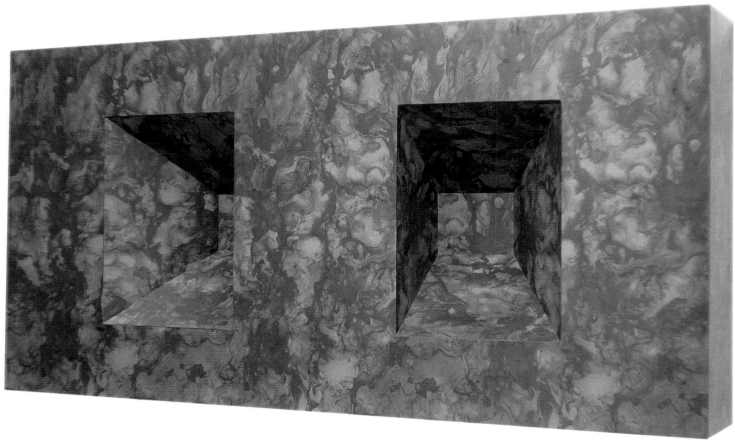

48
Two Indentations, 1967
Formica on wood,
48 x 96 x 13 in. (121.9 x 243.8 x 33 cm)
Collection of Naomi Spector and Stephen Antonakos

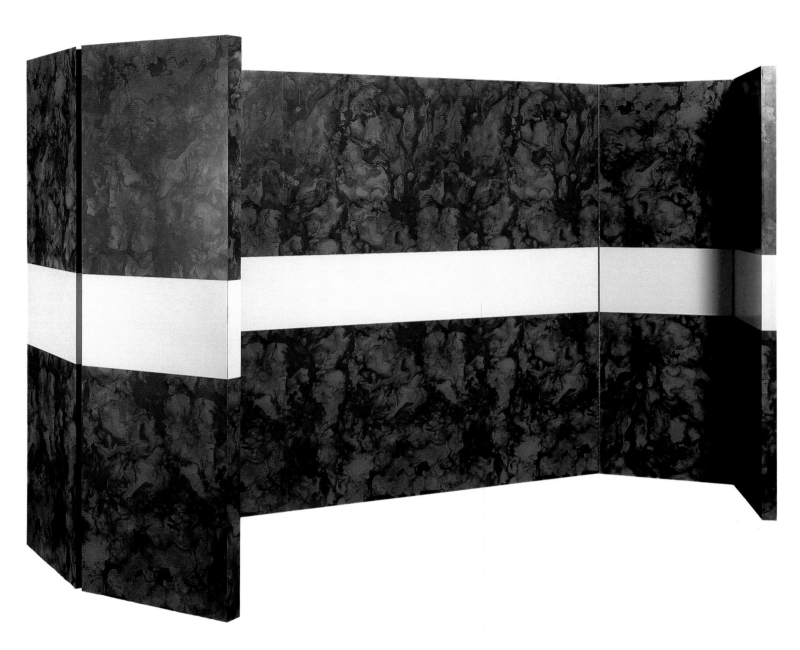

49
Faceted Syndrome, 1967
Formica on wood,
71½ x 191 x 5 in. (181.6 x 485.1 x 12.7 cm)
Collection of the artist

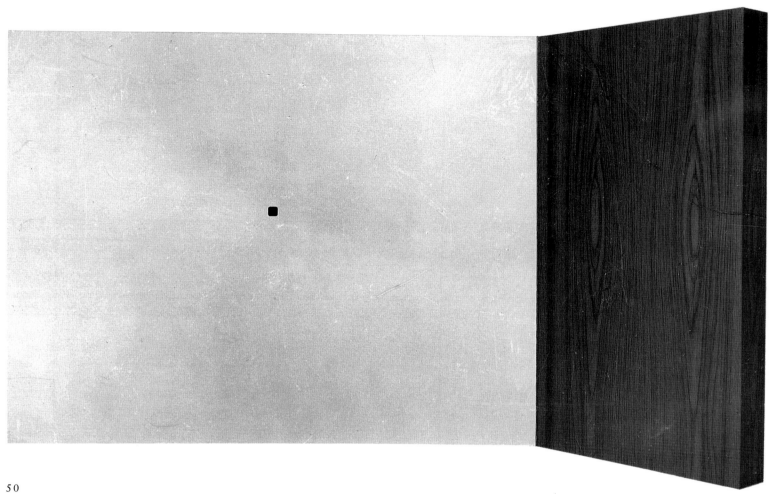

50
Open Door, 1967
Formica on wood, two panels:
left, 59¼ x 59 x 4 in. (150.5 x 149.9 x 10.2 cm);
right, 59¼ x 23¾ x 4 in. (150.5 x 60.3 x 10.2 cm)
Private collection

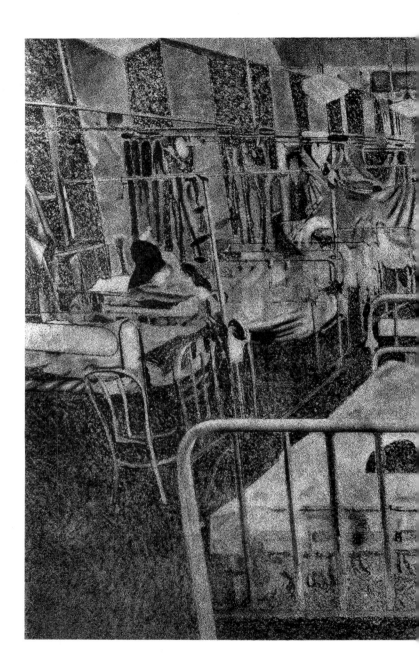

51
Hospital Ward, 1968
Acrylic on celotex, three panels:
68 x 140 in. (172.7 x 355.6 cm) overall
The Detroit Institute of Arts;
Gift of Mr. and Mrs. S. Brooks Barron

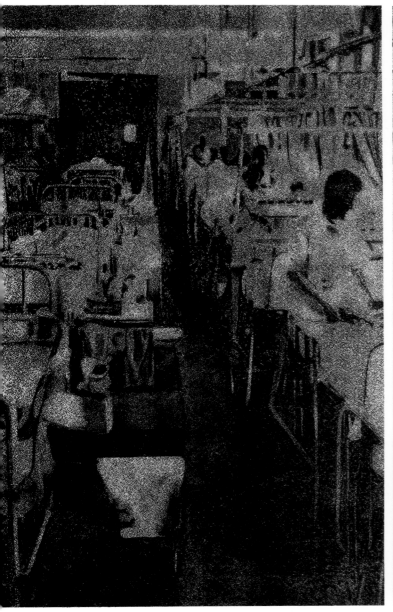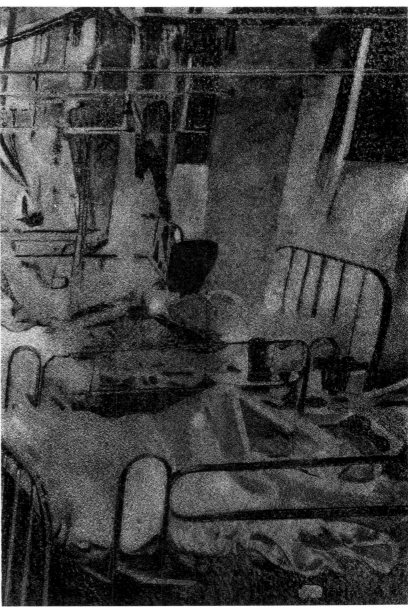

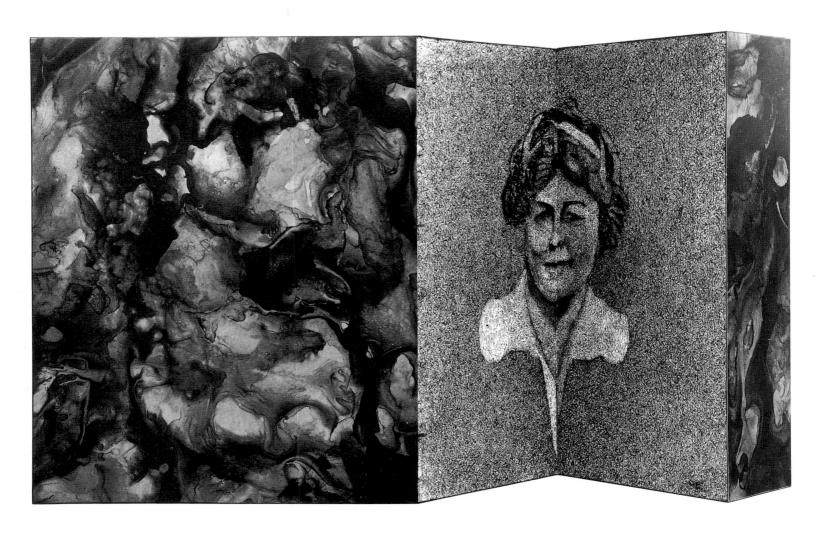

52
Diptych II, 1967
Acrylic on celotex and formica on wood,
20 x 32½ x 9½ in. (50.8 x 82.6 x 24.1 cm)
Collection of Rena Bransten

53
Couch, 1969
Acrylic on celotex,
24¾ x 46¾ in. (62.9 x 118.7 cm)
Vivian Horan Fine Art, New York

54
Untitled (Weaving), 1969
Acrylic on celotex with metal frame,
33⅛ x 24½ in. (84.1 x 62.2 cm)
Laurie Rubin Gallery, New York

55
Weave—Drape, 1971
Acrylic on celotex,
39¾ x 53 in. (101 x 134.6 cm)
Collection of Mr. and Mrs. Richard Plehn

56
Tintoretto's The Rescue of the Body of St. Mark, 1969
Acrylic on celotex with metal frame,
46½ x 51¼ in. (118.1 x 130.2 cm)
Private collection

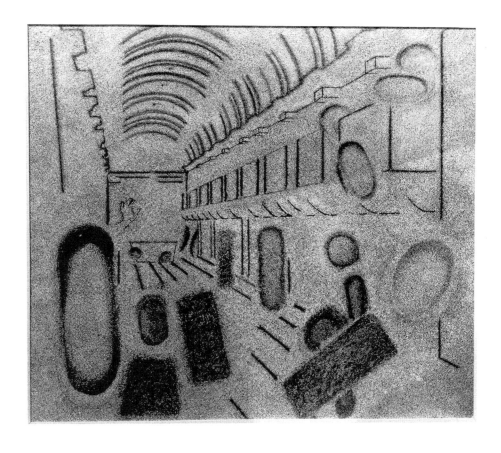

57
Rosehill Pediment, 1970
Acrylic on celotex with metal frames, two panels:
26¼ x 25¼ in. (66.7 x 64.1 cm) each
Estée Lauder, Inc., New York

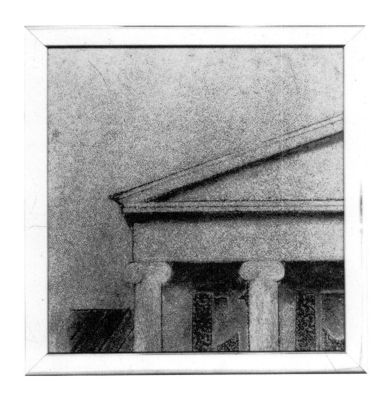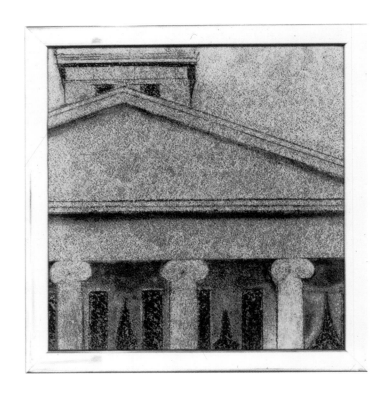

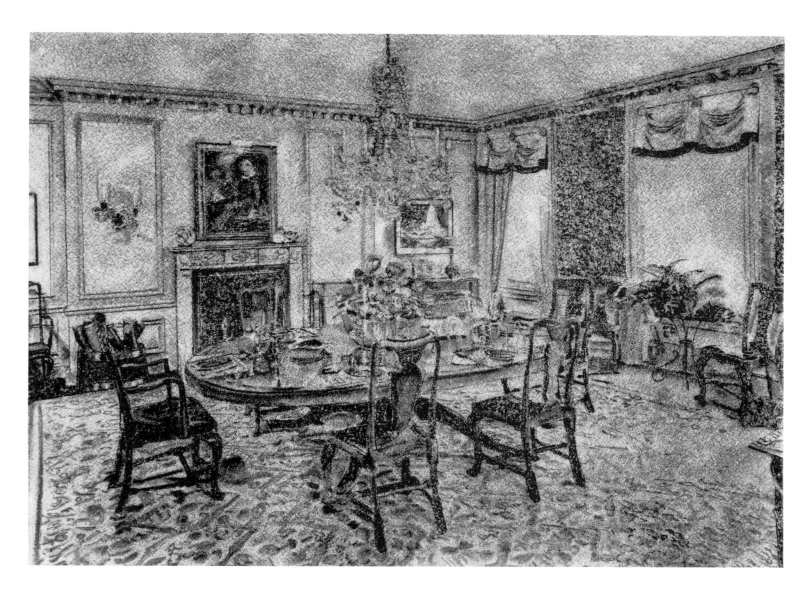

58
Polish Rider, 1970–71
Acrylic on celotex,
44 x 60 in. (111.8 x 152.4 cm)
Museum of Contemporary Art, Chicago;
Gift of Mrs. Robert B. Mayer

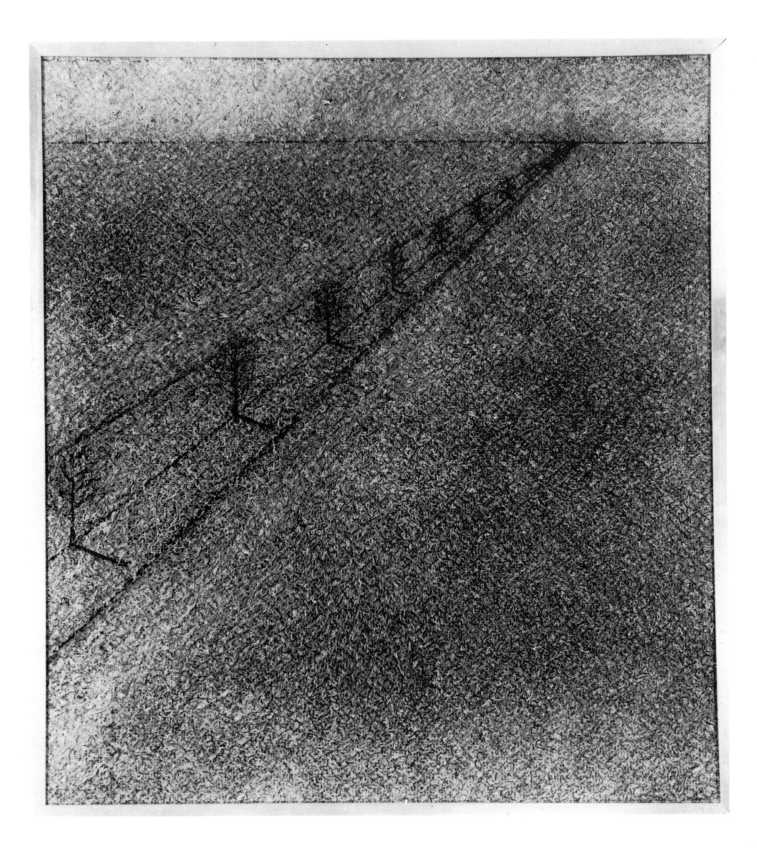

59
Trees Going Away, 1970
Acrylic on celotex with metal frame,
29½ x 25½ in. (74.9 x 64.8 cm)
Private collection

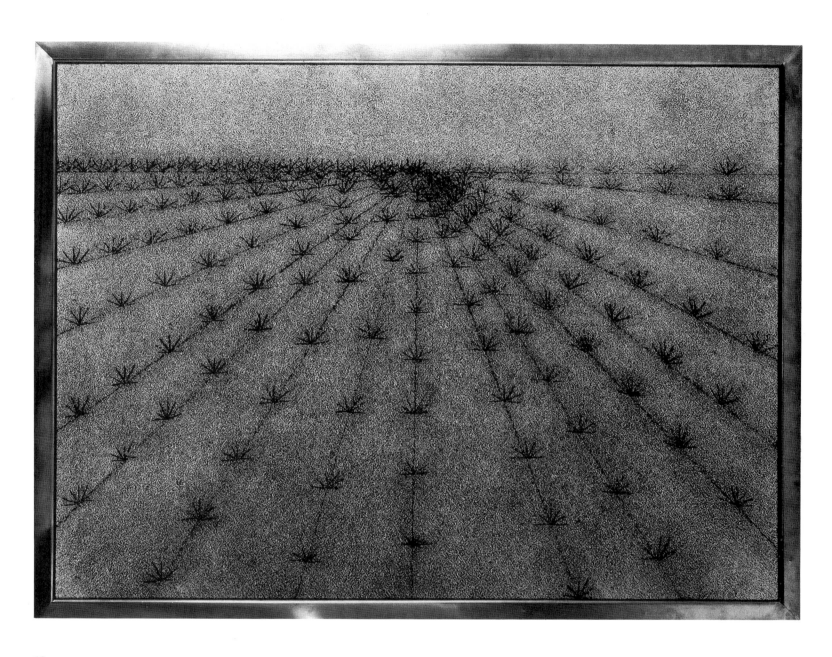

60
Bushes II, 1970
Acrylic on celotex with metal frame,
38 x 49 in. (96.5 x 124.5 cm)
Collection of Robert H. Halff

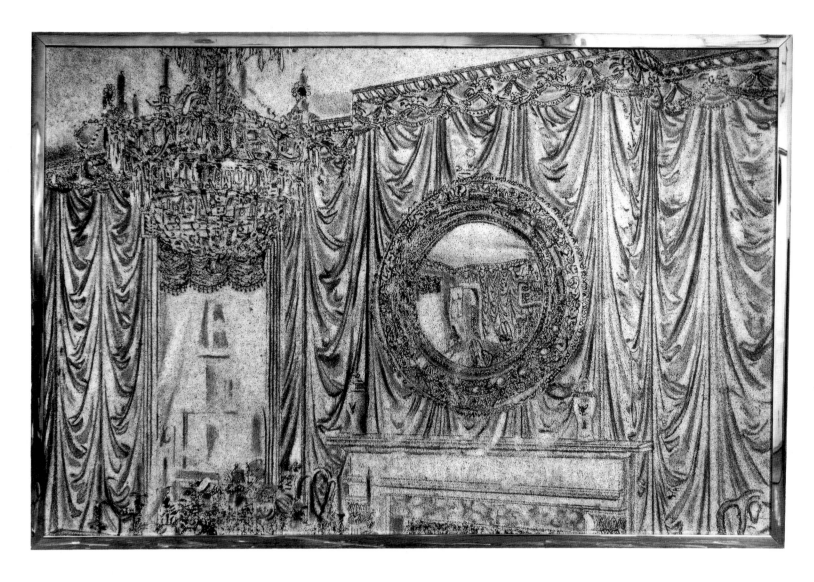

61
Mirror, 1971
Acrylic on celotex with metal frame,
48 x 69 in. (121.9 x 175.3 cm)
Collection of Mr. and Mrs. Ben Dunkelman

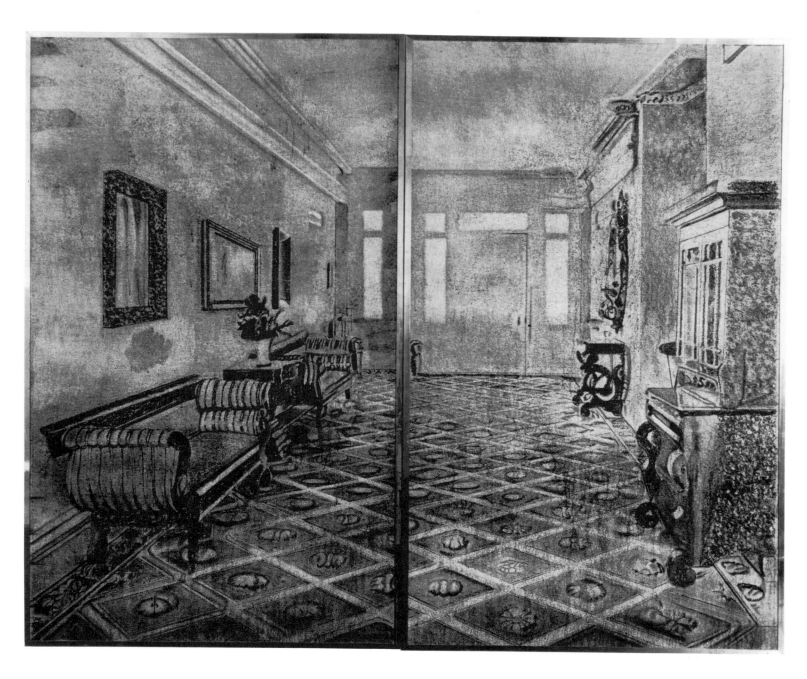

62
Polish Rider IV, 1971
Acrylic on celotex with metal frames, two panels:
76 x 92 in. (193 x 233.7 cm) overall
Kunstmuseum Basel, Switzerland;
Gift of the Emanuel Hoffman Foundation

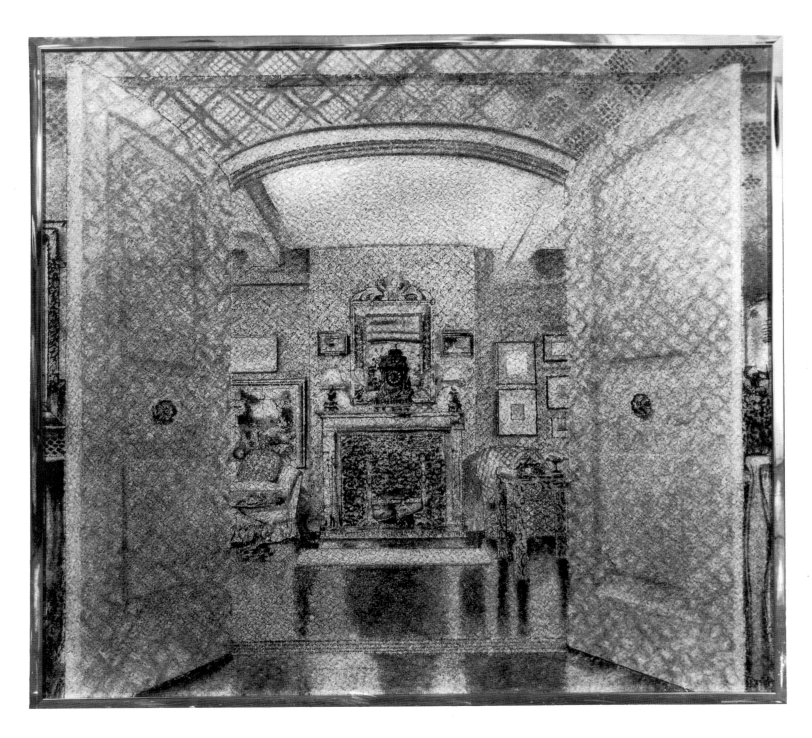

63
Doors, 1971
Acrylic on celotex with metal frame,
43 1/2 x 48 in. (110.5 x 121.9 cm)
Collection of Jan Eric Lowenadler

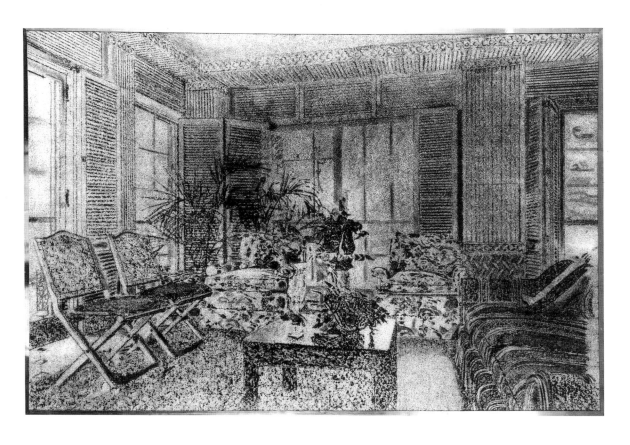

64
The Bush, 1971
Acrylic on celotex with metal frame,
48 x 70½ in. (121.9 x 179.1 cm)
Whitney Museum of American Art, New York;
Gift of Virginia F. and William R. Salomon 72.13

65
Staircase, 1971
Acrylic on celotex,
50¾ x 44½ in. (128.9 x 113 cm)
Collection of Anthony Hallencreutz

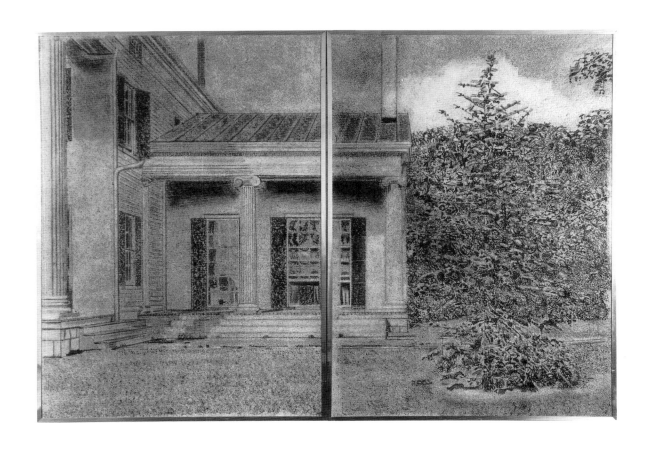

66
The Tree, 1971
Acrylic on celotex with metal frame, 63 x 92 in. (160 x 233.7 cm)
Museum Boymans-van Beuningen, Rotterdam

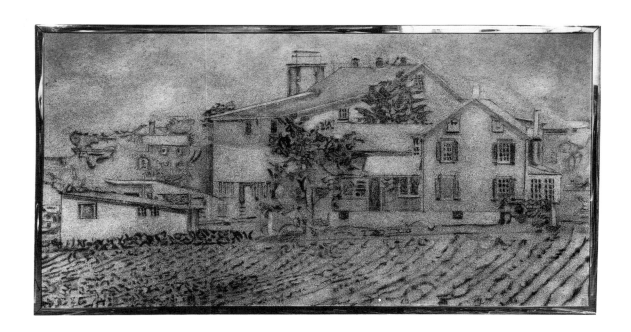

67
Farm III, 1972
Acrylic on celotex with metal frame, 49¼ x 92½ in. (125.1 x 235 cm)
The Oliver-Hoffmann Family Collection

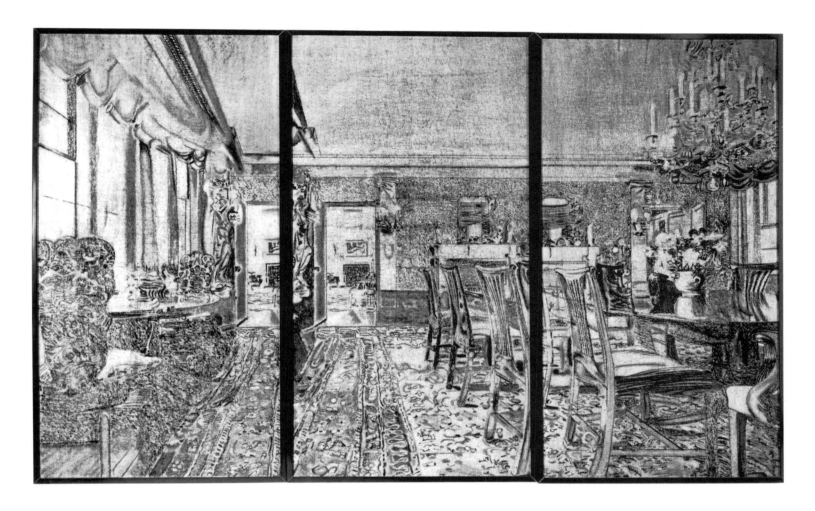

68
Triptych V, 1972
Acrylic on celotex with metal frames, three panels:
87 x 139½ in. (221 x 354.3 cm) overall
Robert B. Mayer Family Collection

69
Destruction III, 1972
Acrylic on celotex with metal frames, two panels:
74 x 88 in. (188 x 223.5 cm) overall
Private collection

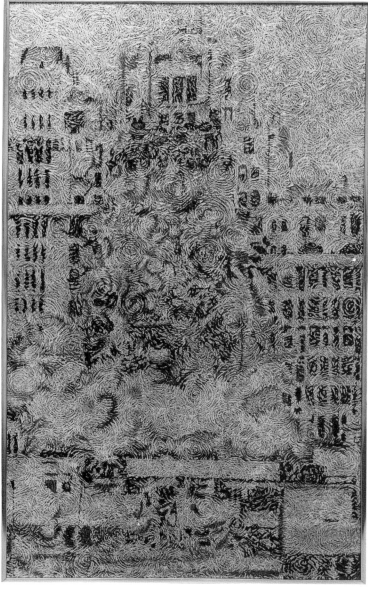

70
Destruction V, 1972
Acrylic on celotex with metal frames, two panels:
40 x 46 in. (101.6 x 116.8 cm) overall
The Eli and Edythe L. Broad Collection

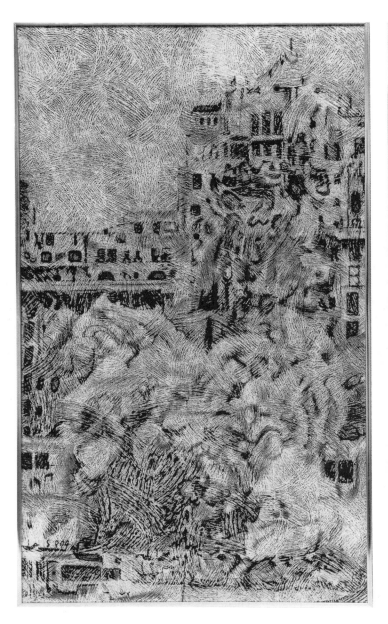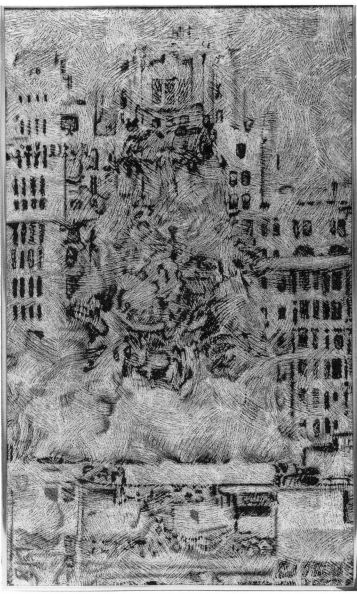

71
Destruction VI, 1972
Acrylic on celotex with metal frames, two panels:
40 x 46 in. (101.6 x 116.8 cm) overall
Private collection

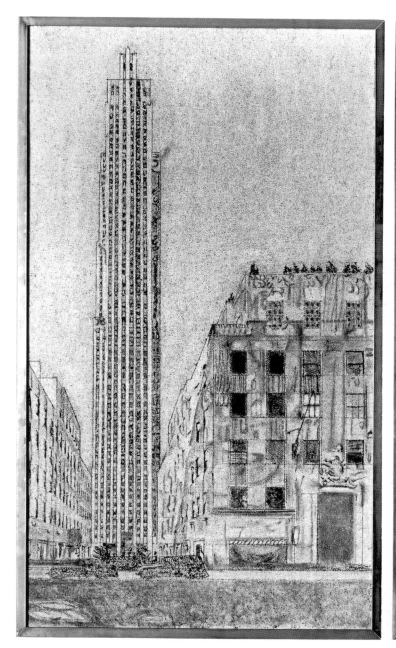

72
Double RCA Tower, 1972
Acrylic on celotex with metal frames, two panels:
79 x 71 in. (200.7 x 180.3 cm) overall
Private collection

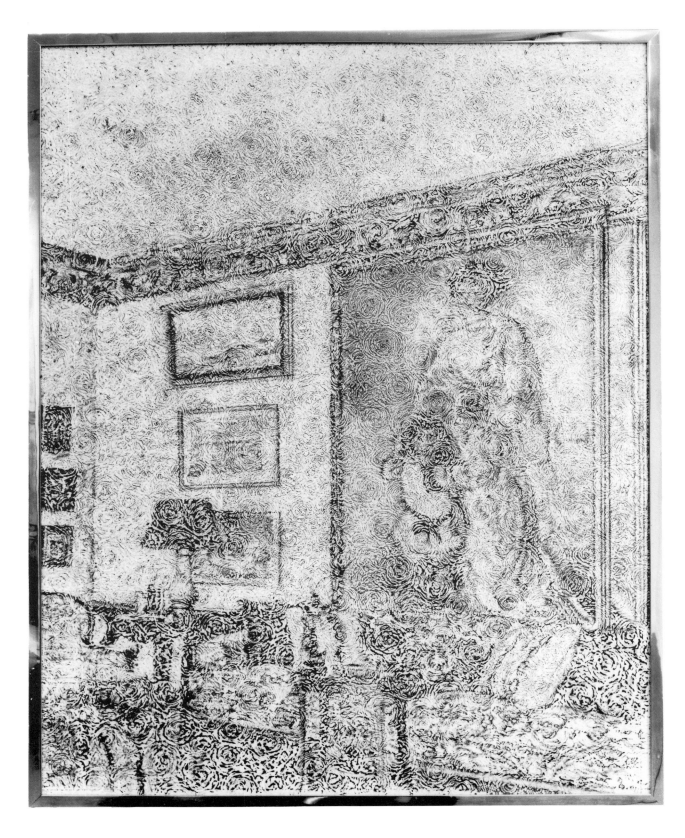

73
Untitled, 1973
Acrylic on celotex with metal frame,
60 x 46⅝ in. (152.4 x 118.4 cm)
Saatchi Collection, London

74
Railroad Track and Fence, 1973
Acrylic on celotex with metal frame,
26 3/8 x 50 1/2 in. (67 x 128.3 cm)
Collection of Paula Cooper

75
Biology Department Building, 1974
Acrylic on celotex with metal frame,
25 1/2 x 38 1/2 in. (64.8 x 97.8 cm)
Collection of Barbara Monasch

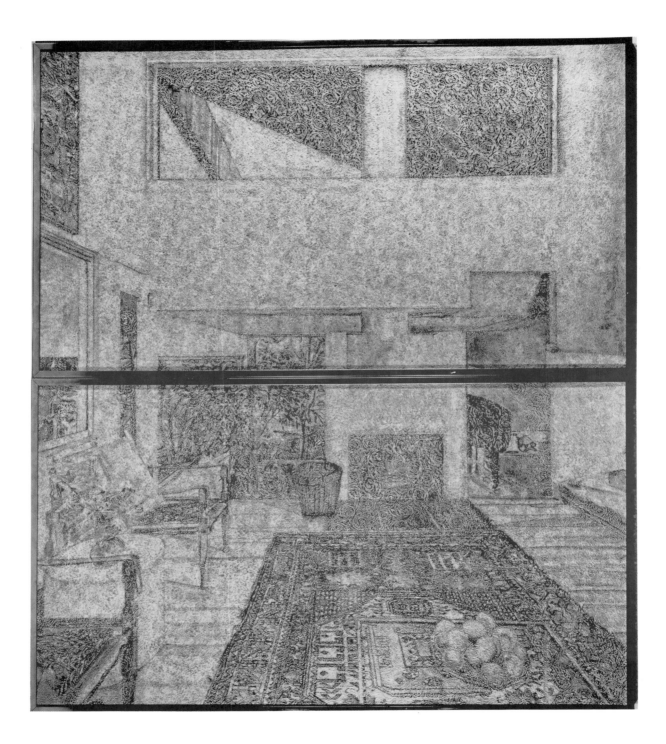

76
Interior (West), 1973
Acrylic on celotex with metal frames, two panels:
top, 48⁷/₈ x 75⁷/₈ in. (124.1 x 192.7 cm);
bottom, 50⁷/₈ x 75⁷/₈ in. (129.2 x 192.7 cm)
Saatchi Collection, London

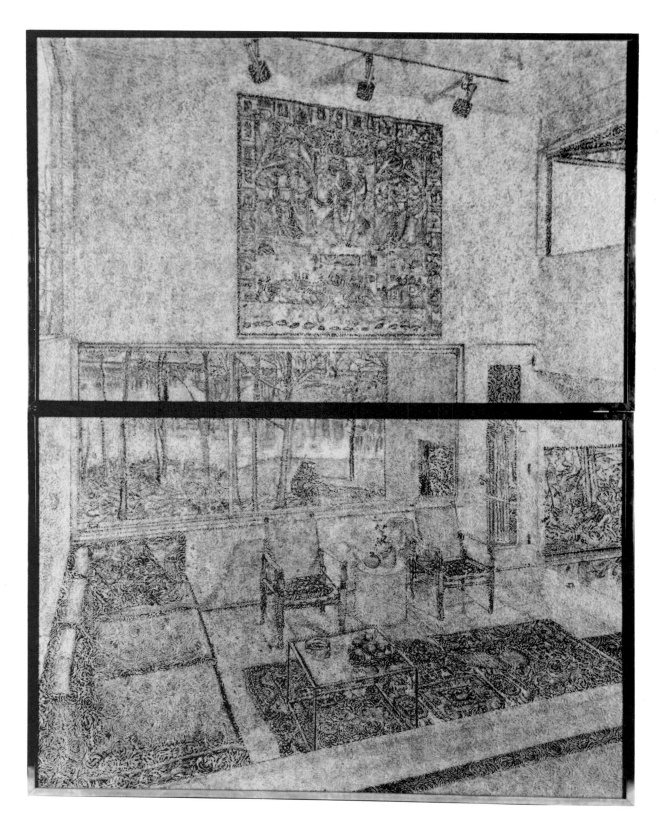

77
Interior (North), 1973
Acrylic on celotex with metal frames, two panels:
top, 52³/₄ x 88¹/₂ in. (134 x 224.8 cm);
bottom, 52¹/₈ x 88¹/₂ in. (132.4 x 224.8 cm)
Saatchi Collection, London

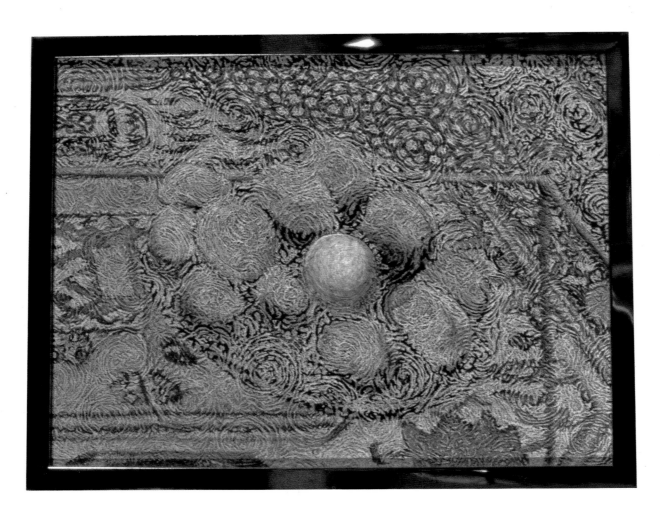

78
Bowl of Peaches on Glass Table, 1973
Acrylic on celotex with metal frame,
19 ½ x 25 in. (49.5 x 63.5 cm)
Collection of Mr. and Mrs. Oscar Feldman

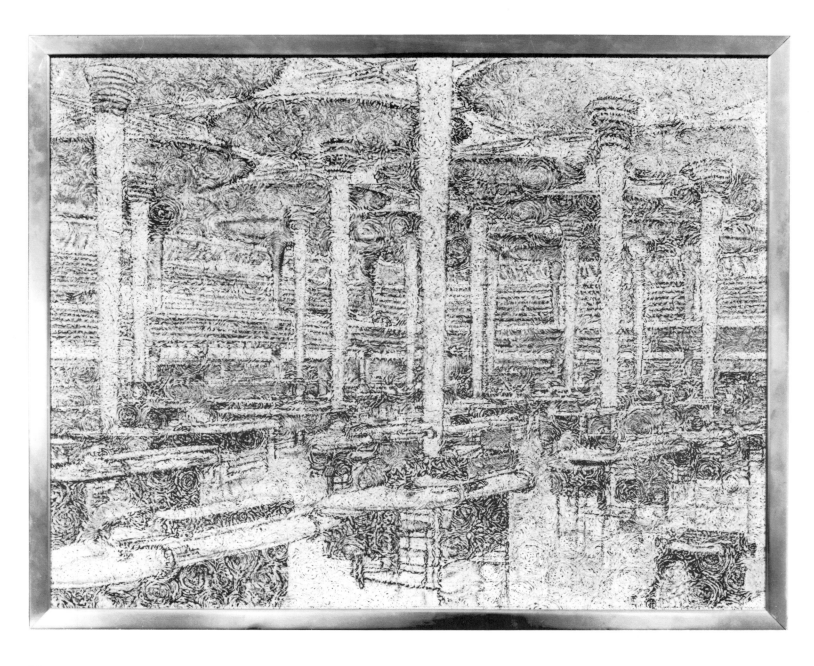

82
Johnson Wax Building, 1974
Acrylic on celotex with metal frame,
47⅝ x 59½ in. (121 x 151.1 cm)
The Edward R. Broida Trust, Los Angeles

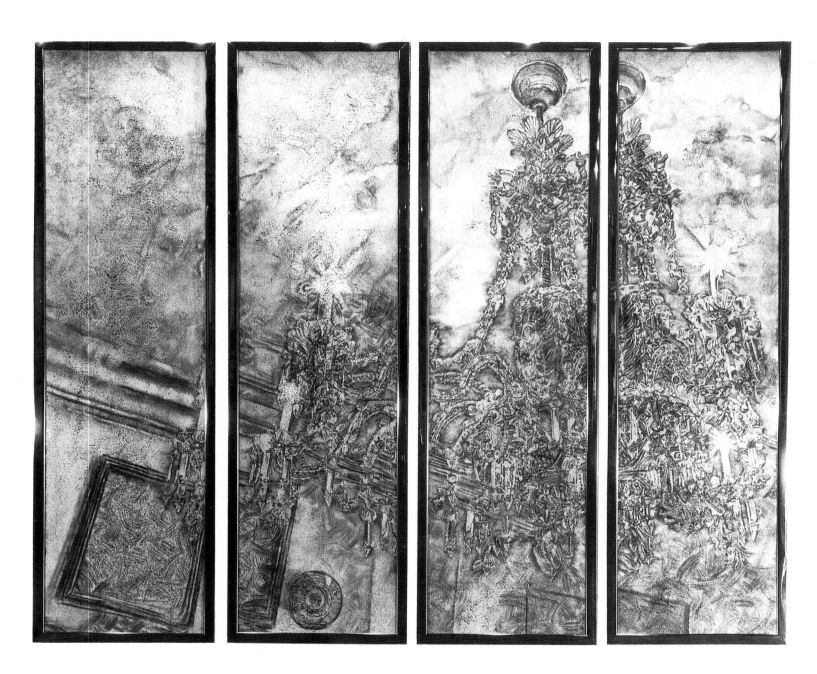

83
Chandelier II, 1976
Acrylic on celotex with metal frames, four panels:
95¹/₂ x 27³/₄ in. (242.6 x 70.5 cm) each
Collection of Balene C. McCormick

84
Weaving #182, 1976
Acrylic on celotex with metal frames, two panels:
34½ x 35⅝ in. (87.6 x 90.5 cm) overall
Private collection

85
Six Mirror Images, 1975–79
Vacuum-formed, metallized plexiglass, formica, and wood,
58 x 155 x 4 in. (147.3 x 393.7 x 10.2 cm) open
The Oliver-Hoffmann Family Collection

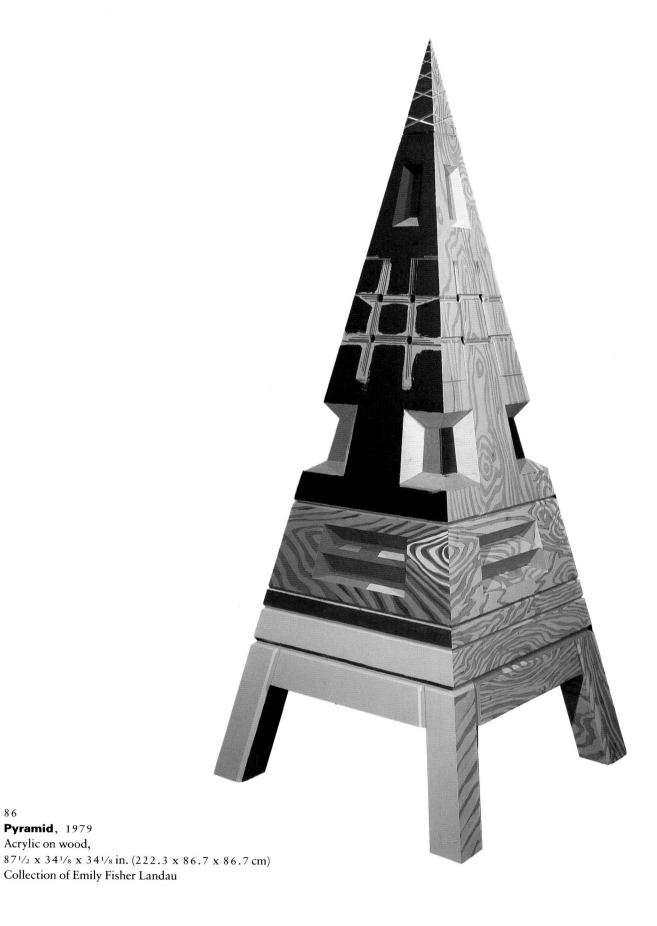

86
Pyramid, 1979
Acrylic on wood,
87½ x 34⅛ x 34⅛ in. (222.3 x 86.7 x 86.7 cm)
Collection of Emily Fisher Landau

87
Chair Table, 1980
Formica on wood with metal handle, two parts:
chair, 41 x 21½ x 24 in. (104.1 x 54.6 x 61 cm);
table, 32 x 48 x 36 in. (81.3 x 121.9 x 91.4 cm)
Museum of Art, Rhode Island School of Design, Providence;
Bequest of Lyra Brown Nickerson, by exchange, and
Georgianna Sayles Aldrich and Walter H. Kimbell Funds

88
Tower III (Confessional), 1980
Formica on wood,
60 x 47 x 32 in. (152.4 x 119.4 x 81.3 cm)
Saatchi Collection, London

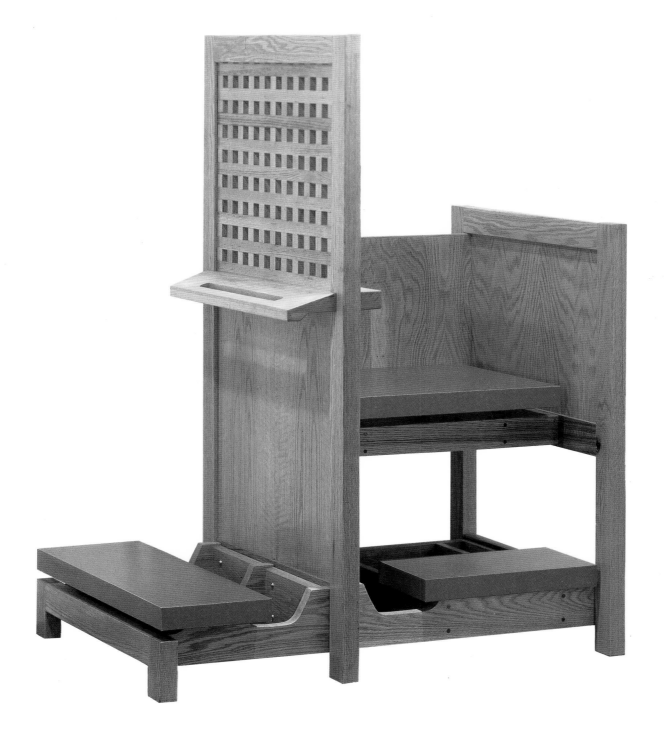

89
Fence II, 1980
Acrylic on celotex with painted wood frames and mirrors, two panels:
52½ x 57½ in. (133.4 x 146.1 cm) each
Shaklee Corporation, San Francisco,
courtesy Daniel Weinberg Gallery, Los Angeles

90
Three Trees (Shark), 1981
Acrylic on wood and celotex, formica, and mirror,
36½ x 57½ x 13¼ in. (92.7 x 146.1 x 33.7 cm)
Collection of Agnes Gund

91
City of Man, 1981
Acrylic on celotex, formica, and plexiglass with painted wood frame,
77³/₄ x 179³/₄ x 5⁷/₈ in. (197.5 x 456.6 x 14.9 cm)
Collection of Emily Fisher Landau

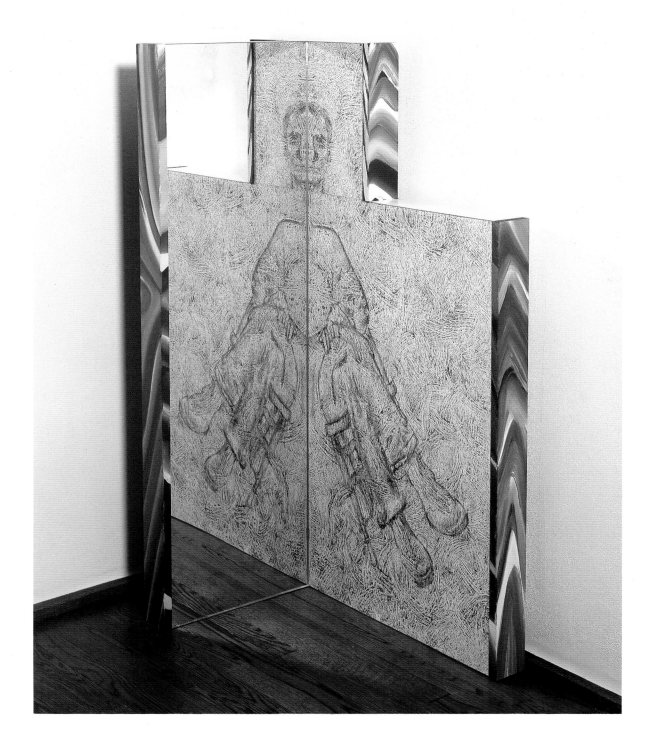

92
Janus II, 1981
Acrylic on celotex with mirror and formica,
52¼ x 33½ x 19 in. (132.7 x 85.1 x 48.3 cm)
Collection of Jeffrey and Marsha Miro

93
Williamsburg Pagoda, 1981
Acrylic on celotex, formica, and wood,
87 x 73¾ x 8 in. (221 x 187.3 x 20.3 cm)
Virginia Museum of Fine Arts, Richmond;
Gift of The Sydney and Frances Lewis Foundation

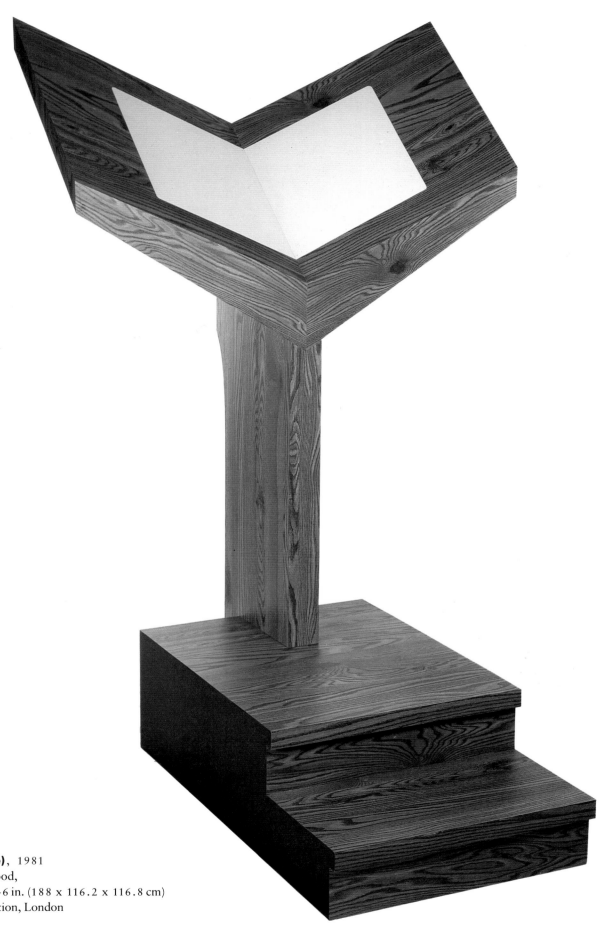

94
Book II (Nike), 1981
Formica on wood,
74 x 45¾ x 46 in. (188 x 116.2 x 116.8 cm)
Saatchi Collection, London

138

95
Book III (Laocoön), 1981
Formica on wood with metal handles and vinyl cushion,
48 x 28 x 41 in. (121.9 x 71.1 x 104.1 cm)
Musée Nationale d'Art Moderne, Centre Georges Pompidou, Paris

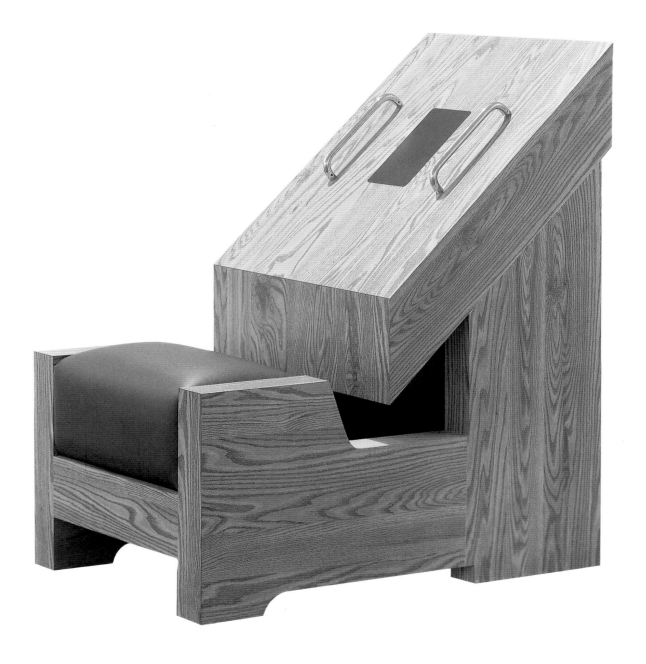

96
Chair and Window, 1983
Acrylic on celotex with painted wood frame,
53¾ x 51½ in. (136.5 x 130.8 cm)
Frederick R. Weisman Collection, Los Angeles

97
Door }, 1983–84
Acrylic on wood and glass, two parts:
door, 81¾ x 65 x 9¾ in. (207.6 x 165.1 x 24.8 cm);
bracket, 74¾ x 25 x 1½ in. (189.9 x 63.5 x 3.8 cm)
Collection of Martin Bernstein

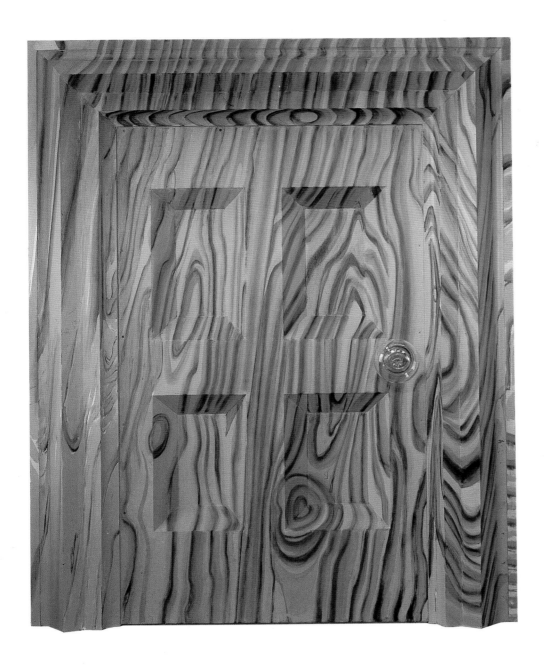
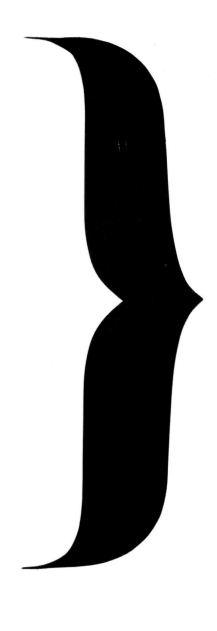

98
Hoosier Cabinet, 1984–85
Formica and acrylic on wood,
66½ x 71½ x 13 in. (168.9 x 181.6 x 33 cm)
Collection of Ghislaine Hussenot

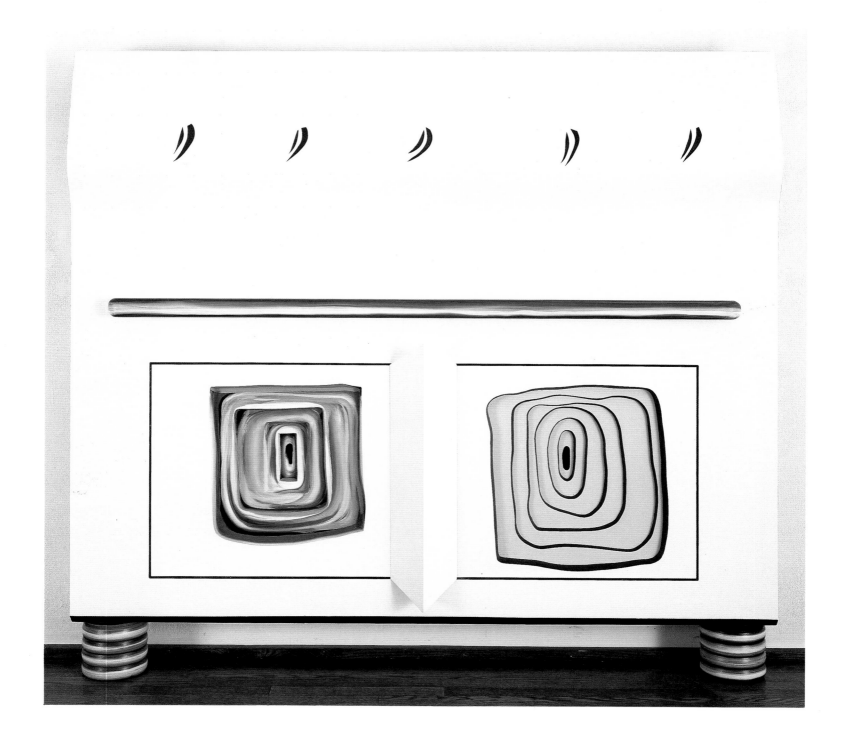

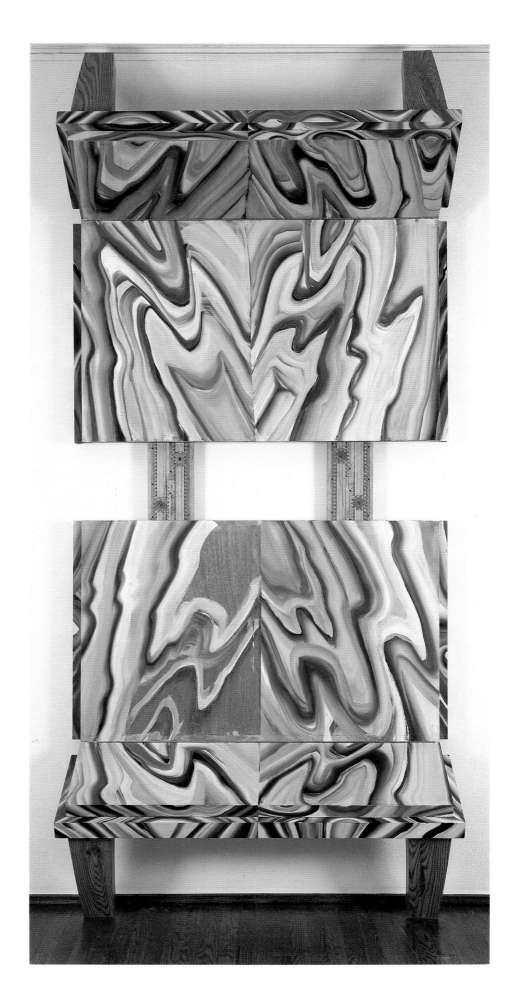

99
Flayed Tables, 1984–85
Acrylic on wood,
123 x 52¹⁄₂ x 18 in.
(312.4 x 133.4 x 45.7 cm) open
Collection of Suzanne and Howard Feldman

100
Up and Across, 1984–85
Acrylic on wood,
61 x 144 x 35 in. (154.9 x 365.8 x 88.9 cm)
Frederick R. Weisman Collection, Los Angeles

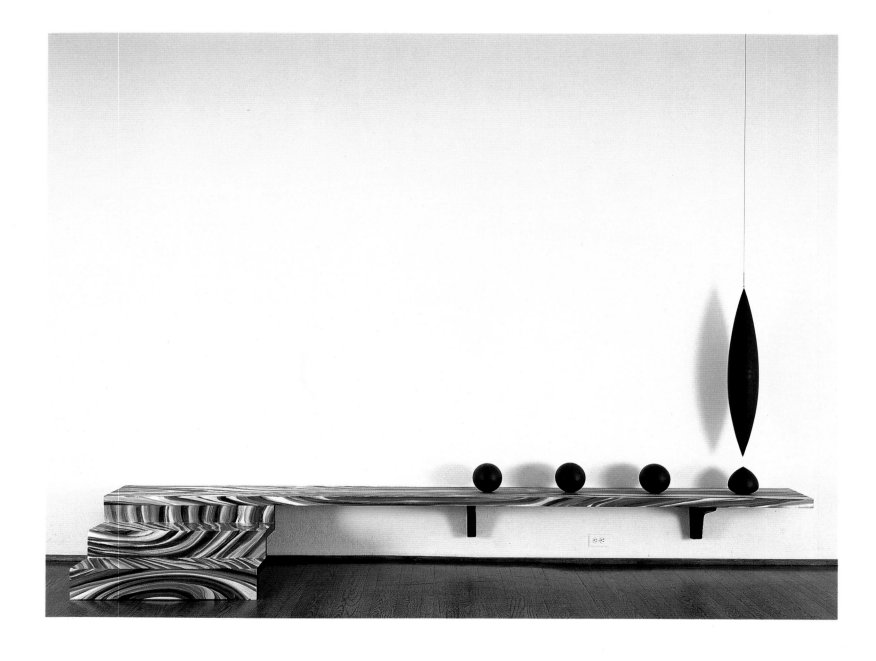

101
Door/Door II, 1984–85
Formica and acrylic on wood,
84 x 136 x 12 in. (213.4 x 345.4 x 30.5 cm)
Collection of Janet Green

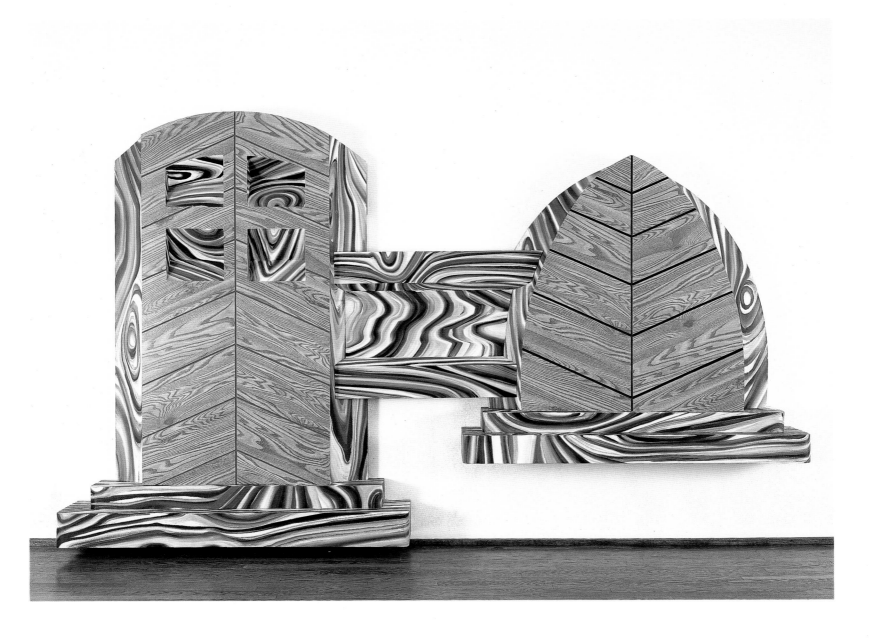

102
Drawing of Table, 1984–85
Rubberized hair and wood,
36 x 46 x 15 in. (91.4 x 116.8 x 38.1 cm)
Private collection

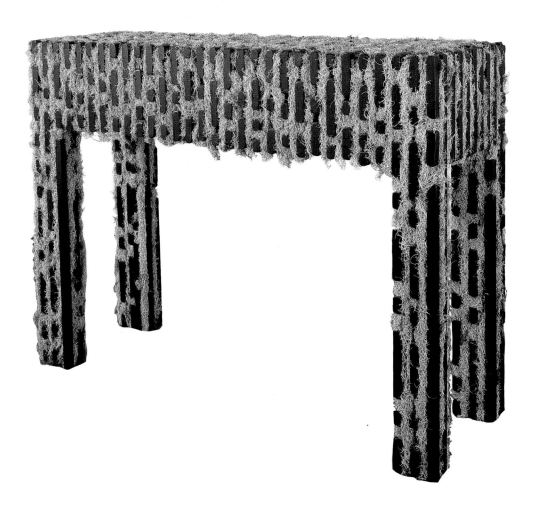

103
Low Overhead, 1984—85
Formica and acrylic on wood,
96 x 94 x 20 in. (243.8 x 238.8 x 50.8 cm)
Walker Art Center, Minneapolis;
T.B. Walker Acquisition Fund

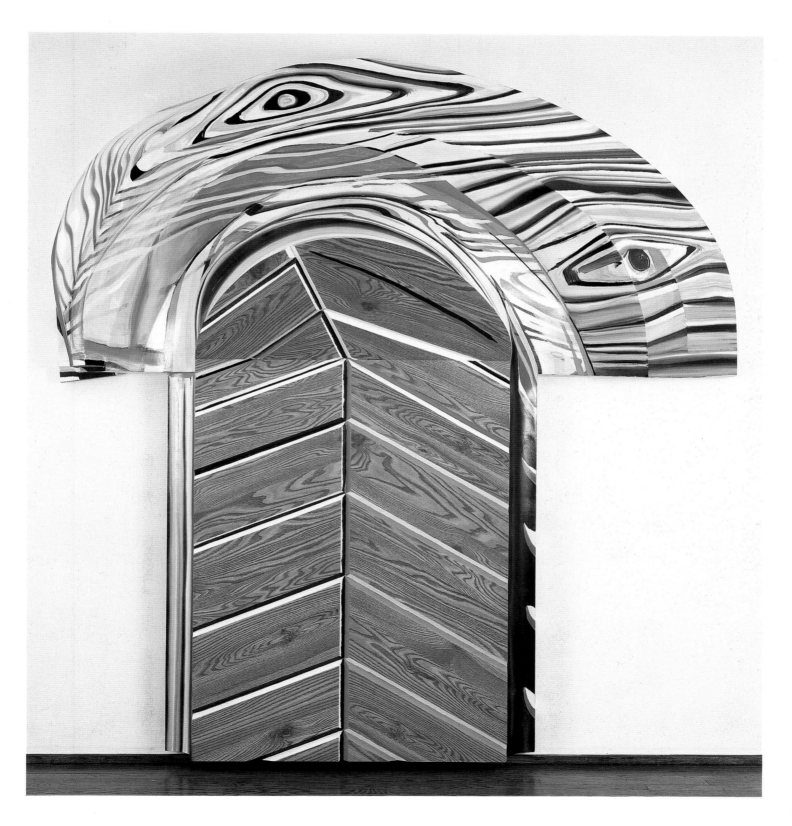

104
Three Dinners, 1984–85
Acrylic on celotex with painted wood frame,
54 x 60 in. (137.2 x 152.4 cm)
Collection of Joseph McHugh

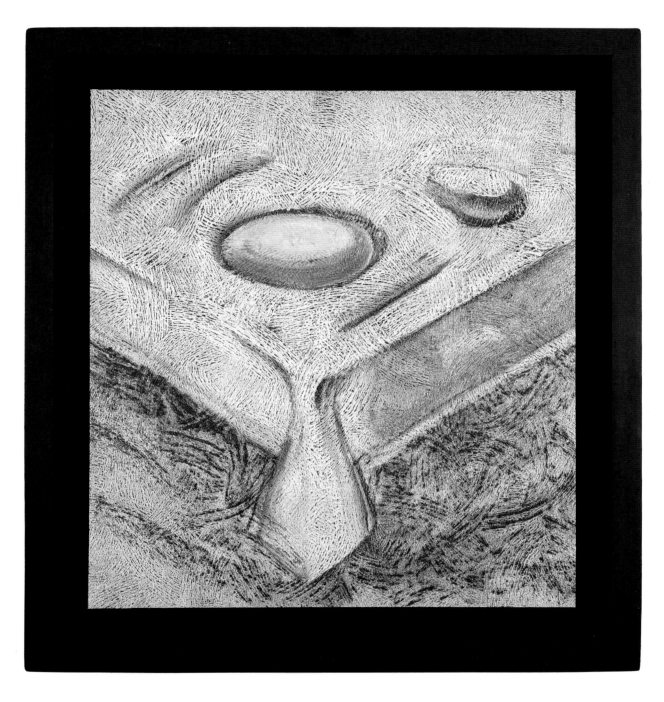

105
Dinner (Corner), 1984–85
Acrylic on celotex with painted wood frame,
30 x 27½ in. (76.2 x 69.9 cm)
Collection of Patricia Brundage and William Copley

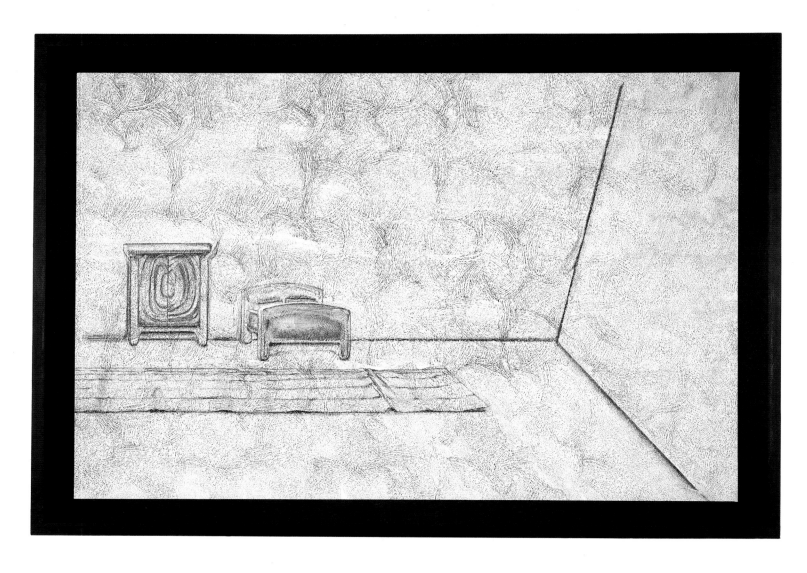

106
Clothes Closet, Bed, Rug, Corner, 1984–85
Acrylic on celotex with painted wood frame,
53 x 76 in. (134.6 x 193 cm)
Collection of Anne and Martin Margulies

150

107
Basket, Mirror, Window, Rug, Table, Door, 1985
Acrylic on celotex with painted wood frame,
54 x 56½ in. (137.2 x 143.5 cm)
Frederick Weisman Company, Los Angeles

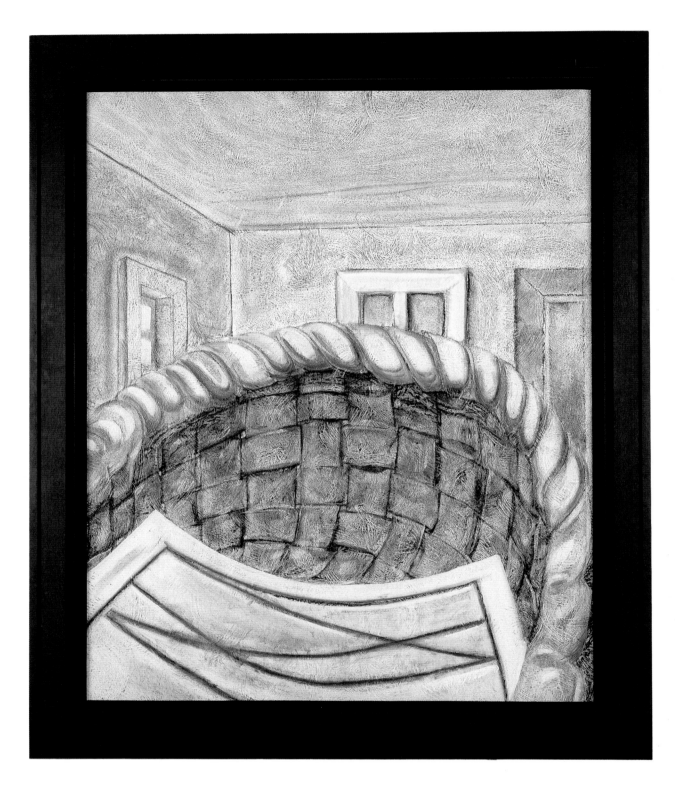

108
D.M.B.R.T.W. I, 1985
Acrylic on celotex with painted wood frame,
68¾ x 56¾ in. (174.6 x 144.1 cm)
Collection of Janet Green

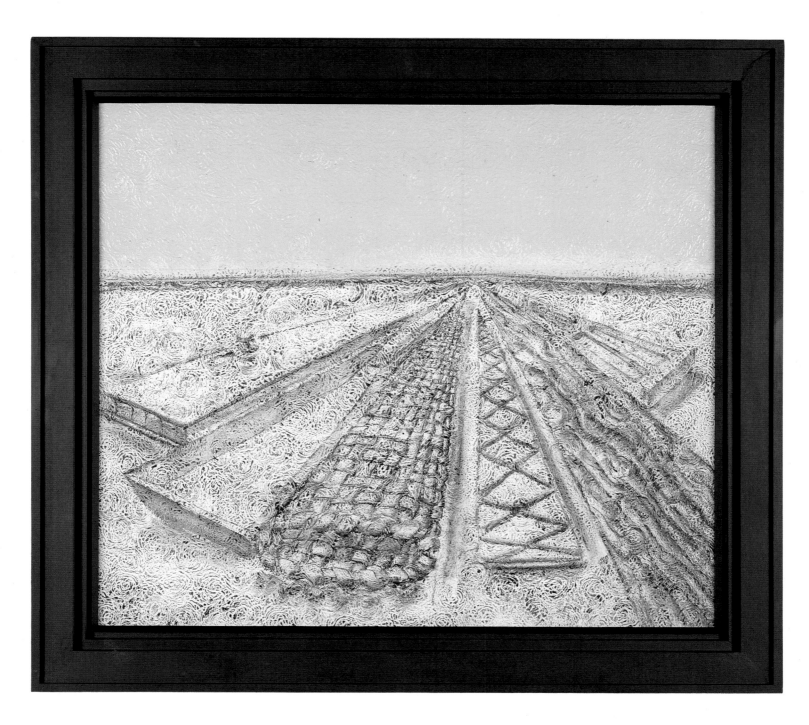

109
D.M.B.R.T.W. II, 1985
Acrylic on celotex with painted wood frame,
53 x 59 in. (134.6 x 149.9 cm)
Collection of George A. and Frances R. Katz

110
Dinner (a), 1986
Formica and acrylic on celotex
with painted wood frame,
61½ x 47½ in. (156.2 x 120.7 cm)
Collection of Estelle Schwartz

111
Dinner (b), 1986
Formica and acrylic on celotex
with painted wood frame,
57 x 45½ in. (144.8 x 115.6 cm)
Collection of Thomas Ammann

112
Two Dinners (a), 1986
Formica and acrylic on celotex
with painted wood frame,
63 x 61½ in. (160 x 156.2 cm)
Gagosian Gallery, Inc., New York

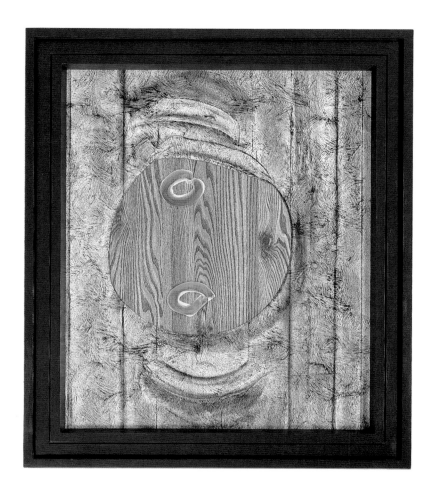

113
Two Dinners (b), 1986
Formica and acrylic on celotex
with painted wood frame,
56½ x 48 in. (143.5 x 121.9 cm)
The Oliver-Hoffmann Family Collection

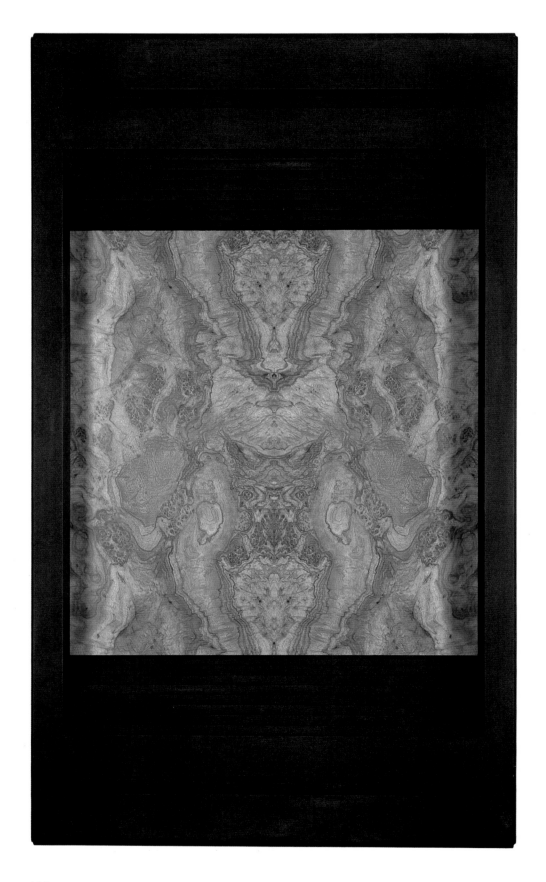

114
Loop, 1986
Formica and acrylic on wood,
96 x 52¾ x 10⅜ in. (243.8 x 134 x 26.4 cm)
Collection of Bette Ziegler

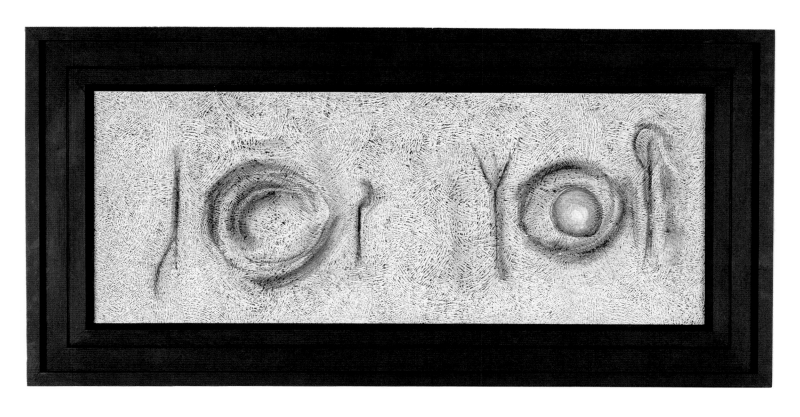

115
Dinner (Two), 1986
Acrylic on celotex with painted wood frame,
27³/₄ x 55³/₄ in. (70.5 x 141.6 cm)
Collection of William S. Ehrlich

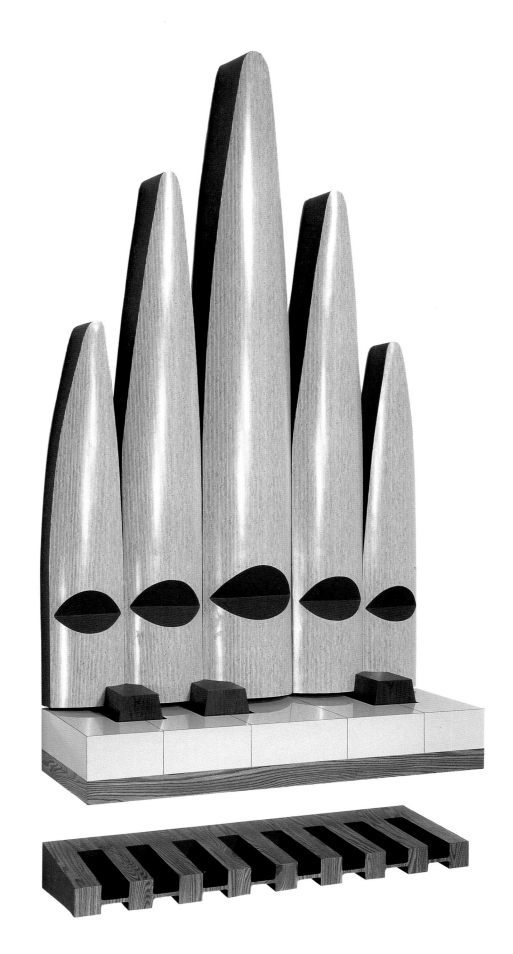

116
Organ of Cause and Effect III, 1986
Formica and acrylic on wood,
129 x 61¾ x 18 in. (327.7 x 156.8 x 45.7 cm)
Whitney Museum of American Art, New York;
Purchase, with funds from the Painting and
Sculpture Committee 87.6 a–f

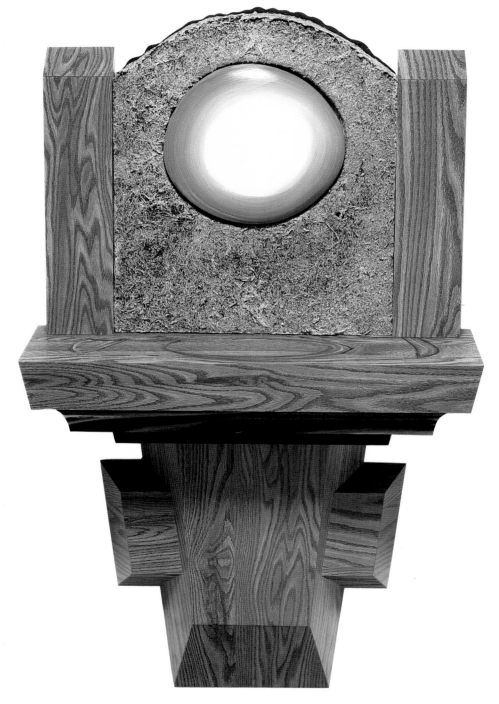

117
Dinner, 1987
Formica and acrylic on wood with cloth,
51 x 28 x 11⁷⁄₈ in. (129.5 x 71.1 x 30.2 cm)
Collection of Janet Green

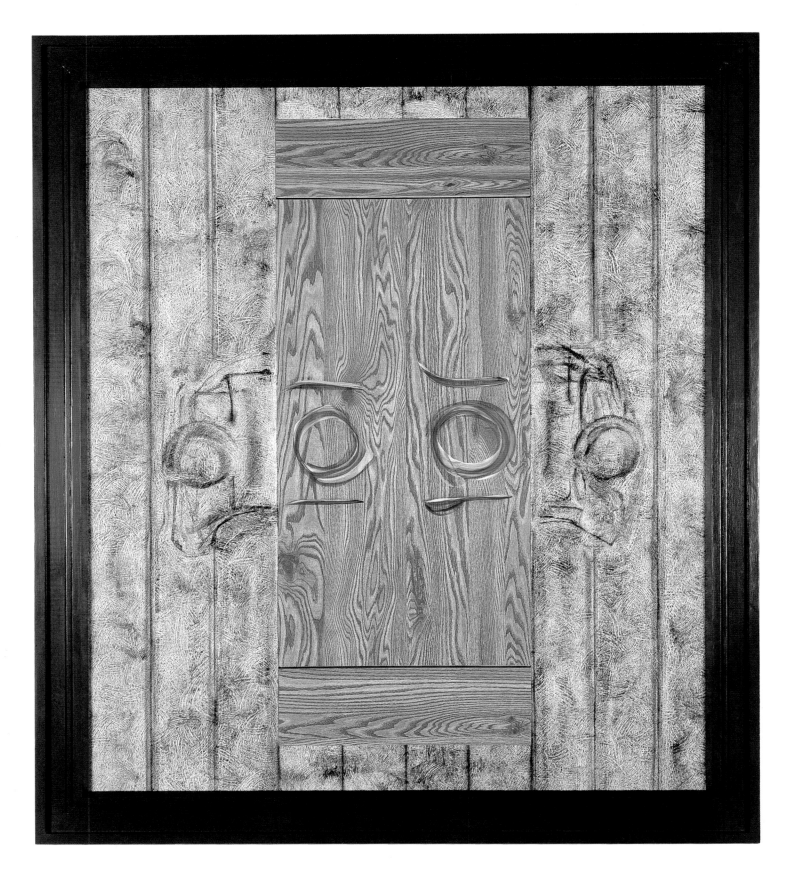

118
Two Diners, 1987
Formica and acrylic on celotex with painted wood frame,
91¾ x 79¼ x 5⅛ in. (233 x 201.3 x 13 cm)
Collection of Asher Edelman

Exhibitions and Selected Bibliography

Exhibitions are listed in chronological order; a bullet (•) denotes a one- or two-person exhibition. Catalogues are cited within the data on each exhibition, with reviews immediately following. Books and articles unrelated to exhibitions are listed at the end of each year.

1959 • Art Directions Gallery, New York. "Dick Artschwager and Richard Rutkowski." October 19–31.

> Judd, Donald. "Dick Artschwager and Richard Rutkowski." *Art News*, 58 (October 1959), p. 63.
>
> Tillim, Sidney. "Dick Artschwager, Richard Rutkowski." *Arts*, 34 (October 1959), p. 61.

1964 Dwan Gallery, Los Angeles. "Box Show." February 2–29.

> Factor, Donald. "Boxes." *Artforum*, 2 (April 1964), pp. 20–23.

Davison Arts Center, Wesleyan University, Middletown, Connecticut. "The New Art." March 1–22 (catalogue, with introduction by Lawrence Alloway).

Albright-Knox Art Gallery, Buffalo. "Light and Lively." April 10–May 3.

Leo Castelli Gallery, New York. "Group Exhibition: Artschwager, Christo, Hay, Watts." May 2–June 3.

> Campbell, Lawrence. "Richard Artschwager, Christo, Alex Hay and Robert Watts." *Art News*, 63 (Summer 1964), p. 15.
>
> Judd, Donald. "Four." *Arts Magazine*, 38 (September 1964), pp. 69–70.

Leo Castelli Gallery, New York. "Group Exhibition: Artschwager, Lichtenstein, Rosenquist, Stella, Warhol." September 16–October 22.

1965 • Leo Castelli Gallery, New York. "Artschwager." January 30 –February 24.

> Campbell, Lawrence. "Richard Artschwager." *Art News*, 64 (March 1965), p. 17.
>
> Judd, Donald. "Richard Artschwager." *Arts Magazine*, 39 (March 1965), p. 60.

The Pace Gallery, New York. "Beyond Realism." May 4–29 (catalogue, with essay by Michael Kirby).

McDevitt, Jan. "The Object: Still Life. Interviews with the New Object Makers, Richard Artschwager and Claes Oldenburg, on Craftsmanship, Art, and Function." *Craft Horizons*, 25 (September–October 1965), pp. 28–32, 54.

Rose, Barbara. "ABC Art." *Art in America*, 53 (October–November 1965), pp. 57–69.

1966 The Solomon R. Guggenheim Museum, New York. "The Photographic Image." January 12–February 13 (catalogue, with introduction by Lawrence Alloway).

> Pincus-Witten, Robert. "New York: The Photographic Image." *Artforum*, 43 (March 1966), pp. 47–50.

Whitney Museum of American Art, New York. "Contemporary American Sculpture: Selection I." April 5–May 15 (catalogue, with introduction by Lawrence Alloway).

The Jewish Museum, New York. "Primary Structures." April 27–June 12 (catalogue, with essay by Kynaston McShine).

Richard Bellamy/Noah Goldowsky Gallery, New York. "From Arp to Artschwager I." June 30–September 5.

William Rockhill Nelson Gallery and Atkins Museum of Fine Arts, Kansas City, Missouri. "Sound, Light, Silence: Art That Performs." November 4–December 4 (catalogue, with essay by Ralph T. Coe).

"Artschwager," Leo Castelli Gallery, New York, 1965

"Artschwager," Leo Castelli Gallery, New York, 1965 (*Expressionism and Impressionism* [1963] on wall at center).

Pincus-Witten, Robert. "Sound, Light and Silence in Kansas City." *Artforum*, 5 (January 1967), pp. 51–52.

Leo Castelli Gallery, New York. "Benefit Show for Experiments in Art and Technology Inc." December 6–10.

Whitney Museum of American Art, New York. "Annual Exhibition 1966: Contemporary Sculpture and Prints." December 6, 1966–February 5, 1967 (catalogue).

Lippard, Lucy R. *Pop Art*. New York: Frederick A. Praeger, 1966, pp. 136, 137.

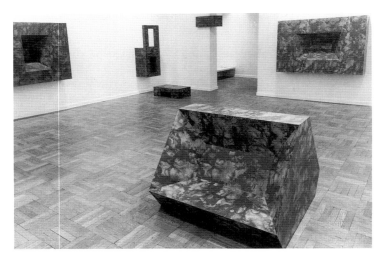

"Richard Artschwager," Leo Castelli Gallery, New York, 1967

1967 The Aldrich Museum of Contemporary Art, Ridgefield, Connecticut. "Cool Art—1967." January 7–March 17 (catalogue, with essay by Larry Aldrich).

Bianchini Gallery, New York. "Richard Artschwager/Joe Goode/Claes Oldenburg/Robert Watts/H.C. Westermann." January 14–February 4.

Richard Bellamy/Noah Goldowsky Gallery, New York. "Richard Artschwager: Myron Stout: Peter Young." Closed February 11.

> Benedikt, Michael. "Richard Artschwager, Myron Stout, and Peter Young." *Art News*, 65 (February 1967), p. 10.

Leo Castelli Gallery, New York. "Leo Castelli: Ten Years." February 4–16 (catalogue).

Kent State University School of Art Gallery, Kent, Ohio. "First Kent Invitational." February 12–March 10 (brochure, with essay by John A. Clowes).

Finch College Museum of Art, New York. "Art in Process." Opened March 9 (catalogue, with foreword by Elayne H. Varian).

Ithaca College Museum of Art, Ithaca, New York. "Selected New York Artists." April 4–May 27 (catalogue, with essay by Harris Rosenstein).

Galerie Ricke, Cologne, West Germany. "Programm 1." May–June.

Jones Hall Art Center, University of Saint Thomas, Houston. "Mixed Masters." May–September (catalogue, with essay by Kurt von Meier).

Vassar College Art Gallery, Poughkeepsie, New York. "Realism Now." May 8–June 12 (catalogue, with essay by Linda Nochlin).

York University Art Gallery, Toronto. "American Art of the Sixties in Toronto Private Collections." May 31–June 28.

Milwaukee Art Center. "Directions '68: Options." June 22–August 18 (catalogue, with essays by Lawrence Alloway and Tracy Atkinson). Traveled to Museum of Contemporary Art, Chicago.

Kassel, West Germany. "Documenta 4." June 27–October 6 (catalogue, with essays by Arnold Bode, Max Imdahl, and Jean Leering).

The Museum of Modern Art, New York. "The 1960s: Paintings and Sculptures from the Museum Collection." June 28–September 24.

Richard Bellamy/Noah Goldowsky Gallery, New York. "From Arp to Artschwager II." June 30–September 5.

> Siegel, Jeanne. "Arp to Artschwager." *Arts Magazine*, 42 (September–October 1967), p. 60.

Museum of Art, University of Oklahoma, Norman, and Oklahoma Art Center, Oklahoma City. "East Coast—West Coast Paintings." September 15–October 27 (catalogue). Traveled to Philbrook Art Center, Tulsa.

The University Art Gallery, Oakland University, Rochester, Michigan. "Personal Preferences: Paintings and Sculptures from the Collection of Mr. and Mrs. S. Brooks Barron." October 3–November 12.

• Leo Castelli Gallery, New York. "Richard Artschwager." December 30, 1967–January 23, 1968.

> Baker, Elizabeth C. "Artschwager's Mental Furniture." *Art News*, 66 (January 1968), pp. 48–49, 58–61.

> Battcock, Gregory. "Richard Artschwager." *Arts Magazine*, 42 (February 1968), p. 67.

> Canaday, John. "Art." *The New York Times*, January 6, 1968, Section 1, p. 25.

> Perreault, John. "The New-Old Look." *The Village Voice*, January 11, 1968, p. 18.

> Pincus-Witten, Robert. "Richard Artschwager, Castelli Gallery." *Artforum*, 6 (March 1968), pp. 58–59.

> Willard, Charlotte. "Richard Artschwager: Leo Castelli Gallery." *New York Post*, January 6, 1968, Magazine section, p. 14.

Artschwager, Richard. "The Hydraulic Door Check." *Arts Magazine*, 42 (November 1967), pp. 41–43.

1968 University of California, Davis. "Richard Artschwager." Spring.

- Galerie Konrad Fischer, Düsseldorf, West Germany. "Artschwager." June 18–July 9.

Richard Bellamy/Noah Goldowsky Gallery, New York. "From Arp to Artschwager III." June 30–September 5.

Whitney Museum of American Art, New York. "1968 Annual Exhibition: Contemporary American Sculpture." December 17, 1968–February 9, 1969 (catalogue).

> Pomeroy, Ralph. "New York: And Now, Anti-Museum Art?" *Art and Artists,* 3 (March 1969), pp. 58–60.

Battcock, Gregory, ed. *Minimal Art: A Critical Anthology.* New York: E.P. Dutton and Co., 1968, pp. 35, 64, 276–78, 294, 389, 410.

1969 Wallraf-Richartz-Museum and Museum Ludwig, Cologne, West Germany. "Kunst der sechziger Jahre: Sammlung Ludwig." Opened February 28 (catalogue, with essay by Evelyn Weiss).

Wide White Space Gallery, Antwerp, Belgium. "Young American Artists." March.

Neue Nationalgalerie, West Berlin. "Sammlung 1968 Karl Ströher." March 1–April 14 (catalogue, with essay by Hans Strelow and Jürgen Wissmann).

Cultural Center, New Jersey State Museum, Trenton. "Soft Art." March 1–April 27 (catalogue, with essay by Ralph Pomeroy).

Galerie Ricke, Cologne, West Germany. "6 Künstler: Artschwager, Bollinger, Buthe, Kuehn, Serra, Sonnier." March 12–April 29.

Kunsthalle Bern, Switzerland. "Live in Your Head. When Attitudes Become Form: Works—Concepts—Processes—Situations—Information." March 22–April 27 (catalogue, with essays by Scott Burton, Grégoire Muller, Harald Szeemann, and Tommaso Trini).

Indianapolis Museum of Art. "Painting and Sculpture Today: 1969." May 4–June 1 (catalogue, with foreword by Robert J. Rohn and introduction by Richard L. Warrum).

Milwaukee Art Center. "Directions 2: Aspects of a New Realism." June 21–August 10 (catalogue, with essay by John Lloyd Taylor). Traveled to Contemporary Arts Museum, Houston; Akron Art Institute, Ohio.

Hayward Gallery, London. "Pop Art Redefined." July 9–September 3 (catalogue, with introductions by Suzi Gablik and John Russell, and essays by Lawrence Alloway, John McHale, and Robert Rosenblum).

> Russell, John. "Pop Reappraised." *Art in America,* 57 (July–August 1969), pp. 78–89.

Seattle Art Museum. "557,087." September 5–October 5 (catalogue). Traveled, as "955,000," to Vancouver Art Gallery, British Columbia.

- Galerie Ricke, Cologne, West Germany. "Richard Artschwager." September 12–October 14.

Museum of Contemporary Art, Chicago. "Art by Telephone." November 1–December 14 (catalogue, with essay by Jan van der Marck).

The Jewish Museum, New York. "A Plastic Presence." November 19, 1969–January 4, 1970 (catalogue, with introduction by Tracy Atkinson). Traveled to Milwaukee Art Center; San Francisco Museum of Art.

Leo Castelli Gallery, New York. "Benefit Exhibition: Art for the Moratorium." December 11–13.

The Snite Museum of Art, University of Notre Dame, Indiana. "Erotic Art." 1969.

"Sculpture: Floating Wit." *Time,* 93 (January 3, 1969), p. 44.

1970
- Eugenia Butler Gallery, Los Angeles. "Richard Artschwager." March 24–April 11.

> Plagens, Peter. "Los Angeles: Richard Artschwager." *Artforum,* 8 (June 1970), pp. 89–90.

- Onnasch Galerie, West Berlin. "Richard Artschwager." April 1–30.

The Jewish Museum, New York. "Using Walls (Indoors)." May 12–June 21 (catalogue, with essay by Susan Tunarkin).

Museum of Contemporary Art, Chicago. "Radical Realism." May 22–June 4 (catalogue).

Galerie Ricke, Cologne, West Germany. "Programm III." June–September.

The Brooklyn Museum, New York. "Seventeenth National Print Exhibition." June 1–September 1 (catalogue).

The Museum of Modern Art, New York. "Information." July 2–September 20 (catalogue, with essay by Kynaston McShine).

> Battcock, Gregory. "Information Exhibition." *Arts Magazine,* 44 (Summer 1970), pp. 24–27.

> Kramer, Hilton. "Show at the Modern Raises Questions." *The New York Times,* July 2, 1970, Section 2, p. 26.

- Lo Guidice Gallery, Chicago. "New Paintings by Richard Artschwager." November 11–December 7.

University of Maryland Art Gallery, Baltimore. "Editions in Plastic." December 3, 1970–January 23, 1971 (catalogue, with essays by Marchal E. Landgren and Alan de Leiris).

Whitney Museum of American Art, New York. "1970 Annual Exhibition: Contemporary American Sculpture." December 12, 1970–February 7, 1971 (catalogue, with foreword by John I.H. Baur).

Neue Galerie der Stadt Aachen, West Germany. "Klischee und Antiklischee." 1970 (catalogue).

Amaya, Mario. "Collectors: Mr. and Mrs. Jack W. Glenn." *Art in America,* 58 (March–April 1970), pp. 86–89.

1971 • Park Sonsbeek, Arnhem/Utrecht, The Netherlands. "Sonsbeek Buiten de Perken." June 19–August 15 (catalogue, with Artschwager interview by Wouter Kotte).

Albright-Knox Art Gallery, Buffalo. "¿Kid Stuff?" July 25–September 6 (catalogue, with essays by William Burback, Charlotte B. Johnson, and Gordon M. Smith).

Karp, Ivan. "Rent Is the Only Reality or the Hotel Instead of the Hymn." *Arts Magazine,* 46 (December 1971–January 1972), pp. 47–51.

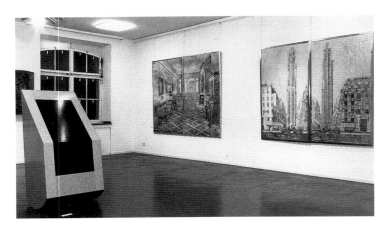

"Richard Artschwager," Galerie Ricke, Cologne, 1972

1972 Whitney Museum of American Art, New York. "1972 Annual Exhibition: Contemporary American Painting." January 25–March 19 (catalogue, with foreword by John I.H. Baur).

• Leo Castelli Gallery, New York. "Richard Artschwager: Paintings." April 1–15.

Battcock, Gregory. "New York." *Art and Artists,* 7 (June 1972), pp. 50–51.

Josephson, Mary. "Richard Artschwager at Castelli." *Art in America,* 60 (September–October 1972), pp. 116–17.

Kingsley, April. "Richard Artschwager." *Art News,* 71 (May 1972), p. 10.

Lubell, Ellen. "Richard Artschwager." *Arts Magazine,* 46 (May 1972), pp. 67–70.

Ratcliff, Carter. "New York Letter." *Art International,* 16 (Summer 1972), pp. 72–80.

Ente Manifestazioni Genovesi, Genoa, Italy. "Immagine per la Città." April 8–June 11 (catalogue, with essays by Gianfranco Bruno, Franco Sborgi, and Vittorio Fagone).

Galerie Ricke, Cologne, West Germany. "Zeichnungen." April 15–May 11.

Indianapolis Museum of Art. "Painting and Sculpture Today." April 26–June 4 (catalogue, with foreword by Carl J. Weinhardt, Jr., and introduction by Richard L. Warrum).

• Galerie Ricke, Cologne, West Germany. "Richard Artschwager: Neue Bilder." May 13–June 13.

Kassel, West Germany. "Documenta 5." June 30–October 8 (catalogue, with foreword by Harald Szeemann and essays by various authors).

Kerber, Bernhard. "Documenta und Szene Rhein-Ruhr." *Art International,* 16 (October 1972), pp. 68–77.

La Jolla Museum of Contemporary Art, California. "Dealer's Choice." July 15–August 31.

Madison Art Center, Wisconsin. "New American Abstract Paintings." October–November (catalogue).

Galerie des 4 Mouvements, Paris. "Hyperréalistes Américains." October 25–November 25 (catalogue, with essays by Daniel Abadie and Udo Kultermann).

Neue Galerie der Stadt Aachen, West Germany. "Kunst um 1970/Art around 1970." 1972 (catalogue, with essay by Wolfgang Becker).

1973 • Dunkelman Gallery, Toronto. "Richard Artschwager: Paintings." January 6–20.

Marshall, W. Neil. "Toronto Letter." *Art International,* 17 (Summer 1973), pp. 40–43.

• Museum of Contemporary Art, Chicago. "Richard Artschwager/Alan Shields." February 3–March 25 (catalogue, *Richard Artschwager,* with essay by Catherine Kord and Richard Artschwager).

Meadow Brook Art Gallery, Oakland University, Rochester, Michigan. "American Realism: Post Pop." February 18–March 25 (catalogue, with introduction by Henry Geldzahler).

Museum of Art, Rhode Island School of Design, Providence. "Selection III: Contemporary Graphics from the Museum Collection." April 5–May 6.

Leo Castelli Gallery, New York. "Group Exhibition: Artschwager, Chamberlain, Davis, Kelly, Lichtenstein, Morris, Owen, Rauschenberg, Rosenquist, Stella." June 23–September 22.

Kunstmuseum Luzern, Switzerland. "Ein grosses Jahrzehnt amerikanischer Kunst: Sammlung Peter Ludwig." July 15–September 16.

Galerie Arditti, Paris. "Hyperréalistes Américains." October 16–November 30 (catalogue, with introduction by Carroll Edward Hogan).

• Leo Castelli Gallery, New York. "Artschwager: Recent Paintings." November 17–December 8.

Collins, James, "Richard Artschwager, Castelli Gallery Uptown." *Artforum,* 12 (February 1974), pp. 74–76.

Derfner, Phyllis. "New York." *Art International,* 18 (January 1974), pp. 18–20.

Stitelman, Paul. "Richard Artschwager." *Arts Magazine,* 48 (January 1974), pp. 70–74.

Thomsen, Barbara. "Richard Artschwager." *Art News,* 73 (January 1974), pp. 89–90.

Cysach Gallery, Houston. "Drawings." December 11, 1973–January 8, 1974.

Paula Cooper Gallery, New York. "Drawings and Other Work." December 15, 1973–January 9, 1974.

Louisiana Museum, Humlebaek, Denmark. "Ekstrem Realisme." 1973 (catalogue).

Belocan, Andrea G., and Mendini, Francesco. "Il Componente al Bagno." *Casabella* (May 1973), pp. 14–16.

Lippard, Lucy R. *Six Years: The Dematerialization of the Art Object from 1966 to 1972.* New York: Praeger Publishers, 1973), pp. 31–32.

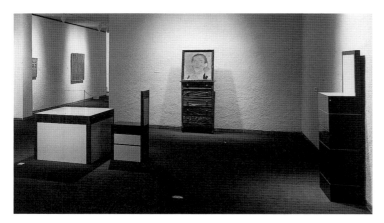

"American Pop Art," Whitney Museum of American Art, New York, 1974

1974 Leo Castelli Gallery, New York. "Group Drawing Exhibition: Artschwager, Bontecou, Chamberlain, Daphnis, Darboven, Davis, Flavin, Huebler, Johns, Judd, Kelly, Lichtenstein, Morris, Nauman, Oldenburg, Owen, Rauschenberg, Rosenquist, Ruscha, Serra, Stella, Twombly." February 16–March 2.

Whitney Museum of American Art, New York. "American Pop Art." April 6–June 16 (catalogue, with essay by Lawrence Alloway).

　　　Derfner, Phyllis. "New York Letter." *Art International,* 18 (Summer 1974), pp. 46–51.

　　　Perreault, John. "Classic Pop Revisited." *Art in America,* 62 (March–April 1974), pp. 64–68.

• Daniel Weinberg Gallery, San Francisco. "Richard Artschwager: Recent Paintings." May 2–29.

Prints on Prince Street, New York. "Works by Richard Artschwager, Joel Shapiro, Joe Zucker." June 1–15.

Leo Castelli Gallery, New York. "In Three Dimensions." September 21–October 12.

• Galerie Ileana Sonnabend, Geneva. "Richard Artschwager." October 1–31. Traveled.

Sable-Castelli Gallery, Toronto. "An Exhibition of Works on Paper." December 7–31.

Lunds Konsthall, Lund, Sweden. "Amerikansk Realism." 1974 (catalogue).

Kerber, Bernhard. "Richard Artschwager." *Kunstforum International* (January 1974), pp. 124–31.

1975 • Leo Castelli Gallery, New York. "Artschwager: Door, Window, Table, Basket, Mirror, Rug." March 15–29.

　　　Russell, John. "Art." *The New York Times,* March 22, 1975, p. 26.

　　　Smith, Roberta. "Richard Artschwager." *Artforum,* 13 (Summer 1975), p. 74.

　　　Zimmer, William. "Richard Artschwager." *Arts Magazine,* 49 (June 1975), pp. 7–10.

Städtisches Museum Leverkusen, Schloss Morsbroich, West Germany. "Zeichnungen 3 USA." May–June.

• Jared Sable Gallery, Toronto. "Richard Artschwager." May 24–June 14.

Leo Castelli Gallery, New York. "Group Exhibition: Artschwager, Chamberlain, Darboven, Grisi, Huebler, Judd, Kelly, Kosuth, Lichtenstein, Morris, Nauman, Owen, Rauschenberg, Rosenquist, Warhol." June 7–September 5.

• Galerie Neuendorf, Hamburg, West Germany. "Richard Artschwager." August 1–30.

Bykert Gallery, New York. "Richard Artschwager, Robert Gordon, John Torreano, Joe Zucker." September 13–27.

　　　Lorber, Richard. "Group Show." *Arts Magazine,* 50 (December 1975), pp. 22–25.

Texas Gallery, Houston. "A Group Show Selected by Klaus Kertess." September 15–October 11.

Institute of Contemporary Art of the University of Pennsylvania, Philadelphia. "Painting, Sculpture and Drawing of the 60's and 70's from the Dorothy and Herbert Vogel Collection." October 7–November 18 (catalogue, with foreword by Suzanne Delehanty). Traveled to Contemporary Arts Center, Cincinnati.

Brooke Alexander Gallery, New York. "Works on Paper." October 25–November 22.

Fine Arts Gallery, State University of New York, College at Oneonta. "Some Local Painters." November 20–December 17.

• Daniel Weinberg Gallery, San Francisco. "Richard Artschwager Drawings." December 6, 1975–January 10, 1976.

　　　Albright, Thomas. "Hanging around Galleries." *San Francisco Chronicle,* January 3, 1970, p. 30.

•Galerie Charles Kirwin, Brussels. "Aspects de l'Art Américain." 1975.

Galleria dell'Ariete, Milan. "Revisione 1." 1975.

Musée d'Ixelles, Brussels. "Je/Nous." 1975.

Alloway, Lawrence. *Topics in American Art Since 1945.* New York: W.W. Norton and Company, 1975, pp. 185–86, 189.

1976 • Walter Kelly Gallery, Chicago. "Ten Years of the Black Spot." January 9–February 11.

> Morrison, C.L. "Chicago: Richard Artschwager, Walter Kelly Gallery." *Artforum,* 14 (April 1976), pp. 78–79.

Zolla/Lieberman Gallery, Chicago. "Inaugural Exhibition." March 12–April 20.

Sable-Castelli Gallery, Toronto. "Survey—Part II." March 13–April 3.

Whitney Museum of American Art, New York. "200 Years of American Sculpture." March 16–December 26 (catalogue, with essays by Tom Armstrong, Wayne Craven, Norman Feder, Barbara Haskell, Rosalind E. Krauss, Daniel Robbins, and Marcia Tucker).

Fine Arts Center Gallery, University of Massachusetts, Amherst. "Critical Perspectives in American Art." April 10–May 9 (catalogue, with essays by Hugh M. Davies, Sam Hunter, Rosalind Krauss, and Marcia Tucker).

Leo Castelli Gallery, New York. "300 Artists to Support the N.Y. Studio School." April 22–24 (brochure, with foreword by Andrew Forge).

P. S. 1, Institute for Art and Urban Resources, Long Island City, New York. "Rooms." June 9–26 (catalogue, with essay by Alanna Heiss).

> Foote, Nancy. "The Apotheosis of the Crummy Space." *Artforum,* 15 (October 1976), pp. 28–37.

Leo Castelli Gallery, New York. "Group Exhibition: Artschwager, Chamberlain, Daphnis, Dibbets, Flavin, Judd, Kelly, Lichtenstein, Morris, Nauman, Noland, Oldenburg, Owen, Rauschenberg, Serra, Stella, Weiner." June 19–September 10.

Venice, Italy. "37th Venice Biennale." July 14–October 10 (catalogue, with essays by various authors).

> Martin, Henry. "The 37th Venice Biennale." *Art International,* 20 (September 1976), pp. 14–24, 59.

Daniel Weinberg Gallery, San Francisco. "Richard Artschwager, Chuck Close, Joe Zucker." September 14–October 22 (catalogue, with essay by Catherine Kord). Traveled to La Jolla Museum of Contemporary Art, California; University of California, Davis.

> Beamguard, Bud. "Close, Zucker, Artschwager." *Artweek,* October 2, 1976, pp. 1, back cover.

• Castelli Graphics, New York. "Richard Artschwager." November 6–27.

Frackman, Noel. "Richard Artschwager." *Arts Magazine,* 51 (January 1977), pp. 24–29.

Artschwager, Richard, and Catherine Kord. *Basket Table Door Window Mirror Rug.* New York: Terry Printing, 1976.

1977 • Sable-Castelli Gallery, Toronto. "Richard Artschwager." January 8–22.

The Art Institute of Chicago. "Society for Contemporary Art 35th Exhibition: Drawings of the 70's." March 12–April 24 (brochure, with foreword by Harold Joachim).

Institute of Contemporary Art of the University of Pennsylvania, Philadelphia. "Improbable Furniture." March 10–April 10 (catalogue, with essays by Suzanne Delehanty and Robert Pincus-Witten). Traveled to La Jolla Museum of Contemporary Art, California.

Margo Leavin Gallery, Los Angeles. "Fine Paintings and Drawings." April 20–May 14.

Multiples, New York. "Group Exhibition." May.

> Schwartz, Ellen. "Richard Artschwager." *Art News,* 76 (September 1977), pp. 100–01.

Renaissance Society at the University of Chicago. "Ideas in Sculpture 1865–1977." May 1–June 1.

Archer M. Huntington Galleries, Art Museum, University of Texas at Austin. "New in the Seventies." August 21–September 25 (catalogue).

Brooke Alexander Gallery, New York. "Selected Prints 1960–1977." September 7–October 2 (catalogue).

Museum of Contemporary Art, Chicago. "A View of a Decade." September 10–November 11 (catalogue, with essays by Martin Friedman, Peter Gay, and Robert Pincus-Witten).

Thorpe Intermedia Gallery, Sparkill, New York. "Outside the City Limits: Landscape by New York Artists." October 16–November 13 (catalogue, with introduction by Lola B. Gellman and essay by John Perreault).

Madison Art Center, Wisconsin. "Works on Paper by Contemporary American Artists." December 4, 1977–January 15, 1978.

Sculpture Now Gallery, New York. "Cornell Then, Sculpture Now." December 5, 1977–January 15, 1978 (catalogue, with foreword by Thomas W. Leavitt and essay by Robert Hobbs). Traveled to Herbert F. Johnson Museum, Cornell University, Ithaca, New York.

La Jolla Museum of Contemporary Art, California. "Recent Acquisitions: Selected Works 1974–1977." December 9, 1977–January 15, 1978.

Worcester Art Museum, Massachusetts. "For Collectors 1977." December 10, 1977–January 8, 1978.

Sultan, Donald, and Nancy Davidson, eds. *Name Book I: Statements on Art.* Chicago: N.A.M.E. Gallery, 1977, pp. 15–24.

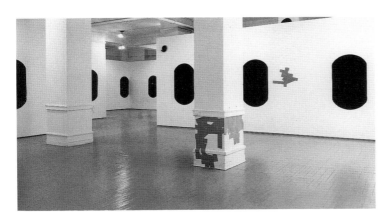
"Richard Artschwager," The Clocktower, New York, 1978

1978 • Castelli Graphics, New York. "Richard Artschwager: Drawings." January 14–February 4.

> Frackman, Noel. "Richard Artschwager/Mary Ellen Mark." *Arts Magazine,* 52 (April 1978), pp. 31–32.

Daniel Weinberg Gallery, San Francisco. "Up Against the Wall." January 28–February 25.

Paula Cooper Gallery, New York. "A Changing Group Exhibition." January 28–March 4.

• Texas Gallery, Houston. "Richard Artschwager." February 14–March 11.

Multiples/Marian Goodman Gallery, New York. "Objects." February 25–April 1.

Mead Art Gallery, Amherst College, Massachusetts. "New York Now." March 9–April 12.

Galerie Gillespie-de Laage, Paris. April.

• The Clocktower, Institute for Art and Urban Resources, New York. "Richard Artschwager." April 5–29.

> Frank, Peter. "New York Reviews: Richard Artschwager." *Art News,* 77 (October 1978), pp. 173–84.

> Glueck, Grace. "Art People." *The New York Times,* April 14, 1978, Section C, p. 19.

• Morgan Gallery, Shawnee Mission, Kansas. "Richard Artschwager: Paintings and Drawings." April 7–29.

The Museum of Modern Art, New York. "Selections from the Collection." May 25–August 9.

Northpark National Bank, Dallas. "Leo Castelli Gallery at Northpark National Bank." June 15–August 15.

• Kunstverein Hamburg, West Germany. "Zu Gast in Hamburg—Richard Artschwager." September 14–October 22 (catalogue, with essay by Catherine Kord). Traveled to Neue Galerie-Sammlung Ludwig, Aachen, West Germany.

> Winter, P. "Kunstverein in Hamburg; Neue Galerie, Aachen; Ausstellungen." *Kunstwerk,* 31 (December 1978), pp. 64–65.

Bodley Gallery, New York. "Art Begins with A." October 14–November 11.

Albright-Knox Art Gallery, Buffalo. "American Paintings of the 1970s." December 8, 1978–January 14, 1979 (catalogue, with essay by Linda L. Cathcart). Traveled to Newport Harbor Art Museum, Newport Beach, California; The Oakland Museum, California; Cincinnati Art Museum; Art Museum of South Texas, Corpus Christi; Krannert Art Museum, University of Illinois, Champaign.

Mary Boone Gallery, New York. "Drawing Show." December 16, 1978–January 11, 1979.

> Welish, Marjorie. "The Elastic Vision of Richard Artschwager." *Art in America,* 66 (May–June 1978), pp. 85–87.

1979 Leo Castelli Gallery, New York. "Drawings by Castelli Artists." March 3–24.

Aspen Center for the Visual Arts, Colorado. "American Portraits of the Sixties and Seventies." June–August.

• Albright-Knox Art Gallery, Buffalo. "Richard Artschwager's Theme(s)." July 6–August 12 (catalogue, with essays by Richard Armstrong, Linda L. Cathcart, and Suzanne Delehanty). Traveled to Institute of Contemporary Art of the University of Pennsylvania, Philadelphia; La Jolla Museum of Contemporary Art, California; Contemporary Arts Museum, Houston.

> Donohue, Victoria. "The Tide Turns for an Eccentric." *Philadelphia Inquirer,* November 19, 1979, p. K12.

> Kalil, S. "Artschwager's Wonderland—Contemporary Arts Museum, Houston; Traveling Exhibit." *Artweek,* 11 (April 19, 1980), p. 1.

> Smith, Roberta. "The Artschwager Enigma." *Art in America,* 67 (October 1979), pp. 93–95.

Texas Gallery, Houston. "From Allen to Zucker." August 17–September 28.

• Leo Castelli Gallery, New York. "A Survey of Sculpture and Paintings from the 60s and 70s." September 22–October 13.

> Russell, John. "Art." *The New York Times,* October 5, 1979, p. 21.

Hayden Gallery, Massachusetts Institute of Technology, Cambridge. "Corners." September 29–November 4.

Sunne Savage Gallery, Boston. "Thirty Years of Box Construction." November 2–30.

University of Hartford, Connecticut. "Imitations of Life." November 6–28.

• Asher/Faure Gallery, Los Angeles. "Richard Artschwager." November 17–December 15.

> Armstrong, Richard. "Asher/Faure Gallery, Los Angeles, Exhibition." *Flash Art,* nos. 96–97 (March–April 1980), p. 30.

Neue Galerie-Sammlung Ludwig, Aachen, West Germany, 1979.

Bleckner, Ross. "Transcendent Anti-Fetishism." *Artforum,* 17 (March 1979), pp. 50–55.

1980 Joe and Emily Lowe Art Gallery, Syracuse University, New York. "Current/New York." January 27–February 24.

Bell Gallery, Brown University, Providence, Rhode Island. "Brown Invitational Exhibition." February 1–24.

Neuberger Museum, State University of New York at Purchase. "Hidden Desires." March 9–June 15.

• Museum of Art, Rhode Island School of Design, Providence. "Sculpture by Richard Artschwager." March 11–April 6.

> Tolnick, Judith. "Richard Artschwager." *Art New England,* 1 (April 1980), n.p.

• Daniel Weinberg Gallery, San Francisco. "Richard Artschwager." Opened May 13.

The Museum of Modern Art, New York. "Contemporary Sculpture: Selections from the Museum of Modern Art." May 18–August 7.

Venice, Italy. "39th Venice Biennale." June 1–September 30. (catalogue, with essays by various authors).

Castelli Graphics, New York. "Master Prints by Castelli Artists." June 7–28.

Galerie Ricke, Cologne, West Germany. "Die ausgestellten Arbeiten sind zwischen 1966 und 1972 entstanden." July 8–September 17.

Kunsthaus, Zurich. "Reliefs." August 22–November 2. Traveled to Westfälisches Landesmuseum, Münster, West Germany.

Institute of Contemporary Art of the University of Pennsylvania, Philadelphia. "Drawings: The Pluralist Decade." October 4–November 9.

Amelie A. Wallace Gallery, State University of New York, Old Westbury. "Pedagogical Exhibition: Images, Objects, Ideas." October 13–November 6.

The Brooklyn Museum, New York. "American Drawing in Black and White: 1970–1980." November 2, 1980–January 18, 1981.

Art Latitude Gallery, New York. "The Image Transformed." November 4–29.

Castelli Graphics, New York. "Amalgam." November 22–December 20.

Joe and Emily Lowe Art Gallery, Syracuse University, New York. "All in a Line." November 23, 1980–January 18, 1981.

Leo Castelli Gallery, New York. "Drawings to Benefit the Foundation for Contemporary Performance Arts, Inc." November 29–December 12.

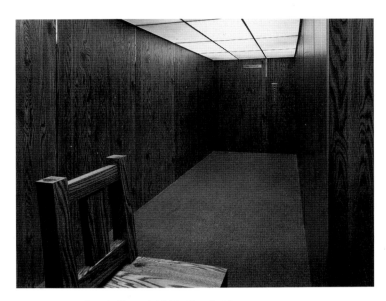

"Rooms," Hayden Gallery, M.I.T., Cambridge, 1981

1981 Metro Pictures, New York. "Paintings." January 9–30.

Hayden Gallery, Massachusetts Institute of Technology, Cambridge. "Rooms: Installations by Richard Artschwager, Cynthia Carlson, Richard Haas." January 17–March 1.

> Taylor, Robert. "Other Voices, Other Rooms." *Boston Sunday Globe,* February 8, 1981, p. B13.

Neil Ovsey Gallery, Los Angeles. "Selections from Castelli: Drawings and Works on Paper." January 18–February 21.

• Young/Hoffman Gallery, Chicago. "Richard Artschwager: Paintings and Objects from 1962–1979." February 8–March 4.

P.S. 1, Institute for Art and Urban Resources, Long Island City, New York. "Eight Funny Artists: Wit and Irony in Art." April 26–June 14.

Galerie Gillespie-de Laage-Salomon. "Trois Dimensions—Sept Américains." April 28–May 2.

The Aldrich Museum of Contemporary Art, Ridgefield, Connecticut. "The New Dimensions in Drawing." May 3–September 6.

Rosa Esman Gallery, New York. "Architecture by Artists." May 27–June 27.

Cologne, West Germany. "Internationale Ausstellung Köln 1981." May 30–August 16.

Galerie Ricke, Cologne, West Germany. "Neunzehnhundert-achtundsechzig." July 10–September 10.

Margo Leavin Gallery, Los Angeles. "Cast, Carved, and Constructed." August 1–September 19.

Kunsthalle Basel, Switzerland. "Amerikanische Zeichnungen siebziger Jahre." October 3–November 15.

Sewell Art Gallery, Rice University, Houston. "Variants: Drawings by Contemporary Sculptors." November 2–

December 12. Traveled to Art Museum of South Texas, Corpus Christi; High Museum of Art, Atlanta.

Quay Gallery, San Francisco. "Sculptor's Works on Paper." November 3–28.

• Leo Castelli Gallery, New York. "Richard Artschwager." November 14–December 19.

 Cavaliere, Barbara. "Richard Artschwager." *Arts Magazine,* 56 (February 1982), p. 17.

 Smith, V. "Leo Castelli Gallery, New York: Exhibit." *Flash Art,* no. 105 (December 1981–January 1982), p. 57.

Landfall Gallery, Chicago. "Possibly Overlooked Publications." November 20, 1981–January 16, 1982.

Harm Bouckaert Gallery, New York. "Drawing Invitational." December 2, 1981–January 2, 1982.

 Vernet, G. "Drawing Invitational 1981." *Arts Magazine,* 56 (February 1982), p. 25.

• Van Buren/Brazelton/Cutting Gallery, Cambridge, Massachusetts. "Richard Artschwager." December 16, 1981–January 24, 1982.

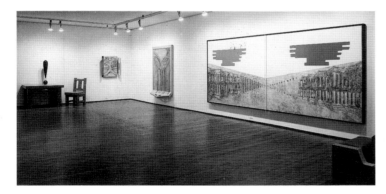

"Richard Artschwager," Leo Castelli Gallery, New York, 1981

1982 Aspen Center for the Visual Arts, Colorado. "Castelli and His Artists: 25 Years." April 23–June 6. Traveled to La Jolla Museum of Contemporary Art, California; Leo Castelli Gallery, New York; Portland Center for the Visual Arts, Oregon; Laguna Gloria Art Museum, Austin, Texas.

Kassel, West Germany. "Documenta 7." June 19–September 28 (catalogue, with foreword by R.H. Fuchs and essays by Coosje van Bruggen, Germano Celant, Johannes Gachnang, and Gerhard Stoyck).

Margo Leavin Gallery, Los Angeles. "Works in Wood." July 10–September 11.

Avery Center for the Arts, Bard College, Annandale-on-Hudson, New York. "The Rebounding Surfaces." August 15–September 24.

The Aldrich Museum of Contemporary Art, Ridgefield, Connecticut. "Postminimalism." September 19–December 19.

University of California, Davis. "Sculptors at UC Davis: Past and Present." September 20–October 29.

Joe and Emily Lowe Art Gallery, Syracuse University, New York. "Outside New York City: Drawing to Sculpture." September 26–October 31.

• Susanne Hilberry Gallery, Birmingham, Michigan. "Richard Artschwager: New Work." November 13–December 31.

Pratt Graphics Center, New York. "The Destroyed Print." November 15–December 11.

Barbara Gladstone Gallery, New York. "Cruciform." December 7, 1982–January 8, 1983.

1983 Ronald Feldman Fine Arts, New York. "1984—A Preview." January 26–March 12.

Castelli Graphics, New York. "Black and White: A Print Survey." January 29–February 26.

Daniel Weinberg Gallery, Los Angeles. "Drawing Conclusions—A Survey of American Drawings: 1958–1983." January 29–February 26.

Multiples/Marian Goodman Gallery, New York. "An Exhibition of Small Paintings, Drawings, Sculptures, and Photographs." February 10–March 5.

Pratt Graphics Center, New York. "From the Beginning." February 18–March 24.

• Mary Boone Gallery, New York. "Richard Artschwager." March 5–26.

 Glueck, Grace. "Art." *The New York Times,* March 18, 1983, p. 10.

 Kuspit, Donald B. "Richard Artschwager at Mary Boone." *Art in America,* 71 (September 1983), pp. 171–72.

Baskerville + Watson, New York. "Borrowed Time." March 9–April 9.

The Clocktower, Institute for Art and Urban Resources, New York. "Habitats." March 9–April 9.

Institute of Contemporary Art of the University of Pennsylvania, Philadelphia. "Connections—Bridges, Ladders, Ramps, Staircases, Tunnels." March 11–April 24 (catalogue, with essay by Janet Kardon).

Museum of Art, Rhode Island School of Design, Providence. "Furniture, Furnishing: Subject and Object." March 12–June 27 (catalogue, with essay by Judith Hoos Fox).

Freedman Gallery, Albright College, Reading, Pennsylvania. "Day In/Day Out: Ordinary Life as a Source of Art." March 14–April 17.

Whitney Museum of American Art, New York. "1983 Biennial Exhibition." March 23–May 23 (catalogue, with introduction by Barbara Haskell, Richard Marshall, and Patterson Sims).

Ashbery, John. "Biennials Bloom in the Spring." *Newsweek*, April 18, 1983, pp. 93–94.

Levin, Kim. "Double Takes." *The Village Voice*, April 26, 1983, pp. 91–92, 108.

Smith, Roberta. "Taking Consensus." *The Village Voice*, April 26, 1983, pp. 91–92.

Museum of Contemporary Art, Chicago. "10 Years of Collecting at the Museum of Contemporary Art." April 14–June 10.

• Daniel Weinberg Gallery, Los Angeles. "Richard Artschwager." June 16–July 16.

The Parrish Art Museum, Southampton, New York. "The Painterly Figure." July 14–September 4 (catalogue, with essay by Klaus Kertess).

Daniel Weinberg Gallery, Los Angeles. "Group Show." September 1–October 8.

The Tate Gallery, London. "New Art." September 14–October 23 (catalogue, with foreword by Alan Bowness and essay by Michael Compton).

Mathews Hamilton Gallery, Philadelphia. "19th and 20th Century Fine Art." Opened September 23.

Susanne Hilberry Gallery, Birmingham, Michigan. "Drawings." October 22–November 29.

Grey Art Gallery and Study Center, New York University. "The Permanent Collection: Highlights and Recent Acquisitions." December 12, 1983–January 2, 1984.

Smith, Roberta, "Expression with the Ism." *The Village Voice*, March 29, 1983, p. 81.

Van Bruggen, Coosje. "Richard Artschwager." *Artforum*, 22 (September 1983), pp. 44–51.

1984 Tanja Grunert/Regine Tafel, Stuttgart, West Germany. "Idea." March 9–April 30.

Donald Young Gallery, Chicago. "American Sculpture." April 28–June 2.

Fuller Goldeen Gallery, San Francisco. "50 Artists/50 States." July 11–August 25.

Margo Leavin Gallery, Los Angeles. "American Sculpture." July 17–September 15.

Daniel Weinberg Gallery, Los Angeles. "Richard Artschwager, John Chamberlain, Donald Judd." July 25–August 25.

Harm Bouckaert Gallery, New York. "Synthetic Art: The Big Show." September 6–October 6.

Paula Cooper Gallery, New York. "A Changing Group Exhibition." September 8–29.

First Street Forum, St. Louis. "Familiar Forms/Unfamiliar Furniture." September 19–November 10 (catalogue, with essay by Emily Rauh Pulitzer).

Visual Arts Gallery, Florida International University, Miami. "Sculptors' Drawings 1910–1980: Selections from the Permanent Collection (of the Whitney Museum of American Art, New York)." September 21–October 17 (brochure, with essay by Paul Cummings). Traveled to Aspen Art Museum, Colorado; Art Museum of South Texas, Corpus Christi; Philbrook Art Center, Tulsa, Oklahoma.

Hirshhorn Museum and Sculpture Garden, Smithsonian Institution, Washington, D.C. "Content: A Contemporary Focus, 1974–1984." October 4, 1984–January 6, 1985 (catalogue, with essays by Howard Fox, Miranda McClintic, and Phyllis Rosenzweig).

Barbara Toll Fine Arts, New York. "Drawings." December 6–22.

• Matrix Gallery, University Art Museum, University of California, Berkeley. "Richard Artschwager/Matrix 82." December 15, 1984–February 15, 1985 (brochure, with introduction by Connie Lewallen).

Musée Nationale d'Art Moderne, Centre Georges Pompidou, Paris. "Alibis." 1984.

Ammann, Jean-Christophe. "Richard Artschwager." In *Art of Our Time: The Saatchi Collection*. London: Lund Humphries Publishers, 1984, II, pp. 9–11.

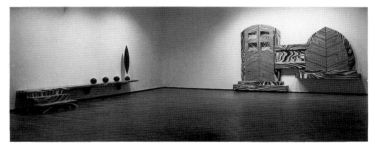

"Richard Artschwager," Leo Castelli Gallery, New York, 1985

1985 Susanne Hilberry Gallery, Birmingham, Michigan. "Figurative Sculpture." January 29–February 28.

International With Monument, New York. "Group Exhibition." February 1–28.

• Leo Castelli Gallery, New York. "Richard Artschwager." February 2–23.

Tazzi, P.L. "Leo Castelli Gallery, New York: Exhibit." *Artforum*, 23 (Summer 1985), p. 108.

Whitney Museum of American Art at Philip Morris, New York. "The Box Transformed." February 15–April 25 (brochure).

Edith C. Blum Art Institute, Bard College, Annandale-on-Hudson, New York. "The Maximal Implications of the Minimal Line." March 24–April 28.

Galerie Ghislaine Hussenot, Paris. March 29–May 2.

Larry Gagosian Gallery, Los Angeles. "60s Color." April 16–May 11.

Museum of Contemporary Art, Chicago. "Selections from the William J. Hokin Collection." April 20–June 16.

Donald Young Gallery, Chicago. "Artschwager, Judd, Nauman: 1965–1985." May 7–June 15.

Brooke Alexander Gallery, New York. "Drawing: Paintings and Sculpture." May 29–June 29.

Mary Boone Gallery/Michael Werner Gallery, New York. "B.A.M. Benefit." June 1–29.

Daniel Weinberg Gallery, Los Angeles. "Now and Then: A Selection of Recent and Earlier Paintings." June 1–August 31.

Whitney Museum of American Art, New York. "Drawing Acquisitions, 1981–85." June 11–September 22 (catalogue, with essay by Paul Cummings).

Whitney Museum of American Art, Fairfield County, Stamford, Connecticut. "Affiliations: Recent Sculpture and Its Antecedents." June 28–August 24 (brochure).

• Kunsthalle Basel, Switzerland. "Richard Artschwager." October 6–November 10 (catalogue, with essay by Jean-Christophe Ammann). Traveled to Stedelijk van Abbemuseum, Eindhoven, The Netherlands, and CAPC, Musée d'Art Contemporain de Bordeaux, France.

> Dienst, R.G. "Kunsthalle Basel; Stedelijk van Abbemuseum Eindhoven; Musée d'Art Contemporain de Bordeaux, Exhibits." *Kunstwerk*, 39 (February 1986), pp. 69–70.

Holly Solomon Gallery, New York. "Paintings, Sculpture, and Furnishings." December 5–31.

• Daniel Weinberg Gallery, Los Angeles. "Richard Artschwager." November 5–29.

Larry Gagosian Gallery, Los Angeles. "Actual Size." September 24–October 16.

Yau, John. "Richard Artschwager's Linear Investigations." *Drawing*, 11 (January–February 1985).

1986 Museum of Art, Fort Lauderdale, Florida. "An American Renaissance: Paintings and Sculpture Since 1940." January 12–March 30 (catalogue, with essays by Malcolm R. Daniel, Harry F. Gaugh, and Sam Hunter).

Donald Young Gallery, Chicago. "Recent Acquisitions." January 31–February 28.

Daniel Weinberg Gallery, Los Angeles. "Objects from the Modern World." February 18–March 3.

Bell Gallery, Brown University, Providence, Rhode Island. "Definitive Statements: American Art 1964–66." March 1–30. Traveled to The Parrish Art Museum, Southampton, New York.

Donald Young Gallery, Chicago. "Works on Paper." March 7–April 26.

Kent Fine Art, Inc., New York. "Reality Remade." March 15–April 19 (catalogue).

Whitechapel Art Gallery, London. "The Painter-Sculptor in the Twentieth Century." March 27–May 25.

Whitney Museum of American Art, New York. "Sacred Images in Secular Art." May 1–July 13 (brochure).

Marian Goodman Gallery, New York. "Sculpture Show." June 5–28.

Pat Hearn Gallery, New York. "Drawings." June 20–July 22.

Althea Viafora Gallery, New York. "Works on Paper." July 1–31.

Harm Bouckaert Gallery, New York. "Richard Artschwager, Alan Saret, and Pat Steir." September 11–October 11.

Bess Cutler Gallery, New York. "When Attitudes Become Form." September 13–October 15.

• Mary Boone Gallery/Michael Werner Gallery, New York. "Richard Artschwager." October 4–25.

Kent Fine Art, Inc., New York. "American Myths." October 9–November 11 (catalogue).

• Daniel Weinberg Gallery, Los Angeles. "Richard Artschwager: Recent Paintings." November 5–29.

Thomas Segal Gallery, Boston. "Salute to Leo Castelli." November 19–January 5.

Brooke Alexander Gallery, New York. "Benefit for The Kitchen." December 9–20.

Loughelton Gallery, New York. "Greenberg's Dilemma." December 13, 1986–January 11, 1987.

1987 Pat Hearn Gallery, New York. "Group Show: Ti Shan Hsu, John Armleder and Richard Artschwager." January 3–February 1.

Barbara Toll Fine Arts, New York. "Monsters: The Phenomena of Dispassion." January 17–February 7.

Michael Kohn Gallery, Los Angeles. "The Great Drawing Show 1587–1987." February 13–March 26.

Leo Castelli Gallery, New York. "Artschwager, Nauman, Stella." May 17–July 31.

Mary Boone Gallery/Michael Werner Gallery, New York. "Benefit for the Armitage Ballet." June 6–27.

Marian Goodman Gallery, New York. "A Sculpture Show." June 9–August 14.

Kassel, West Germany, "Documenta 8." June 14–September 17 (catalogue, with introduction by Manfred Schneckenburger and essays by various authors).

Westfälisches Landesmuseum, Münster. "Skulptur Projekte in 1987, Münster." June 14–October 4 (catalogue, with preface by Klaus Bussmann and Kasper König, and introduction by Georg Jappe).

Works in the Exhibition

The following works are being shown at the Whitney Museum of American Art. Dimensions are in inches, followed by centimeters; height precedes width precedes depth.

Sculptures

Handle, 1962
Wood,
30 x 48 x 4 (76.2 x 121.9 x 10.2)
Collection of Kasper König

Portrait I, 1962
Acrylic on wood and celotex,
74 x 26 x 12 (188 x 66 x 30.5)
Collection of Kasper König

Table and Chair, 1962–63
Acrylic on wood, two parts: table,
29½ x 23¾ x 16½ (74.9 x 60.3 x 41.9);
chair, 37 x 17¾ x 20¼ (94 x 45.1 x 51.4)
Collection of Paula Cooper

Chair, 1963
Formica on wood,
37 x 20 x 22 (94 x 50.8 x 55.9)
Collection of Mr. and Mrs. S. Brooks Barron

Portrait II, 1963
Formica on wood,
68 x 26 x 13 (172.7 x 66 x 33)
Private collection

Description of Table, 1964
Formica on wood,
26¼ x 32 x 32 (66.7 x 81.3 x 81.3)
Whitney Museum of American Art, New York;
Gift of the Howard and Jean Lipman
Foundation, Inc. 66.48

Long Table with Two Pictures, 1964
Formica on wood and acrylic on celotex with
wood frames, three parts: table,
33¾ x 96 x 22¼ (85.7 x 243.8 x 56.5);
two pictures, 42 x 32¼ (106.7 x 81.9) each
Saatchi Collection, London

Mirror/Mirror—Table/Table, 1964
Formica on wood, four parts: two mirrors,
37 x 25 x 5 (94 x 63.5 x 12.7) each;
two tables, 24 x 25 x 30 (61 x 63.5 x 76.2) each
The Museum of Contemporary Art, Los Angeles;
The Barry Lowen Collection

Table with Pink Tablecloth, 1964
Formica on wood,
25½ x 44 x 44 (64.8 x 111.8 x 111.8)
Saatchi Collection, London

Triptych II, 1964
Formica on wood,
40 x 92 x 6 (101.6 x 233.7 x 15.2)
Kent Fine Art, Inc., New York

Piano, 1965
Formica on wood,
32 x 48 x 19 (81.3 x 121.9 x 48.3)
Collection of Edward R. Downe, Jr.

Piano II, 1965–79
Formica on wood with rubberized hair,
33¾ x 34 x 130 (85.7 x 86.4 x 330.2)
Collection of Robert Freidus

Chair, 1966
Formica on wood,
59 x 18 x 30 (149.9 x 45.7 x 76.2)
Saatchi Collection, London

Double Speaker, 1966
Formica on wood,
15½ x 26 x 12¼ (39.4 x 66 x 31.1)
Nicola Jacobs Gallery, London

Untitled, 1966
Formica on wood,
48 x 72 x 12 (121.9 x 182.9 x 30.5)
La Jolla Museum of Contemporary Art,
California

Cradle, 1967
Formica on wood,
40¼ x 48⅛ x 24 (102.2 x 122.2 x 61)
The Detroit Institute of Arts;
Gift of Mr. and Mrs. S. Brooks Barron

Faceted Syndrome, 1967
Formica on wood,
71½ x 191 x 5 (181.6 x 485.1 x 12.7)
Collection of the artist

Two-Part Invention, 1967
Formica on wood, two parts: wall piece,
57 x 21½ x 16 (144.8 x 54.6 x 40.6);
floor piece, 10¼ x 33 x 21½ (26 x 83.8 x 54.6)
The Albert A. List Family Collection

Six Mirror Images, 1975–79
Vacuum-formed, metallized plexiglass,
formica, and wood,
58 x 155 x 4 (147.3 x 393.7 x 10.2) open
The Oliver-Hoffmann Family Collection

Pyramid, 1979
Acrylic on wood,
87½ x 34⅛ x 34⅛ (222.3 x 86.7 x 86.7)
Collection of Emily Fisher Landau

Tower II, 1979
Formica and lacquer on wood,
102 x 30⅝ x 71⅝ (259.1 x 77.8 x 181.9)
Collection of Janet Green

Tower III (Confessional), 1980
Formica on wood,
60 x 47 x 32 (152.4 x 119.4 x 81.3)
Saatchi Collection, London

Book II (Nike), 1981
Formica on wood,
74 x 45¾ x 46 (188 x 116.2 x 116.8)
Saatchi Collection, London

Door }, 1983–84
Acrylic on wood and glass, two parts:
door, 81¾ x 65 x 9¾ (207.6 x 165.1 x 24.8);
bracket, 74¾ x 25 x 1½ (189.9 x 63.5 x 3.8)
Collection of Martin Bernstein

Door/Door II, 1984–85
Formica and acrylic on wood,
84 x 136 x 12 (213.4 x 345.4 x 30.5)
Collection of Janet Green

Drawing of Table, 1984–85
Rubberized hair and wood,
36 x 46 x 15 (91.4 x 116.8 x 38.1)
Private collection

Flayed Tables, 1984–85
Acrylic on wood,
123 x 52½ x 18 (312.4 x 133.4 x 45.7) open
Collection of Suzanne and Howard Feldman

Hoosier Cabinet, 1984–85
Formica and acrylic on wood,
66½ x 71½ x 13 (168.9 x 181.6 x 33)
Collection of Ghislaine Hussenot

Up and Across, 1984–85
Acrylic on wood,
61 x 144 x 35 (154.9 x 365.8 x 88.9)
Frederick R. Weisman Collection, Los Angeles

Organ of Cause and Effect III, 1986
Formica and acrylic on wood,
129 x 61¾ x 18 (327.7 x 156.8 x 45.7)
Whitney Museum of American Art, New York;
Purchase, with funds from the Painting and
Sculpture Committee 87.6 a–f

Loop, 1986
Formica and acrylic on wood,
96 x 52¾ x 10⅜ (243.8 x 134 x 26.4)
Collection of Bette Ziegler

Paintings

Lefrak City, 1962
Acrylic on celotex with formica frame,
44½ x 97½ (113 x 247.7)
Collection of the artist

Three Musicians, 1963
Acrylic on celotex with formica frame,
29 x 34 (73.7 x 86.4)
Collection of Norman Dolph

Three Women, 1963
Acrylic on celotex with metal frame,
47 x 48½ (119.4 x 123.2)
The Edward R. Broida Trust, Los Angeles

Untitled (Diptych), 1963
Acrylic on celotex, two parts:
13 x 17 x 7¼ (33 x 18.4 x 43.2) each
Collection of Norman Dolph

High-Rise Apartment, 1964
Acrylic on celotex with formica sides,
63 x 48 x 4½ (160 x 121.9 x 11.4)
Smith College Museum of Art, Northampton,
Massachusetts; Gift of Philip Johnson

Tract Home, 1964
Acrylic on celotex with formica frame,
48¼ x 68½ (122.6 x 174)
Collection of Kimiko and John Powers

Chair, Chair, Sofa, Table, Table, Rug, 1965
Acrylic on celotex with metal frame,
23⅛ x 41⅛ (58.7 x 104.5)
Collection of Jill and Douglas Walla

House, 1966
Acrylic on celotex with metal frame,
57 x 43 (144.8 x 109.2)
Collection of John Torreano

Office Scene, 1966
Acrylic on celotex with metal frame,
42 x 43 (106.7 x 109.2)
Collection of Mr. and Mrs. S. Brooks Barron

Sailors, 1966
Acrylic on celotex with metal frames,
four panels: 25 x 22½ (63.5 x 57.2) each
Collection of Jill and Douglas Walla

Hospital Ward, 1968
Acrylic on celotex, three panels:
68 x 140 (172.7 x 355.6) overall
The Detroit Institute of Arts;
Gift of Mr. and Mrs. S. Brooks Barron

Untitled (Weaving), 1969
Acrylic on celotex with metal frame,
33⅛ x 24½ (84.1 x 62.2)
Laurie Rubin Gallery, New York

Weaving, 1969
Acrylic on celotex with metal frame,
45 x 73 (114.3 x 185.4)
Private collection

Mirror, 1971
Acrylic on celotex with metal frame,
48 x 69 (121.9 x 175.3)
Collection of Mr. and Mrs. Ben Dunkelman

Polish Rider IV, 1971
Acrylic on celotex with metal frame,
two panels: 76 x 92 (193 x 233.7) overall
Kunstmuseum Basel, Switzerland;
Gift of the Emanuel Hoffman Foundation

Destruction III, 1972
Acrylic on celotex with metal frames,
two panels: 74 x 88 (188 x 223.5) overall
Private collection

Destruction V, 1972
Acrylic on celotex with metal frames,
two panels: 40 x 46 (101.6 x 116.8) overall
The Eli and Edythe L. Broad Collection

Double RCA Tower, 1972
Acrylic on celotex with metal frames,
two panels: 79 x 71 (200.7 x 180.3) overall
Private collection

Triptych V, 1972
Acrylic on celotex with metal frames,
three panels: 87 x 139½ (221 x 354.3) overall
Robert B. Mayer Family Collection

Bowl of Peaches on Glass Table, 1973
Acrylic on celotex with metal frame,
19½ x 25 (49.5 x 63.5)
Collection of Mr. and Mrs. Oscar Feldman

Garden, 1973
Acrylic on celotex with metal frames,
eight panels: 46 x 25¼ (116.8 x 64.1) each
Gagosian Gallery, Inc., New York

Interior (North), 1973
Acrylic on celotex with metal frames,
two panels: top, 52¾ x 88½ (134 x 224.8);
bottom, 52⅛ x 88½ (132.4 x 224.8)
Saatchi Collection, London

Interior (West), 1973
Acrylic on celotex with metal frames,
two panels: top, 48⅞ x 75⅞ (124.1 x 192.7);
bottom, 50⅞ x 75⅞ (129.2 x 192.7)
Saatchi Collection, London

Untitled, 1973
Acrylic on celotex with metal frame,
60 x 46⅝ (152.4 x 118.4)
Saatchi Collection, London

Johnson Wax Building, 1974
Acrylic on celotex with metal frame,
47⅝ x 59½ (121 x 151.1)
The Edward R. Broida Trust, Los Angeles

Rockefeller Center IV, 1974
Acrylic on celotex with metal frame,
63⅞ x 52½ (162.2 x 133.4)
Collection of Ann and Donald Brown

Chandelier II, 1976
Acrylic on celotex with metal frames,
four panels: 95½ x 27¾ (242.6 x 70.5) each
Collection of Balene C. McCormick

Fence II, 1980
Acrylic on celotex with painted wood frame
and mirror, two panels:
52½ x 57½ (133.4 x 146.1) each
Shaklee Corporation, San Francisco

City of Man, 1981
Acrylic on celotex, formica, and plexiglass
with painted wood frame,
77¾ x 179¾ x 5⅞ (197.5 x 456.6 x 14.9)
Collection of Emily Fisher Landau

Janus II, 1981
Acrylic on celotex with mirror and formica,
52¼ x 33½ x 19 (132.7 x 85.1 x 48.3)
Collection of Jeffrey and Marsha Miro

Three Trees (Shark), 1981
Acrylic on wood and celotex,
formica, and mirror,
36½ x 57½ x 13¼ (92.7 x 146.1 x 33.7)
Collection of Agnes Gund

Williamsburg Pagoda, 1981
Acrylic on celotex, formica, and wood,
87 x 73¾ x 8 (221 x 187.3 x 20.3)
Virginia Museum of Fine Arts, Richmond;
Gift of The Sydney and Frances Lewis Foundation

Clothes Closet, Bed, Rug, Corner, 1984–85
Acrylic on celotex with painted wood frame,
53 x 76 (134.6 x 193)
Collection of Anne and Martin Margulies

Dinner (Corner), 1984–85
Acrylic on celotex with painted wood frame,
30 x 27½ (76.2 x 69.9)
Collection of Patricia Brundage and
William Copley

D.M.B.R.T.W. I, 1985
Acrylic on celotex with painted wood frame,
68¾ x 56¾ (174.6 x 144.1)
Collection of Janet Green

D.M.B.R.T.W. II, 1985
Acrylic on celotex with painted wood frame,
53 x 59 (134.6 x 149.9)
Collection of George A. and Frances R. Katz

Dinner (Two), 1986
Acrylic on celotex with painted wood frame,
27¾ x 55¾ (70.5 x 141.6)
Collection of William S. Ehrlich

List of Illustrations

Unless otherwise noted, numbers refer to plates.

Apartment House (1964), 29

Basket, Mirror, Window, Rug, Table, Door (1985), 107

Biology Department Building (1974), 75

Book II (Nike) (1981), 94

Book III (Laocoön) (1981), 95

Bowl of Peaches on Glass Table (1973), 78

The Bush (1971), 64

Bushes II (1970), 60

Chair (1963), 15

Chair (1966), 45, p. 32

Chair and Window (1983), 96

Chair/Chair (1965), 31

Chair, Chair, Sofa, Table, Table, Rug (1965), 34

Chair Table (1980), 87

Chandelier II (1976), 83

Chest of Drawers (1964, rebuilt 1979), 26

City of Man (1981), 91

Clothes Closet, Bed, Rug, Corner (1984–85), 106

Corner I (1964), 24

Couch (1969), 53

Counter I (1962), 3

Counter II (1964), 33

Cradle (1967), 42

Cross (1962), 6

Description of Table (1964), 19

Destruction III (1972), 69

Destruction V (1972), 70

Destruction VI (1972), 71

Dinner (1987), 117

Dinner (a) (1986), 110

Dinner (b) (1986), 111

Dinner (Corner) (1984–85), 105

Dinner (Two) (1986), 115

Diptych II (1967), 52

Diptych III (1967), 46

Diptych IV (1964), 21

D.M.B.R.T.W. I (1985), 108

D.M.B.R.T.W. II (1985), 109

Door } (1983–84), 97

Door/Door II (1984–85), 101

Doors (1971), 63

Double RCA Tower (1972), 72

Double Speaker (1966), 37

Drawing of Table (1984–85), 102

Eight Rat Holes (1967–68 and 1973–75), p. 35

Faceted Syndrome (1967), 49

Farm III (1972), 67

Fence II (1980), 89

Flayed Tables (1984–85), 99

Garden (1973), 79

Garden II (1974), 80

Gorilla (1961–62), 2

Handle (1962), 1

High-Rise Apartment (1964), 28

Hoosier Cabinet (1984–85), 98

Hospital Ward (1968), 51

House (1966), 40

Interior (North) (1973), 77

Interior (West) (1973), 76

Janus II (1981), 92

Johnson Wax Building (1974), 82

Key Member (1967), p. 33

Lefrak City (1962), 8

Logus (1967), 47

Long Table with Two Pictures (1964), 22

Loop (1986), 114

Low Overhead (1984–85), 103

Mirror (1971), 61

Mirror/Mirror—Table/Table (1964), 23

Office Scene (1966), 39

Open Door (1967), 50

Organ of Cause and Effect III (1986), 116

Piano (1965), 36

Piano II (1965–79), 35

Polish Rider (1970–71), 58

Polish Rider IV (1971), 62

Portrait I (1962), 7

Portrait II (1963), 14

Pyramid (1979), 86

Railroad Track and Fence (1973), 74

Rockefeller Center IV (1974), 81

Rocker (1964), 32

Rosehill Pediment (1970), 57

Sailors (1964), 27

Sailors (1966), 38

Seated Group (1962), p. 29

Six Mirror Images (1975–79), 85

Sliding Door (1964), 17

Staircase (1971), 65

Step 'n' See II (1966), 41

Swivel (1963), 9

Table and Chair (1962–63), 4

Table and Chair (1963–64), 16

Table with Pink Tablecloth (1964), 18

Three Dinners (1984–85), 104

Three Musicians (1963), 12

Three Trees (Shark) (1981), 90

Three Women (1963), 13

Tintoretto's The Rescue of the Body of St. Mark (1969), 56

Tower (1964), 25

Tower III (Confessional) (1980), 88

Tract Home (1964), 20

The Tree (1971), 66

Trees Going Away (1970), 59

Triptych (1962), 5

Triptych II (1964), 30

Triptych V (1972), 68

Two Diners (1987), 118

Two Dinners (a) (1986), 112

Two Dinners (b) (1986), 113

Two Indentations (1967), 48

Two-Part Invention (1967), 44

Untitled (1962), p. 16

Untitled (1966), 43

Untitled (1967), p. 34

Untitled (1967), p. 34

Untitled (1973), 73

Untitled (1981), p. 42

Untitled (Diptych) (1963), 11

Untitled (Table) (1962), p. 27

Untitled (Weaving) (1969), 54

Up and Across (1984–85), 100

Walker (1964), 10

Weave—Drape (1971), 55

Weaving #182 (1976), 84

Williamsburg Pagoda (1981), 93

Photograph Credits

Photographs accompanying this text have been supplied, in the majority of cases, by the owners or custodians of the works, as cited in the captions. The following list applies to photographs for which an additional acknowledgment is due. Numbers are those of the plates, unless otherwise indicated.

Christian Baur: 72

Ben Blackwell: Frontis.

Rudolph Burckhardt: 16, 20, 29, 37, 43, 50, 69, 70, 71, pp. 33, 161 (right and left), 162

Geoffrey Clements: 4, pp. 22, 165

Henri Dauman: p. 31

Bevan Davies: 24, 33

D. James Dee: p. 167

© The Detroit Institute of Arts: 51

Susan Einstein: 46

© Herb Engelsberg: p. 168

Anne Gold: 7, p. 164

Bruce C. Jones: 73, 75, 80–82

Peter Moore: 27, 38, 40, 52, pp. 32, 34

William Nettles: 21

© Douglas M. Parker Studio: 5, 54, 107, 110–113

Eric Pollitzer: 10, 17, 23, 34, 61, 63, 65, 67, 68, 74

Nathan Rabin: 1, 57, 59, 60, 62, 64, 66

© Harry Shunk: 55

Shunk-Kender: 58

© Steven Sloman: 19

Glenn Steigelman: 87, 91–93, 95, p. 169

Secol Thetford: 32, 76, 77

Jerry L. Thompson: 11, 12

Herbert P. Vose: 28

© Dorothy Zeidman: 3, 85, 97–106, 108, 109, 114, 115, 118, p.170

Zindman/Fremont: 6, 8, 14, 15, 31, 41, 44, p.35

This publication was organized at the
Whitney Museum of American Art
by Doris Palca, Head, Publications and
Sales; Sheila Schwartz, Editor;
Deborah Lyons, Associate Editor; and
Vicki Drake, Assistant.

It was designed by Anita Meyer, Boston,
typeset in Univers and Sabon by
Monotype Composition, Boston, and
printed in Hong Kong by the
South China Printing Company.